The Summits of Snowdonia

A GUIDE TO THE 600-METRE MOUNTAINS OF SNOWDONIA

Terry Marsh

Illustrations and maps by
the author

ROBERT HALE · LONDON

D0620345

© *Terry Marsh 1984*
First published in Great Britain 1984
First paperback edition 1993

Unacknowledged poetry quotations are by the author

ISBN 0 7090 5248 0

Robert Hale Limited
Clerkenwell House
Clerkenwell Green
London EC1R 0HT

Printed in Great Britain by St Edmundsbury Press Limited
Bury St Edmunds, Suffolk
Bound by WBC Bookbinders Limited

Contents

Maps

Illustrations

Acknowledgements

My thanks are especially due to my friend Allan Rimmer, who surveyed some of the mountains for me during the preparation of the draft, and cast his journalist's eye over the draft and finished manuscript; also to Tim Owen in the Ordnance Survey at Southampton who read the manuscript and checked all the heights and map references for me; to my colleague the Chief Librarian of Wigan and his staff, who produced all the books I asked for; to the staff of the Map and Print Room in the National Library of Wales, Aberystwyth; and to all those, particularly Eric and Ron, who accompanied me on the mountains, often in the belief that they were doing all the hard work while I gained all the credit.

I am deeply grateful to my friend, artist John Henshall, who until recently lived in the Nantlle Valley and whose poetry, some of it specially written, appears in this book. I am indebted to Herbert Carr for permission to quote from *The Mountains of Snowdonia*; and to Esme Firbank, now Kirby, Chairman of the Snowdonia National Park Society, for a quotation from her work.

Similarly I must thank the staff of the Snowdonia National Park Office for information about access arrangements and for permission to quote from their publicity leaflets; also the Forestry Commission, the Nature Conservancy Council and the National Trust for permission to quote from their publications.

The maps are based on Ordnance Survey Maps with the sanction of the Controller of Her Majesty's Stationery Office. Crown copyright reserved.

Foreword

This book is a guide and checklist to all the 600-metre summits in Snowdonia, including the Berwyn Hills which straddle the National Park boundary. It is intended for dedicated walkers who want a complete list of summits to 'tick off', and the less frequent visitor to Wales seeking the best or easiest approaches into the mountains.

It is not, however, a step-by-step guide and gives no detailed accounts of routes except where, on the ground, there is doubt or when to do so could be a valuable aid in misty conditions. The maps in the book are purely diagrammatic, intended only to show the relationship between mountains. They are no substitute for Ordnance Survey maps, and the book is compiled on the assumption that walkers will, in the main, use the 1:50,000 scale maps.

There are notes of historical, legendary and passing interest, intended to induce the walker into a better understanding of the Welsh heritage and the people and countryside of Wales. The book includes lists giving heights and grid references of all the summits.

Not every line of ascent is mentioned: in some instances there are justifiable grounds for not doing so. If a route is obvious, even though it may require map and compass work, the walker is left to his or her own devices. But armed with this book, a map and a compass (and the knowledge to use them), a way can be found up and down every mountain.

To a companion on a country walk

Do not talk, lest we fail to see
 The glorious scene which surrounds us;
Do not talk, lest we fail to hear
 The sounds of the birds around us;
Do not talk, lest we fail to smell
 The scents in the country air;
Do not talk, lest we fail to touch
 The hand of a God who is there.

To a companion after a country walk

With a welcome drink, in a country inn
 At the end of a glorious day
We will talk and talk as much as we wish –
 There'll be much for us to say.
But in hills on high or in valleys low
 If we talk we will miss such a lot,
But now let us talk, let us talk, let us talk
 Of the memories we have got.

JOHN HENSHALL

Introduction

Generally, though incorrectly, only the mountain ranges which dominate the extreme north-west of Wales are known by the name *Snowdonia* – *Eryri* in the old Welsh. The error arises from the presence here of the prince of the Welsh mountain scene, *Yr Wyddfa (Snowdon)*, so it is assumed that only those mountains flanking the central massif bear the name. In fact, *Snowdonia* covers a far larger domain of over 2,000 square kilometres (840 square miles) and extends far south to Bala and beyond.

Walkers who venture into the hills of Snowdonia will find themselves among mountains that have an affinity with higher ranges elsewhere in the world. The terrain is often rugged and broken; evidence of the carving hand of ice is encountered everywhere; summits, in the main, are sharp and accessible only by routes that are devious, steep and rocky, and connecting ridges have at least one side which falls steeply to a valley or *cwm*. In winter it is a paradise, or a deathtrap, according to one's ability. What may not be readily grasped, for the geology of Snowdonia is not easily understood, is that the whole area was once completely under the sea: fossil sea shells found in the sedimentary rocks of Snowdon, Moel Hebog and elsewhere prove this point. (Yet it is interesting to note that when, less than two hundred years ago, George Louis Leclerc, Comte de Buffon, a French naturalist, propounded his prescient theory that sea shells found embedded in high mountain rocks were evidence that the sea had once been there, no less an eminent man of letters than Voltaire disputed the theory as 'mystical nonsense', saying simply that the shells had been taken there by pilgrims.)

In the case of Snowdon the geological history is further compli-

cated by the presence of large quantities of volcanic material. The only explanation for this state of confusion is that it all emanated from submarine volcanic activity.

Whatever the contrivances that produced them, here are some of the finest summits to be found anywhere in Britain; this book sets out to list them. All the summits are contained in the Snowdonia National Park, with the exception of the Berwyn Hills, but these are so close as to justify their inclusion.

The sport of climbing on, or walking up, Britain's mountains developed from the practice of walking for health, but in common with trends elsewhere in the world the early excursions were made for the purpose of scientific research – the study of flowers, geology etc. Not until the mid-nineteenth century was the widespread dislike of mountains as places inhabited by evil spirits finally dispelled, though the 'fastnesses of Snowdonia' had long before then been the refuge in times of trouble of the ubiquitous Owain Glyndwr.

The original concept of listing and ascending all the mountains of a given area above a certain height is credited to Sir Hugh T. Munro, a founder member of the Scottish Mountaineering Club when it was established in 1889. Munro published two years later his *Tables of the 3,000-feet Mountains of Scotland*, which rapidly became, and still remain, justifiably famous among the mountaineering fraternity. Sir Hugh, himself a seasoned traveller, succeeded in ascending all but two of his listed mountains before he died in 1919. The Tables have since been revised, reprinted and metricated as new survey techniques and progress etched new standards into their original content. This has been done even to the extent that in the latest edition of the Tables the *Munro* (as each became known) which Sir Hugh saved for a final celebration no longer qualifies as a Munro. It makes interesting speculation that if at some time in the future Sir Hugh's only other omission – The Inaccessible Pinnacle, Sgurr Dearg – fails to be considered as a mountain, or the true summit of one, his name will at last reach the hallowed list of all those who have completed the ascent of all the Munros, many years after his death! But the 'Inn. Pinn.' may have to collapse first.

Soon after Munro published his Tables, other mountaineers applied his principles to areas outside Scotland. The Reverend W. T. Elmslie published in 1933 a list of all the 'Two Thousand Footers' of England based on a survey of Bartholomew's Half

Inch Maps. Many of Elmslie's 'Two Thousand Footers' were no more than any 'point marked on the map, with the height-figure of two thousand feet or more', and a far cry from being mountain summits. F. H. F. Simpson in 1937 produced a limited list of English summits, which was extended and improved in 1939, and again in 1940, this time by the inclusion of Wales. Fifteen years later W. McKnight Docharty compiled a list of mountains over 2,500 feet, which he extended in 1962 to take in most of the mountains over 2,000 feet. Many of these early lists were published in the journals of various clubs – the Rucksack Club, the Fell and Rock Club, the Scottish Mountaineering Club – but they soon became in greater demand as the sport developed. In 1974, by which time, largely due to the activities and penmanship of that reclusive Lakeland 'artefact' A. Wainwright guidebooks and checklists were an established part of the mountaineering scene, Nick Wright produced a complete list of the *English Mountain Summits*, an expansive book with much useful information.

In all these lists, except Elmslie's, the qualification used to determine a 'mountain's' inclusion in each list was one contour ring as shown on the Ordnance Survey One Inch Maps, even though one contour ring said very little about the identity of a mountain. The main problem in adopting such a criterion is that a mere rise of 5 feet can generate a contour ring, while a rise of 45 feet may not do so.

In 1973 George Bridge, author of the *Bibliography of British Climbing Guidebooks*, published tables of mountains of 2,000 feet and more in altitude in England and Wales, requiring each mountain to be separated from all others by 'a real rise of fifty feet or more all round'. Bridge used Ordnance Survey Six Inch Maps, supplemented by maps at other scales. Yet another qualification appears in Munro's Tables, for although the Tables are primarily concerned with heights over 3,000 feet, they do also contain separate tables of heights over 2,500 feet – *Corbetts*, which require a minimum of 500 feet of re-ascent all round – and a list of the *Hills in the Scottish Lowlands, 2,000 feet and above*. These latter hills are known as *Donalds*, after their compiler, Mr Percy Donald. The qualification which Donald required for a mountain, or, as he called them, 'Tops', is a drop of 100 feet on all sides. He goes on, however, to include all 'elevations of sufficient topographical merit with a drop of between 100 feet and 50 feet on all sides'.

So, three methods of determining what constitutes a moun-

tain, but if there is one thing this book does not intend, it is to add a fourth. Mountaineers will in any event climb what they want to climb whether or not it meets some magical mystery height, and rightly so. But for those who want the challenge of completeness, and judging by the kudos attached to those who have climbed all the Munros there will be many of them, there must be some sense of uniformity in spite of geological differences. That is not to say that all mountains elsewhere in Britain should be treated in exactly the same way as in Scotland when there is so obviously a vast difference of scale in terms of both distance and quantity. If they were, and it would be a difficult comparison to make, England could boast no more than seven Munros, all of them in the Lake District, Wales fifteen (including the rather dubious Garnedd Uchaf) and Ireland eleven. But where there is the possibility of uniformity it should be adopted. For this reason the criterion applied in compiling this table of heights is that adopted by Donald, subject to metric conversion and adjustment.

Conversion to metric systems may not be wholly accepted, but it is upon us, and strict conversion produces nonsensical results, necessitating slight revision. Furthermore, although the maps on which the research for this book was carried out are the latest 1:10,000 maps produced by the Ordnance Survey, most hill-walkers will have access only to the 1:50,000 maps, which are nevertheless quite adequate.

For many parts of Britain the 1:50,000 maps have been completely metricated, but in Snowdonia only Sheets 114, 115 and 117 have been resurveyed and metricated, and of those three only Sheet 115 contains mountains within the scope of this book. The remaining maps are simply photographic enlargements of the former One Inch Maps and will not appear as wholly metricated maps before 1984–5.

On metricated maps the vertical distance between two contour rings is 10 metres (32.8 feet), while on all other maps it is 50 feet with metric heights, to the nearest metre, supplanted on them. Establishing with certainty re-ascents of 100 feet and 50 feet, which is what Donald's standards necessitate, requires five and three contour rings respectively on metricated maps, but only three and two contour rings respectively on other maps. To resolve this dilemma, and to guarantee continued validity of the lists given in this book, I have amended slightly the criteria for re-ascent to 30 metres (98.4 feet) in place of the former standard of

100 feet, and 15 metres (49.2 feet) in place of the former 50 feet. In all cases I have calculated the amount of minimum re-ascent using the latest 1:10,000 maps, which has the effect of producing results which are apparently inconsistent with information on the 1:50,000 maps.

Wholly metricated or not, none of the maps now available, except the slightly dated 1:25,000 Outdoor Leisure Maps, gives other than metric heights. For this reason metric heights are used throughout the book. Strict conversion of 2,000 feet, which otherwise would have been the 'cut-off' point, produces 609.60741 metres: 610 metres produces an equally silly 2,001.288 feet. Such exactitude is not a common feature of the average hill-walker's outlook, but unless a list is made of every mountain regardless of height, taking into account that Holyhead Mountain on Anglesey is a little over 700 feet, and Bangor Mountain, almost in the centre of a town, may well be less, a line must be drawn somewhere. Six hundred metres seems a convenient figure, with no more nor less meaning than 2,000 feet or 3,000 feet.

Distances, however, are another matter. The task of converting the nation to kilometres instead of miles must seem a forlorn hope, yet it seems certain to happen. Many people are happy to accept the transition, but for those who are not, or who, like the author, are content with kilometres providing they are accompanied by a conversion into miles, this book opts for a foot in both camps: kilometres first, miles in brackets.

SUMMARY

The following guide-lines have been adopted in compiling the list of summits:

Checklists 1 and 2 list all elevations of 600 metres or more in height, based on a survey of the latest 1:10,000 Ordnance Survey maps, with a minimum of 30 metres re-ascent in all directions. They also include elevations of sufficient topographical merit with a minimum of between 15 and 30 metres of re-ascent in all directions. The sufficiency of topographical merit has been determined by careful consideration on the ground.

The Appendix to the Checklists contains any named elevation of 600 metres or more in height, also based on the 1:10,000 maps, with less than 15 metres of re-ascent, or, if it has between 15 and 30

metres of re-ascent, which has insufficient topographical merit to justify its inclusion in the Checklists.

The Checklists and the Appendix, therefore, list all elevations of 600 metres or more in height, except un-named elevations with less than 15 metres of re-ascent.

Names. The Ordnance Survey spelling has been used throughout, even though it may be inaccurate. Except where appropriate, no attempt has been made to translate the names of the mountains, partly because of the complexities of the Welsh language, but mainly because many names defy translation: the name of the mountain *is* the mountain. How, to draw a parallel, would we explain *The Cheviot* or *Glaramara*? Unless otherwise stated, the name is from the 1:50,000 maps. If there is no name on any map, then the commonly accepted name either locally or among mountaineers has been used. In the absence of anything, the expression 'Un-named summit' has been adopted, followed in parentheses by the name of the next nearest, named mountain or other positively identifiable feature. On the maps these summits are shown simply by their number in Checklist 1.

Number. The number in the text is the number of the mountain in order of altitude, and relates to Checklists 1 and 2.

Heights. Heights are the latest available from the Ordnance Survey and may differ from those on published maps. If there is no height available, the height shown in the list is that of the highest contour ring. In these cases the height is followed by a letter c.

Map references. Map references are calculated using the 1:10,000 maps and as a result produce information which does not always agree with the 1:50,000 and other maps. Study of the situation on the ground, however, will show the later maps to be far more accurate.

Sections. The Sections and their names are those commonly in use without regard to the niceties of the Welsh language; for example, *Carneddau* is used instead of *Carnedds*, and *Rhinogs* instead of *Rhinogydd*.

Map number. The map numbers, i.e. *Sheet No.*, refer to the appropriate sheet(s) of the 1:50,000 series of maps.

1. The routes in this book are described as fair weather ascents. Some ascents may be hazardous in winter conditions, especially if attempted by inexperienced or inadequately equipped walkers. No one should venture into these hills without the appropriate ordnance survey or comparable map, in addition to all other basic items of mountaineering equipment.

2. The routes and lines of ascent described in this book do not necessarily imply that a right of way exists.

Access to the Welsh Countryside

Many walkers, like myself, have for years gone into the hills for recreation, and have done so without trouble or restriction. As a result of this concession – for that is what it is – there is now, among an element of the hill-walking fraternity, a general misconception that we can go wherever we please; we cannot! Every square inch of Britain belongs to someone, and though it may seem that nothing is happening to, or being done with, a certain tract of countryside, this may not necessarily be true, and even if it were, we should not assume that there is an open invitation to enter upon it. Wales is no exception to this.

I have no wish to dwell at length on the rights and wrongs of access, or the legislation which does or does not permit such access. It is complex and invariably involves a good deal of painstaking and delicate negotiation with the people who own the land. I am more concerned to develop an awareness among hill-walkers of our responsibilities to those who own and work the land, since I firmly believe that it is simple lack of awareness which gives rise to the problems and confrontations we hear about from time to time.

It is my experience that walkers are welcome in Wales if they treat farm property, and that includes land, with respect, and consider the problems and needs of the farming community. It is a sad fact that many early guidebooks contained little or no advice about this extremely salient aspect of our recreation, nor did they explain things from the land users' point of view. I hope I can put some of that right.

We have all at some time encountered walls and fences across our intended way, or found gates which may have been tied or

locked shut: there are good reasons for this. We all know it has something to do with sheep or cattle but may remain ignorant on the detail.

Mountain farms, not all of which extend down to the valley bottom, are divided into three parts. The lowest part is composed of the fields around the farmstead where crops, fodder (i.e. hay) and grazing are concentrated and fairly intensively managed. The next part is, in Wales, known as the *ffridd* – a word often found on maps – below the mountain wall, which is an enclosed area under some measure of management, though not to the same extent as the fields lower down. Finally, there is the large area of rough mountain pasture, which is literally the rest of the mountain. So the whole of the mountain has a part to play in the work and livelihood of the farm. To understand just how important this is, it is worth reading Thomas Firbank's book *I Bought a Mountain* – see Bibliography.

The importance, too, of walls and gates should not be overlooked, for there are good reasons why we should not climb over them or leave gates open. At various times of the year a sheep farmer must sort out his flock. Ewes must be separated from rams, lambs from yearlings, and so on. This, obviously, requires many enclosures. The job is a long and difficult one even with the aid of a pair of sheepdogs, and it is only possible if the fields into which the farmer puts the different groups are stock-proof. If gates are left open, or walls damaged, all the hard work of the farmer will be wasted. Most important of all, lambing on mountain farms takes place late in the spring because the winters are so long and severe. For the time of lambing to be correctly controlled, the rams must not be allowed to mix with the ewes earlier than about October. If gates are left open, and rams and ewes are allowed to mix, lambing will occur too early and many lambs will die.

So, unless gates are obviously propped open for some purpose, close them.

Still on the subject of sheep, it is important never to touch or attempt to handle a new-born lamb, no matter how endearing or helpless it may seem; to do so could drive the mother to abandon the lamb, with fatal consequences. If you do find a lamb, seemingly helpless, or injured, report the matter to the farmer rather than attempt well-meaning, but possibly disastrous, action yourself.

Uncontrolled dogs, especially at lambing time, are another form of disaster for the farmer. Though your dog may be very tame and gentle, it is, in the mountains, in an alien environment, and curiosity may well get the better of it. Sheep are instinctively nervous of dogs and may run away. This can cause abortion at lambing time, or direct injury or death to the sheep. They may panic and become trapped on a mountain ledge and die of starvation. So, if you must take your dog, keep it on a lead or long rope; farmers will feel less nervous if dogs are seen to be on leads or, better still, left at home, especially in March and April. In the interest of peaceful co-existence it is better to follow the advice I used to give in my wardening days when assured that a dog was 'fully trained' and 'completely under control' – put it on a lead and set an example to others.

Not all mountain land is farmed for agricultural purposes; a great deal of it is afforested and under the control of the Forestry Commission, or is in the ownership of the Nature Conservancy or the National Trust. On forestry land the rules are clear since they are expressed in the Commission's *Policy and Procedure Paper No. 2*:

> The Commission welcomes the public on foot to all its forests, provided this access does not conflict with the management and protection of the forest, and provided there are no legal agreements which would be infringed by unrestricted public access.

The Nature Conservancy, like the Forestry Commission, are also particularly active in Wales with more than fourteen Nature Reserves within the area covered by this book. The Conservancy makes Nature Reserves accessible for the use and enjoyment of visitors whenever possible:

> . . . but because conservation and research must remain the primary objectives it may be necessary to control access by permit in some cases. This may happen when the land belongs to a private owner whose rights and those of his tenants must be respected, or when delicate experiments are being made. No two reserves are alike and therefore conditions of access must vary, but generally the restrictions imposed are only those which are necessary to avoid damage. Lighting picnic fires, leaving litter or other rubbish, and the polluting of water may often be the result of thoughtlessness rather than deliberate vandalism; but they can easily destroy the careful efforts of management and the results of scientific research. Acts which nobody would think of doing on someone else's private property are sometimes regarded by a minority as

unexceptionable on a nature reserve, just because the land is conserved 'for the nation'. But this attitude ignores the overriding principle that all rights or privileges, no matter where or by whom they are exercised, carry with them corresponding obligations, otherwise those rights or privileges become abuses.

These sentiments, expressed by the Nature Conservancy Council, apply with equal effect to all mountain and countryside areas and find endorsement in the policy of the National Trust, another major landowner:

> The Trust's policy is to give free access at all times to its open spaces, subject only to observance of the recognised country code. There cannot, of course, be unrestricted access to tenanted farms, to young plantations and woods, or to certain nature reserves in the breeding season where the preservation of rare fauna and flora is paramount.

On reflection we may feel that all these limitations impose impossible demands on us; after all we are trying to get away from the restrictions of day-to-day living. But they are, on closer inspection, no more than common sense and the observance of basic courtesies, and this one concept embodies everything needed for harmony and peaceful enjoyment of the countryside. Nothing annoys farmers and landowners more than someone, on his land, insisting on 'rights'. Yet a friendly word or two, or a request in advance for permission to cross land, especially where rights of way do not exist, may well produce for the considerate walker consent to go where, in other circumstances, he would be denied access. This is particularly important in troubled areas like the Arans where such access arrangements as do exist are subject to review.

Finally, a word about the National Park Committee whose work in the field of access has revolved around the negotiation of access agreements to many popular areas in the northern part of Snowdonia. Were it not for their diligence, the splendid Nantlle ridge, for example, would be completely out of bounds, as indeed it once was. Nor would there be free access to cross the main ridge of the Aran Mountains. But there are still many areas not covered by access agreements, or owned by the Forestry Commission, the Nature Conservancy or the National Trust, and it is in these areas that we can all do much to foster good relations, and so preserve for succeeding generations the pleasures of access to the countryside.

PUBLIC TRANSPORT

For the majority of the mountains listed in this book the public transport services provide little direct benefit since they seldom pass in close proximity to the mountain ranges. There are of course exceptions, especially in the northern part of Wales, and details of available services are given below.

Railways. Snowdonia is served by three railway lines:

The North Wales Coast Line operating from Crewe and Chester to Holyhead along the north Wales coast, giving access in the main to the Carneddau range of mountains at Llanfairfechan, Aber, and Bangor.

The Cambrian Coast Line operating from Shrewsbury to Pwllheli through Tywyn and Barmouth, giving access into Snowdonia from the south and west.

The Conwy Valley Line operating from Llandudno (or Llandudno Junction) to Blaenau Ffestiniog.

Further information about these rail services may be obtained from the Information Office at Llandudno Junction (Tel: Llandudno 85151) between the hours 0800 and 2100 each day.

In addition, of course, there are a small number of privately operated narrow gauge railways, and a small, useful pamphlet may be obtained about these, including timetables, from the Narrow Gauge Railways of Wales, Wharf Station, Tywyn, Gwynedd, LL36 9EY. The pamphlet is entitled *The Great Little Trains of Wales*.

Buses. The National Express Coach service operates into Snowdonia throughout the year from Birmingham, Blackpool, Cardiff, Cheltenham, Chester, Liverpool, Manchester and Swansea. These are supplemented during the summer months by buses operating from other areas.

Within Snowdonia bus services are operated by Crosville Motor Services Ltd, and one or two small private companies. Information can be obtained from Crosville Motor Services Ltd, Crane Wharf, Chester, CH1 3SQ (Tel: Chester 381515), and from the individual depots throughout the region. These are at Bangor, Caernarfon, Dolgellau, Machynlleth and Pwllheli. Timetables are also available from National Park Information Centres and from Gwynedd County Council, Planning Department, Maesincla, Caernarfon, Gwynedd, to whom one should send a large stamped addressed envelope.

Checklist of Summits

Checklist of Summits

1. The 600-metre Summits in order of Altitude

No. in order of Altitude	Height	Name	Section in Table 2	Range in Table 2
1	1,085	Yr Wyddfa (Snowdon)	1	Snowdon
2	1,066	Crib y Ddysgl	1	Snowdon
3	1,064	Carnedd Llywelyn	3	Carneddau
4	1,044	Carnedd Dafydd	3	Carneddau
5	999	Glyder Fawr	2	Glyders
6	990	Glyder Fach	2	Glyders
7	978	Pen yr Ole Wen	3	Carneddau
8	976	Foel Grach	3	Carneddau
9	962	Yr Elen	3	Carneddau
10	947	Y Garn	2	Glyders
11	942	Foel Fras	3	Carneddau
12	926	Garnedd Uchaf	3	Carneddau
13	923	Elidir Fawr	2	Glyders
14	923	Crib Goch	1	Snowdon
15	915	Tryfan	2	Glyders
16	905	Aran Fawddwy	9	Arans
17	898	Y Lliwedd	1	Snowdon
18	893	Pen y Gadair (Cader Idris)	8	Cader Idris
19	885	Aran Benllyn	9	Arans
20	872	Moel Siabod	5	Siabod
21	872	Erw y Ddafad Ddu	9	Arans
22	863	Mynydd Moel	8	Cader Idris

No. in order of Altitude	Height	Name	Section in Table 2	Range in Table 2
23	854	Arenig Fawr	7	Arenigs
24	849	Llwytmor	3	Carneddau
25	833	Pen yr Helgi Du	3	Carneddau
26	831	Foel Goch	2	Glyders
27	827	Moel Sych	10	Berwyns
28	827	Cadair Berwyn	10	Berwyns
29	822	Carnedd y Filiast	2	Glyders
30	813	Mynydd Perfedd	2	Glyders
31	811	Cyfrwy	8	Cader Idris
32	807	Bera Bach	3	Carneddau
33	805	Nameless Peak	2	Glyders
34	799	Pen Llithrig y Wrach	3	Carneddau
35	794	Bera Mawr	3	Carneddau
36	791	Mynydd Pencoed	8	Cader Idris
37	785	Cadair Bronwen	10	Berwyns
38	783	Moel Hebog	4	Hebog
39	780	Glasgwm	9	Arans
40	770	Moelwyn Mawr	5	Moelwyns
41	770	Drum	3	Carneddau
42	763	Gallt yr Ogof	2	Glyders
43	758	Drosgl	3	Carneddau
44	756	Y Llethr	6	Rhinogs
45	751	Moel Llyfnant	7	Arenigs
46	750	Diffwys	6	Rhinogs
47	747	Yr Aran	1	Snowdon
48	742	Tomle	10	Berwyns
49	734	Craig Cwm Silyn	4	Nantlle
50	734	Rhobell Fawr	7	Rhobells
51	726	Moel Eilio	1	Eilio
52	720	Rhinog Fawr	6	Rhinogs
53	712	Rhinog Fach	6	Rhinogs
54	710	Moelwyn Bach	5	Moelwyns
55	709	Trum y Ddysgl	4	Nantlle
56	701	Garnedd Goch	4	Nantlle
57	698	Mynydd Mawr	4	Nantlle
58	698	Allt Fawr	5	Moelwyns
59	695	Mynydd Drws y Coed	4	Nantlle
60	691	Foel Wen	10	Berwyns
61	689	Cnicht	5	Moelwyns

No. in order of Altitude	Height	Name	Section in Table 2	Range in Table 2
62	689	Arenig Fach	7	Arenigs
63	689	Foel Hafod Fynydd	9	Arans
64	685	Pen y Bryn Fforchog	9	Arans
65	685	Gwaun y Llwyni	9	Arans
66	683	Gau Craig	8	Cader Idris
67	681	Mynydd Tarw	10	Berwyns
68	679	Godor	10	Berwyns
69	678	Creigiau Gleision	3	Carneddau
70	676	Moel Druman	5	Moelwyns
71	674	Maesglasau	8	Dovey
72	674	Moel Cynghorion	1	Eilio
73	672	Ysgafell Wen	5	Moelwyns
74	671	Esgeiriau Gwynion	9	Arans
75	670	Waun Oer	8	Dovey
76	669	Carnedd y Filiast	7	Arenigs
77	669	Un-named summit (Ysgafell Wen)	5	Moelwyns
78	667	Cyrniau Nod	10	Hirnant
79	667	Tarren y Gesail	8	Tarren Hills
80	662	Dduallt	7	Rhobells
81	661	Tyrau Mawr	8	Cader Idris
82	661	Manod Mawr	5	Ffestiniog
83	659	Cribin Fawr	8	Dovey
84	658	Un-named summit (Manod Mawr)*	5	Ffestiniog
85	655	Moel yr Ogof	4	Hebog
86	655	Post Gwyn	10	Berwyns
87	653	Mynydd Tal y Mignedd	4	Nantlle
88	648	Foel Cwm Sian Llwyd	10	Hirnant
89	648	Moel yr Hydd	5	Moelwyns
90	646	Pen y Boncyn Trefeilw	10	Hirnant
91	643	Carnedd Llechwedd Llyfn	7	Arenigs
92	638	Moel Lefn	4	Hebog
93	634	Tarrenhendre	8	Tarren Hills
94	634	Un-named summit (Creigiau Gleision)	3	Carneddau

* See explanation under *Names*, page 16.

No. in order of Altitude	Height	Name	Section in Table 2	Range in Table 2
95	633	Y Garn	4	Nantlle
96	630	Moel Fferna	10	Berwyns
97	630	Stac Rhos	10	Hirnant
98	629	Y Garn	6	Rhinogs
99	629	Foel Gron	1	Eilio
100	626	Foel y Geifr	10	Hirnant
101	625	Moel y Cerrig Duon	10	Cwm Cynllwyd
102	623	Moel Ysgafarnogod	6	Rhinogs
103	623	Pen y Castell	3	Carneddau
104	623	Moel Penamnen	5	Ffestiniog
105	622	Craig y Llyn	8	Cader Idris
106	621	Un-named summit (089369)	10	Berwyns
107	619	Gallt yr Wenallt	1	Snowdon
108	619	Foel Boeth	7	Arenigs
109	615	Cefn Gwyntog	10	Hirnant
110	614	Llechwedd Du	9	Arans
111	612	Trum y Gwrgedd	10	Hirnant
112	611	Foel Goch	7	Arenigs
113	610	Pen yr Allt Uchaf	9	Arans
114	610	Tal y Fan	3	Carneddau
115	610	Foel Goch	10	Hirnant
116	609	Un-named summit (Bwlch Moch)	1	Snowdon
117	609	Mynydd Craig Goch	4	Nantlle
118	608	Glan Hafon	10	Berwyns
119	607	Moel Meirch	5	Moelwyns
120	606	Un-named summit (Moel y Cerrig Duon)	10	Cwm Cynllwyd
121	605	Foel Goch	1	Eilio
122	604	Mynydd Ceiswyn	8	Dovey
123	604	Mynydd Dolgoed	8	Dovey
124	603	Foel Lwyd	3	Carneddau
125	602	Y Gribin	9	Arans

2. The 600-metre Summits Grouped in Sections by Location

Name	Height	No. in order of Altitude	OS Map	Map Reference
SNOWDON GROUP				
Yr Wyddfa (Snowdon)	1,085	1	115	609544
Crib y Ddysgl	1,066	2	115	611552
Crib Goch	923	14	115	624552
Y Lliwedd	898	17	115	622533
Yr Aran	747	47	115	604515
Gallt yr Wenallt	619	107	115	642533
Un-named summit (Bwlch Moch)	609	116	115	635552
EILIO GROUP				
Moel Eilio	726	51	115	556577
Moel Cynghorion	674	72	115	586564
Foel Gron	629	99	115	560569
Foel Goch	605	121	115	571563

SECTION 2

Name	Height	No. in order of Altitude	OS Map	Map Reference
GLYDERS				
Glyder Fawr	999	5	115	642579
Glyder Fach	990	6	115	656583
Y Garn	947	10	115	631596
Elidir Fawr	923	13	115	612613
Tryfan	915	15	115	664594
Foel Goch	831	26	115	628612
Carnedd y Filiast	822	29	115	620628
Mynydd Perfedd	813	30	115	623619
Nameless Peak	805	33	115	677582
Gallt yr Ogof	763	42	115	685586

Name	Height	No. in order of Altitude	OS Map	Map Reference
CARNEDDAU				
Carnedd Llywelyn	1,064	3	115	684644
Carnedd Dafydd	1,044	4	115	663631
Pen yr Ole Wen	978	7	115	656619
Foel Grach	976	8	115	689659
Yr Elen	962	9	115	674651
Foel Fras	942	11	115	696682
Garnedd Uchaf	926	12	115	687669
Llwytmor	849	24	115	689692
Pen yr Helgi Du	833	25	115	698630
Bera Bach	807	32	115	672678
Pen Llithrig y Wrach	799	34	115	716623
Bera Mawr	794	35	115	675683
Drum	770	41	115	708696
Drosgl	758	43	115	664680
Creigiau Gleision	678	69	115	729615
Un-named summit (Creigiau Gleision)	634	94	115	734622
Pen y Castell	623	103	115	722689
Tal y Fan	610	114	115	729727
Foel Lwyd	603	124	115	720723

Name	Height	No. in order of Altitude	OS Map	Map Reference
HEBOG GROUP				
Moel Hebog	783	38	115	565169
Moel yr Ogof	655	85	115	556478
Moel Lefn	638	92	115	553485
NANTLLE GROUP				
Craig Cwm Silyn	734	49	115	525503
Trum y Ddysgl	709	55	115	545516
Garnedd Goch	701	56	115	511495
Mynydd Mawr	698	57	115	539547
Mynydd Drws y Coed	695	59	115	549518
Mynydd Tal y Mignedd	653	87	115	535514
Y Garn	633	95	115	551526
Mynydd Craig Goch	609	117	115/123	497485

Name	Height	No. in order of Altitude	OS Map	Map Reference
SIABOD				
Moel Siabod	872	20	115	705546
MOELWYNS				
Moelwyn Mawr	770	40	124	658449
Moelwyn Bach	710	54	124	660437
Allt Fawr	698	58	115	682475
Cnicht	689	61	115	645466
Moel Druman	676	70	115	671476
Ysgafell Wen	672	73	115	667481
Un-named summit (Ysgafell Wen)	669	77	115	663485
Moel yr Hydd	648	89	115	672454
Moel Meirch	607	119	115	661504
FFESTINIOG GROUP				
Manod Mawr	661	82	124	724447
Un-named summit (Manod Mawr)	658	84	115	727458
Moel Penamnen	623	104	115	716483

Name	Height	No. in order of Altitude	OS Map	Map Reference
RHINOGS				
Y Llethr	756	44	124	661258
Diffwys	750	46	124	661234
Rhinog Fawr	720	52	124	657290
Rhinog Fach	712	53	124	665270
Y Garn	629	98	124	702230
Moel Ysgafarnogod	623	102	124	658346

SECTION 7

Name	Height	No. in order of Altitude	OS Map	Map Reference
ARENIGS				
Arenig Fawr	854	23	124/125	827369
Moel Llyfnant	751	45	124/125	808352
Arenig Fach	689	62	124/125	821416
Carnedd y Filiast	669	76	124/125	871446
Carnedd Llechwedd Llyfn	643	91	124/125	857446
Foel Boeth	619	108	124	779345
Foel Goch	611	112	125	953423
RHOBELLS				
Rhobell Fawr	734	50	124	787257
Dduallt	662	80	124/125	811274

33

Name	Height	No. in order of Altitude	OS Map	Map Reference
CADER IDRIS GROUP				
Pen y Gadair (Cader Idris)	893	18	124	711130
Mynydd Moel	863	22	124	727137
Cyfrwy	811	31	124	704133
Mynydd Pencoed	791	36	124	711121
Gau Craig	683	66	124	744141
Tyrau Mawr	661	81	124	677135
Craig y Llyn	622	105	124	665119
DOVEY				
Maesglasau	674	71	124/125	823152
Waun Oer	670	75	124	786148
Cribin Fawr	659	83	124	795153
Mynydd Ceiswyn	604	122	124	773139
Mynydd Dolgoed	604	123	124/125	802142
TARREN HILLS				
Tarren y Gesail	667	79	124	711059
Tarrenhendre	634	93	135	683041

Name	Height	No. in order of Altitude	OS Map	Map Reference
ARANS				
Aran Fawddwy	905	16	124/125	863224
Aran Benllyn	885	19	124/125	867243
Erw y Ddafad Ddu	872	21	124/125	865234
Glasgwm	780	39	124/125	837194
Foel Hafod Fynydd	689	63	124/125	877227
Pen y Bryn Fforchog	685	64	124/125	818179
Gwaun y Llwyni	685	65	124/125	857205
Esgeiriau Gwynion	671	74	124/125	889236
Llechwedd Du	614	110	124/125	894224
Pen yr Allt Uchaf	610	113	124/125	869196
Y Gribin	602	125	124/125	843177

Name	Height	No. in order of Altitude	OS Map	Map Reference
BERWYN HILLS				
Moel Sych	827	27	125	066318
Cadair Berwyn	827	28	125	072327
Cadair Bronwen	785	37	125	077346
Tomle	742	48	125	085335
Foel Wen	691	60	125	099334
Mynydd Tarw	681	67	125	113324
Godor	679	68	125	094308
Post Gwyn	655	86	125	048294
Moel Fferna	630	96	125	116398
Un-named summit	621	106	125	089369
Glan Hafon	608	118	125	078274
HIRNANT				
Cyrniau Nod	667	78	125	988279
Foel Cwm Sian Llwyd	648	88	125	996314
Pen y Boncyn Trefeilw	646	90	125	963283
Stac Rhos	630	97	125	969279
Foel y Geifr	626	100	125	937275
Cefn Gwyntog	615	109	125	976266
Trum y Gwrgedd	612	111	125	941284
Foel Goch	610	115	125	943291
CWM CYNLLWYD				
Moel y Cerrig Duon	625	101	125	923242
Un-named summit	606	120	125	918258

Appendix

Other named summits of over 600 metres, with less than 15 metres of re-ascent or which are of lesser topographical merit

Name	Height	Sect. No.	Name	OS Map	Map Reference
Castell y Gwynt*	972	2	Glyders	115	654582
Garnedd Fach*	960c	3	Carneddau	115	658626
Elidir Fach	795	2	Glyders	115	603613
Drws Bach	770c	9	Arans	124/125	863213
Dyrysgol	745	9	Arans	124/125	872213
Llechog	718	1	Snowdon	115	605567
Allt Maenderyn*	704	1	Snowdon	115	605528
Pen Tyrau	697	7	Arenigs	124/125	837383
Craig Ysgafn	689	5	Moelwyns	124	660443
Carnedd y Ddelw	688	3	Carneddau	115	708715
Carreg y Diocyn	673	7	Arenigs	124/125	831363
Crib y Rhiw	670c	6	Rhinogs	124	661250
Foel Rhudd	659	9	Arans	124/125	896239
Y Groes Fagl*	659	10	Hirnant	125	988290
Carnedd y Ci	648	10	Berwyn Hills	125	062341
Gyrn Wigau	643	3	Carneddau	115	654675
Craig Lwyn*	623	3	Carneddau	115	731609
Rhos	619	10	Berwyn Hills	125	124323
Carnedd Lwyd*	616	8	Cader Idris	124	683135
Foel Penolau	614	6	Rhinogs	124	661348
Trum y Sarn*	614	10	Hirnant	125	991302
Pen y Cerrig Duon*	611	10	Hirnant	125	953281
Craig Wen	608	1	Snowdon	115	597509
Waun Goch*	605	9	Arans	124/125	875202
Moel Ffenigl*	603	9	Arans	124/125	873260
Moel Pearce*	601	10	Berwyn Hills	125	063356
Foel Boethwel*	600c	5	Moelwyns	115	651477

* Denotes that the summit is not named on the 1:50,000 map.

Maps showing 600-metre Summits by Section

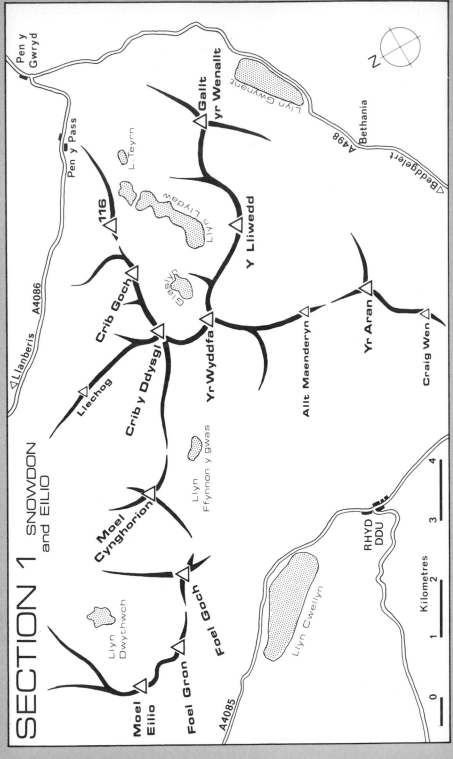

SECTION 1 SNOWDON and EILIO

Moel Eilio

Foel Gron

Foel Goch

A4085

Llyn Dwythwch

Moel Cynghorian

Llyn Ffynnon y gwas

Crib y Ddysgi

Llechog

Crib Goch

116

Yr Wyddfa

Allt Maenderyn

Yr Aran

Craig Wen

Y Lliwedd

Glaslyn

Llyn Llydaw

L. Teyn

Gallt yr Wenallt

Llyn Gwynant

Pen y Gwryd

Pen y Pass

Llanberis A4086

Llyn Cwellyn

RHYD DDU

Bethania

A498 Beddgelert

0 1 2 3 4

Kilometres

N

40

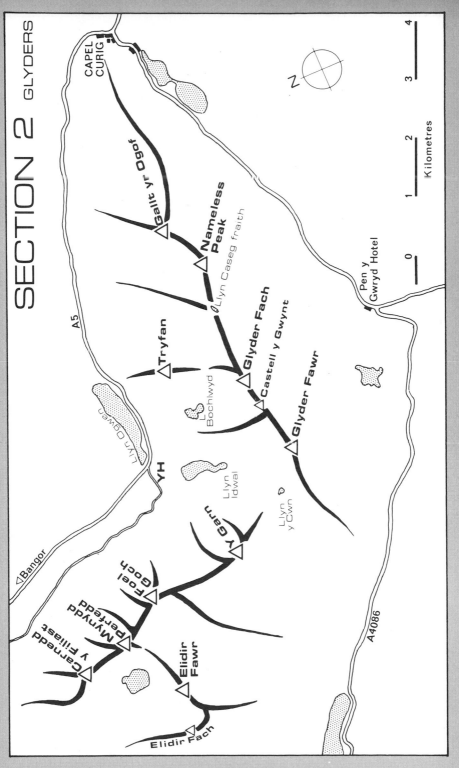

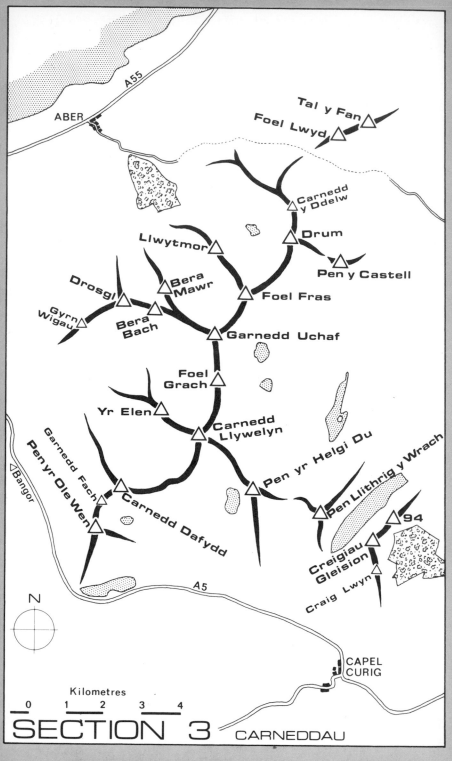

ABER

A55

Tal y Fan
Foel Lwyd

Carnedd
y Ddelw

Drum

Llwytmor

Pen y Castell

Drosgl
Bera
Mawr

Foel Fras

Gyrn
Wigau
Bera
Bach

Garnedd Uchaf

Foel
Grach

Yr Elen

Carnedd
Llywelyn

Pen yr Helgi Du

Pen Llithrig y Wrach

Bangor

Garnedd Fach
Pen yr Ole Wen

Carnedd Dafydd

Creigiau
Gleision

94

Craig Lwyn

A5

N

CAPEL
CURIG

Kilometres

0 1 2 3 4

SECTION 3 CARNEDDAU

42

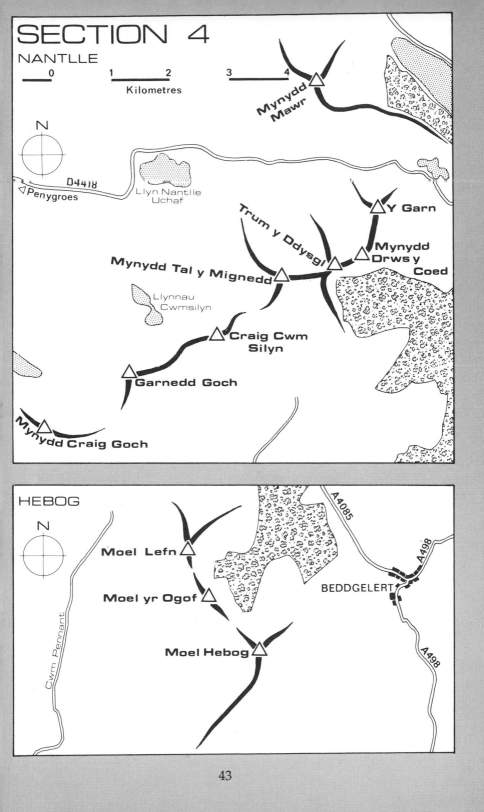

SECTION 4

NANTLLE

0 1 2 3 4
Kilometres

N

D4418
Penygroes
Llyn Nantlle Uchaf

Mynydd Mawr

Trum y Ddysgl

Y Garn

Mynydd Tal y Mignedd

Mynydd Drws y Coed

Llynnau Cwmsilyn

Craig Cwm Silyn

Garnedd Goch

Mynydd Craig Goch

HEBOG

N

Cwm Pennant

Moel Lefn

Moel yr Ogof

Moel Hebog

A4085

A498

BEDDGELERT

A498

43

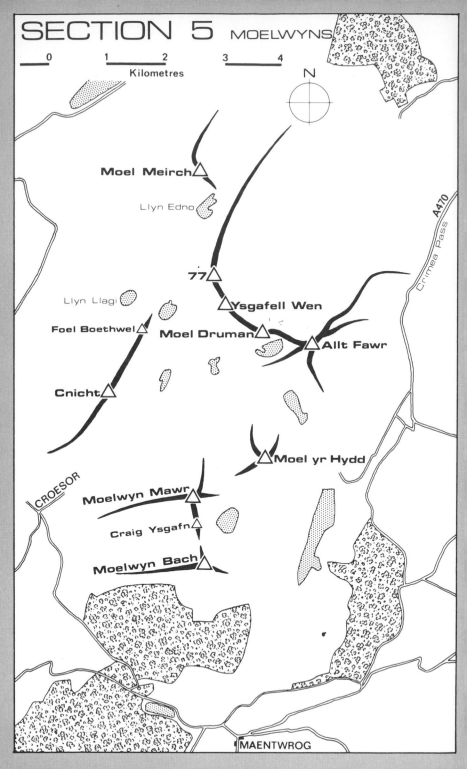

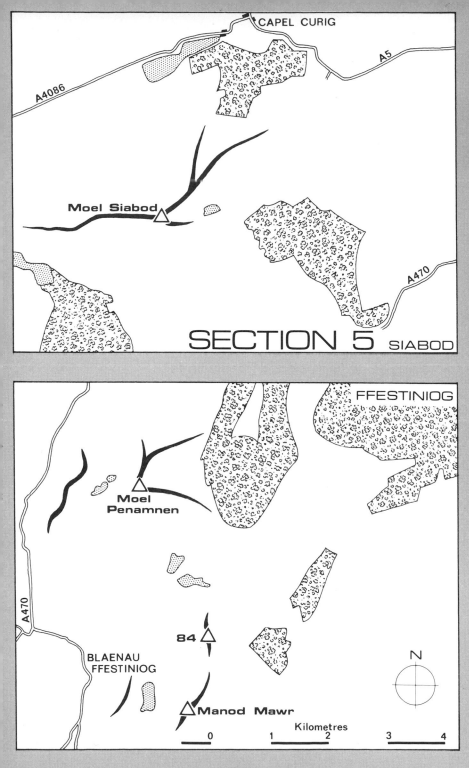

SECTION 5 SIABOD

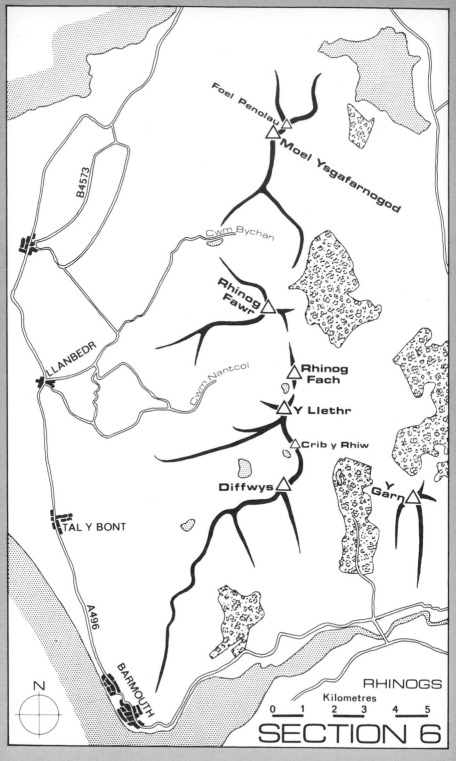

Foel Penolau

Moel Ysgafarnogod

B4573

Cwm Bychan

Rhinog Fawr

LLANBEDR

Cwm Nantcol

Rhinog Fach

Y Llethr

Crib y Rhiw

Diffwys

Y Garn

TAL Y BONT

A496

BARMOUTH

N

RHINOGS

Kilometres

0 1 2 3 4 5

SECTION 6

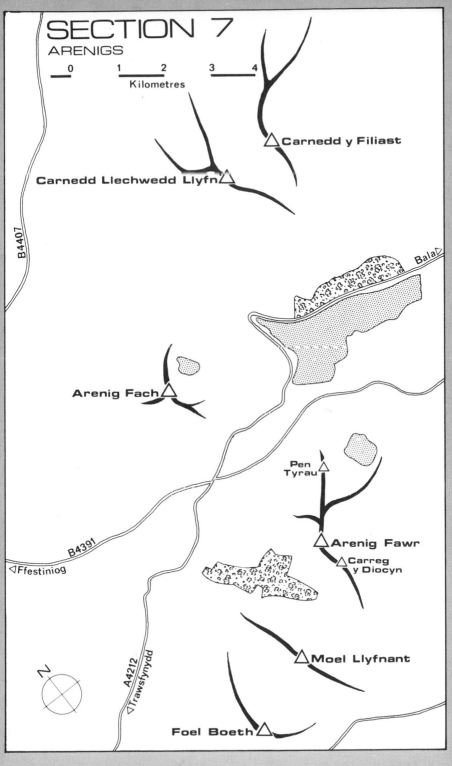

SECTION 7
ARENIGS

0 1 2 3 4
Kilometres

Carnedd y Filiast

Carnedd Llechwedd Llyfn

B4407

Bala

Arenig Fach

Pen Tyrau

Arenig Fawr

Carreg y Diocyn

B4391

Ffestiniog

Moel Llyfnant

N

A4212

Trawsfynydd

Foel Boeth

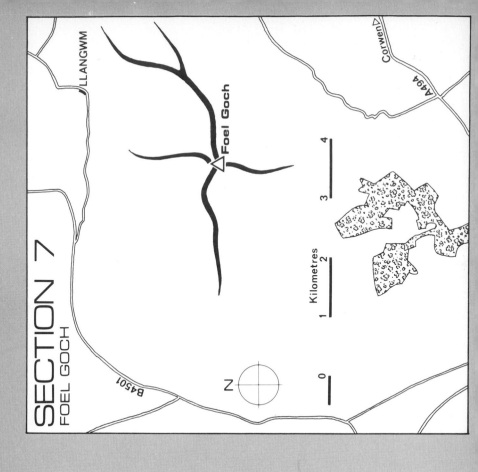

SECTION 7
FOEL GOCH

LLANGWM

Foel Goch

Corwen

A494

B4501

N

Kilometres

0 1 2 3 4

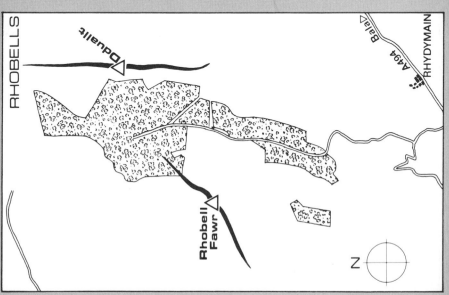

RHOBELLS

Dduallt

Rhobell Fawr

Bala

A494

RHYDYMAIN

N

48

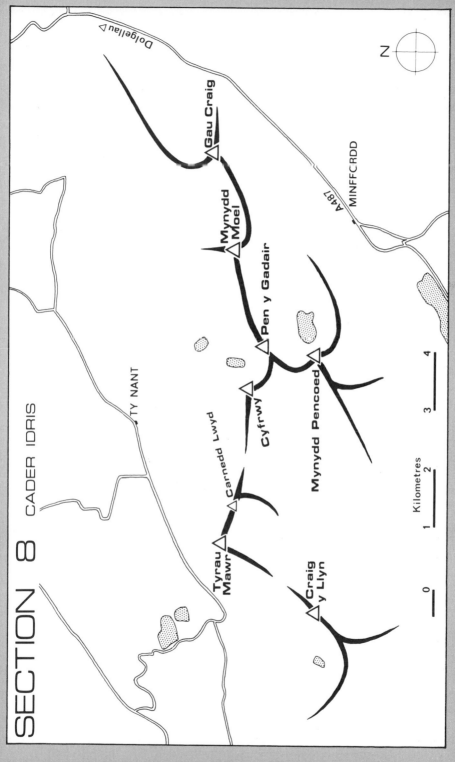

SECTION 8 CADER IDRIS

Dolgellau

Gau Craig

Mynydd Moel

Pen y Gadair

Mynydd Pencoed

Cyfrwy

Carnedd Lwyd

TY NANT

Tyrau Mawr

Craig y Llyn

MINFFORDD

A487

N

Kilometres
0 1 2 3 4

49

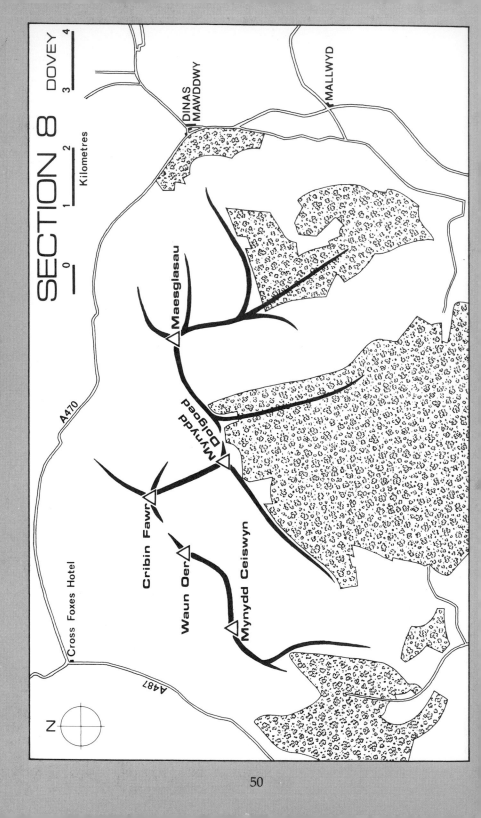

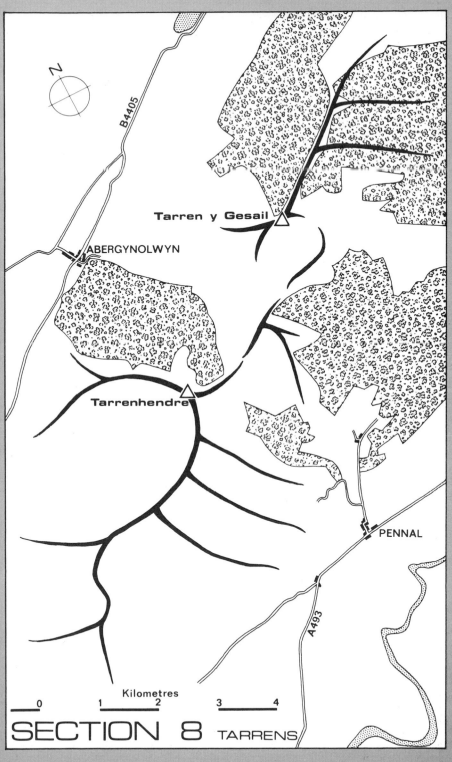

Tarren y Gesail

ABERGYNOLWYN

B4405

Tarrenhendre

PENNAL

A493

Kilometres
0 1 2 3 4

SECTION 8 TARRENS

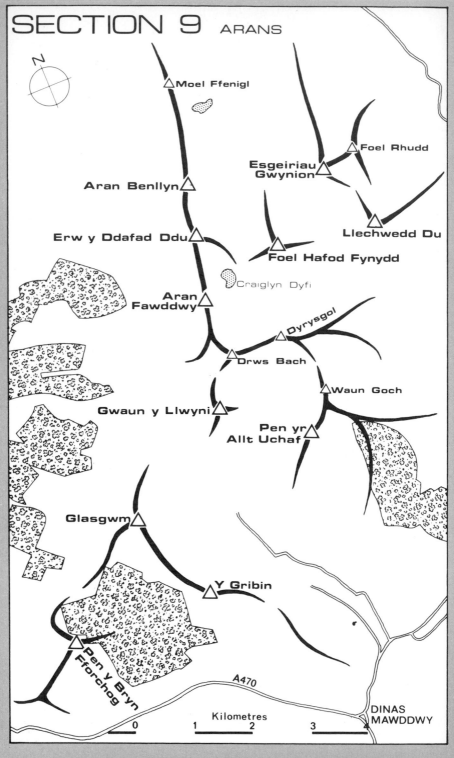

SECTION 9 ARANS

N

△ Moel Ffenigl

Aran Benllyn △

Foel Rhudd △

Esgeiriau
Gwynion △

Erw y Ddafad Ddu △

Llechwedd Du △

Foel Hafod Fynydd △

Craiglyn Dyfi

Aran
Fawddwy △

Dyrysgol △

△ Drws Bach

△ Waun Goch

Gwaun y Llwyni △

Pen yr
Allt Uchaf △

Glasgwm △

Y Gribin △

Pen y Bryn
Fforchog △

A470

DINAS
MAWDDWY

Kilometres

0 1 2 3 4

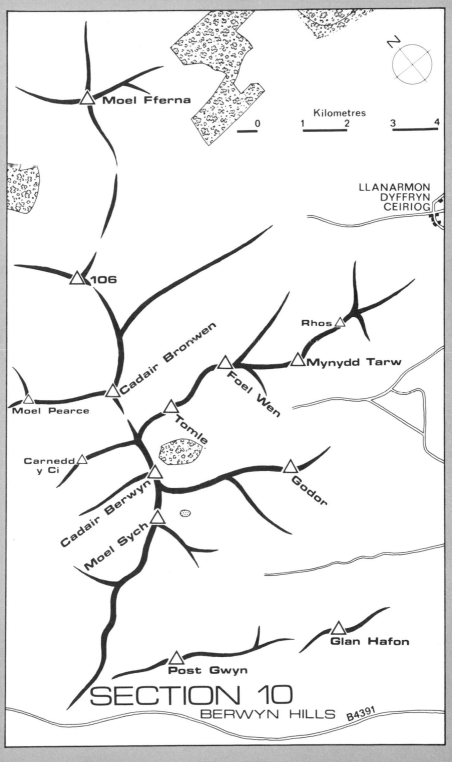

Moel Fferna

Kilometres

0 1 2 3 4

LLANARMON
DYFFRYN
CEIRIOG

106

Rhos

Cadair Bronwen

Mynydd Tarw

Foel Wen

Moel Pearce

Tomle

Carnedd
y Ci

Godor

Cadair Berwyn

Moel Sych

Glan Hafon

Post Gwyn

SECTION 10
BERWYN HILLS

B4391

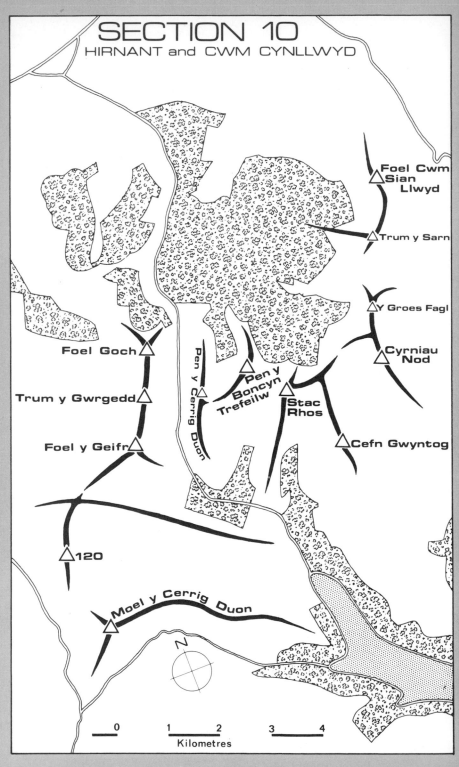

SECTION 10
HIRNANT and CWM CYNLLWYD

Foel Cwm
Sian Llwyd

Trum y Sarn

Y Groes Fagl

Cyrniau Nod

Foel Goch

Pen y Cerrig Duon

Pen y Boncyn Trefeilw

Stac Rhos

Trum y Gwrgedd

Foel y Geifr

Cefn Gwyntog

120

Moel y Cerrig Duon

N

0 1 2 3 4
Kilometres

A-Z
Guide to Summits

A-Z
Guide to Summits

Allt Fawr

58. Sheet 115. Section 5 – Moelwyns. MR 682475. 698 metres.

The *Big Height*, Allt Fawr, is well named and towers above the town of Blaenau Ffestiniog, its dominating eastern slopes scarred by the spoil torn from the Oakeley Quarries. As if in recompense, but more truthfully because of their difficulty of access, the northern slopes, rolling across miles of open moorland to distant Moel Siabod, are unspoiled, providing the solitude-seeker with hours of wandering free.

Allt Fawr may be ascended from Tan y Grisiau (687451) by taking the road from the post office leading under the nearby railway bridge. The road later becomes a quarry track, climbing into Cwmorthin with its ruins and lily-garlanded lake, and then up to the workings of the Rhosydd Quarry on a large plateau which connects the two valleys of Cwmorthin and Cwm Croesor. From the quarry it is possible to follow the rim of Cwmorthin, across very broken ground, to the summit. A better way is to make first for the dam of Llyn Cwm Corsiog, and then to Moel Druman from where a distinct path leads above Llyn Conglog to Allt Fawr.

These routes, however, are better kept for descent since a far superior ascent can be accomplished from the top of the Crimea Pass (698484 – not named on maps) by the north-east ridge. This approach gives extensive views across the intervening moorland *cwm* to Ysgafell Wen and the Snowdon group beyond. As an alternative, a green quarry track just south of the summit of the pass leads, through a gate dedicated to 'Taffy and Mary', to a wide grassy gully down which flow the waters from Llyn Ffridd y

Bwlch. This peaceful lake is held in place by two dams, and from the end of the second dam it is possible to join the north-east ridge at Bwlch y Moch, *the Pass of the Pigs*, from where twenty minutes is all that is needed to reach the two rocky summits: the northerly one is the higher.

Aran Benllyn
19. Sheets 124 and 125. Section 9 – Arans. MR 867243. 885 metres.

Of the 'two vast hills of Aran; or rather, two heads, arising from one base', Aran Benllyn is the lower but is probably better known

Aran Fawddwy (Arans)

than Fawddwy since it is the dominating feature on the skyline above the end of Llyn Tegid when seen from Bala. Thomas Pennant's assessment that both Arans derive from a common base is correct and could just as easily have been extended to include a number of other summits also; the whole ridge of the Arans is one long central spine along the eastern side of the Bala fault.

The main part of this ridge is crossed by a courtesy path negotiated by the National Park Authority with local landowners, and this path is the only line of ascent. To the north the path starts near Llanuwchllyn where the B4403 bends sharply (880297). There is room to park two or three cars, and the way is clearly

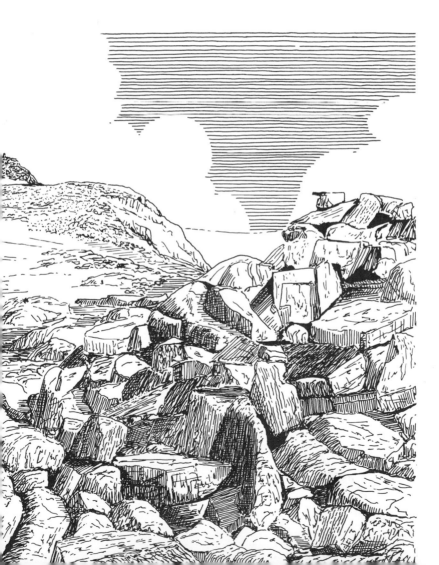

marked where necessary and follows for a while the Afon Twrch before ascending the long northern ridge and reaching Benllyn over the minor top, Moel Ffenigl (873260), which is un-named on the 1:50,000 map.

The summit of Aran Benllyn, like that of Aran Fawddwy, is marked by a large cairn and gives excellent views. Between Benllyn and Fawddwy is the lesser summit, Erw y Ddafad Ddu, from the eastern edge of which there is a dramatic view of Craiglyn Dyfi, the source of the River Dovey.

Aran Fawddwy
16. Sheets 124 and 125. Section 9 – Arans. MR 863224.
905 metres.

Aran Fawddwy is not only the higher of the two Arans but also the highest summit south of a line drawn from Tremadoc to Llanrwst in the Conwy valley. It is also the highest of the whole of the long range of mountains from the border with England to the sea which once formed the southern boundary of Gwynedd, the strongest of the old Welsh states. With the Dovey, which rises immediately below Fawddwy's summit in Craiglyn Dyfi, form-ing a natural barrier, this line is traditionally the dividing line between North and South Wales. Like its near neighbour, Aran Benllyn, Aran Fawddwy's name derives from an ancient territo-rial division, known as a *cantref*, which once belonged to the Middle Kingdom of Powys. The cantref of Penllyn was annexed to Gwynedd by Llywelyn the Great in 1202, but Mawddwy had to await the Edwardian conquest some years later.

Disputed ground then and now, for the Arans have in recent times seen much controversy over access, with aggrieved farmers adopting a determined frame of mind which has only been eased by the delicate negotiations of the National Park Authority, leading to a courtesy path along the main Aran ridge. Points of access to this path are few in number, and those which lead first to Aran Benllyn are given in the entry for that summit.

From the south and west there are only two approaches to Fawddwy's summit. From Esgair-gawr (816224), just off the A494, one route takes the northern bank of the Afon Harnog, gaining the ridge west of Drws Bach, from where it is an easy, but rocky, walk to the summit.

By starting in Cwm Cywarch, north of Dinas Mawddwy, an

ascent can be made through the deep trough of Hengwm. From the lane through Cwm Cywarch a way-marked route starts across a bridge (853187), and then by an ascending traverse across the lower slopes of Pen yr Allt Uchaf (not named on the 1:50,000 map) to a quartz cairn at spot height 568. From here a path across boggy ground leads to the top of Dyrysgol and on, following a fence, to Drws Bach, where there is a small monument to a member of the RAF St Athan Mountain Rescue Team who was killed by lightning near this spot in 1960. Ahead are the southern slopes of Aran Fawddwy, and the going changes abruptly from grass to rock, with the route being indicated by a line of cairns.

The continuation to Aran Benllyn is obvious enough and passes over the lesser summit, Erw y Ddafad Ddu.

Arenig Fach
62. Sheets 124 and 125. Section 7 – Arenigs. MR 821416.
689 metres.

Arenig Fach is a squat hump of a mountain with a bulk only fully appreciated in an approach from the north-west, across that

Drws Bach (Arans)

interminable bogland known as the Migneint. From the slopes of Arenig Fawr to the south, the lower mountain has little appeal, and from the north-east it appears over the intervening slopes and hillocks as a grey, brooding dome. Without a map no one would suspect the presence of Llyn Arenig Fach lying hidden beneath the broken crags of the eastern face of the mountain exactly as Llyn Arenig Fawr lies beneath the eastern crags of Fach's higher companion.

The approach to Arenig Fach across the Migneint is for strong walkers with a yearning for solitude, but it is an experience to be savoured. A start from Pont ar Gonwy (779446) leads straight into the bog of Llechwedd-mawr, and on by Llyn Serw to Cefngarw and the western slopes of the mountain. There are no paths, no useful landmarks except the objective, very few dry places and little prospect of passing walkers in the event of difficulty. Yet it has an appeal which takes people back again and again.

More prosaic is a conventional and straightforward approach from the A4212, starting through a gate at 826400, directly opposite the track to Rhyd y Fen Farm. From this point it is possible to work a way steeply upwards without having to cross walls or fences, though if the bilberries, for which this mountain is famous, are in season, there is a strong likelihood that the summit trig point may never be reached.

Arenig Fawr
23. Sheets 124 and 125. Section 7 – Arenigs. MR 827369.
854 metres.

The Arenigs are in reality a number of small groups of mountains each of which is virtually separate from the others; the only link between them is the wet and sometimes uncompromising nature of the terrain which encompasses them. Arenig Fawr, the higher of the two Arenigs, is no exception and is separated from its nearest neighbour, Moel Llyfnant, by a drop of over 300 metres and a distance of more than 3 kilometres (1.9 miles) by the most convenient route. The *Big Arenig*, however, is a mountain of distinction; its conical summit, set on broad, flanking shoulders, is identifiable from all directions and was commented upon by the Reverend Bingley as he travelled through the Rhinogs. Of greater note is Arenig Fawr's ease of ascent, nevertheless taking the walker through wild and imposing countryside that is little

suspected in such proximity to the 'tamed' tourist area around Bala.

Among the favoured ascents of earlier generations of walkers is that starting from Pont Rhyd y Fen (820394), taking directly to the mountain and ascending the rugged slopes above the quarry, keeping to the right the broken ground called Craig yr Hyrddod. This approach places one between the minor top, Pen Tyrau, and the main summit, with a short, easy walk needed to reach the trig point and shelter, littered with aircraft wreckage, on the summit. There used to be a memorial tablet set in concrete in the walls of the shelter, telling of the crash there in 1943 of an American Flying Fortress with the loss of all six crew.

From Pont Rhyd y Fen it is also possible to follow a track, initially close to the line of the old railway, which, after a short distance travelling west, turns south towards the derelict, but still beautiful, farmhouse, Amnodd Wen (816375). Strong walkers can simply ascend from here to gain the northern end of the summit ridge, or continue in a southern direction along a sketchy path above the line of the forest to the col between Arenig Fawr and Moel Llyfnant. From the col the southwards-extending ridge to Craig y Bychan can be gained without difficulty, and a fence followed to the summit cairn. This latter extension is better used as a descent, or by walkers making for Moel Llyfnant.

The most satisfying ascent is that which takes a grassy path leaving the old Bala-Ffestiniog road 2.5 kilometres (1.6 miles) east of Pont Rhyd y Fen at 845395. This path leads to wild Llyn Arenig Fawr, set against a backdrop of impressive crags, and continues round the lake to a dam. Across the dam a path ascends the ridge rising above the southern shore of the lake, gaining the summit ridge a short distance north of the highest point. In its upper reaches this ridge path needs care in misty conditions, particularly when the second fence-line is reached. The way ahead is not immediately obvious; the fence here turns sharply, and a short way beyond the turn a small pile of rocks enables the fence to be crossed without damage. The continuation on the opposite side of the fence is, however, clear enough.

Yet another fence crosses the summit plateau in a north-south direction and is a helpful guide in poor visibility.

Bera Bach

32. Sheet 115. Section 3 – Carneddau. MR 672678. 807 metres.

The *Great and Little Pyramids*, Bera Mawr and Bera Bach, must have been named by someone looking on them from near the coast at Aber, from where Bera Mawr at least does have a vaguely pyramidal form. Certainly when names were given, it would have been very difficult, if not impossible, to know, as we do now, that Bera Bach, the lesser of the two, is in fact 13 metres higher than Bera Mawr. It is a minor anomaly, repeated on much higher mountains in Scotland, but destined only to give rise to idle speculation.

Lying as it does between Bera Mawr and the lower summit, Drosgl, Bera Bach can scarcely be avoided by walkers ascending either of those two hills, and the lines of ascent, if indeed in this open grassy area any are needed, given in their respective entries are equally appropriate here.

Bera Mawr

35. Sheet 115. Section 3 – Carneddau. MR 675683. 794 metres.

Bera Mawr, in spite of its name, is not the highest point of the grassy sprawl of hills lying north-west of the central ridge of the Carneddau range, but it certainly looks it from virtually every direction. The honour of supremacy, only apparent from a close study of the latest 1:10,000 series Ordnance Survey maps, goes instead to Bera Bach, which is 13 metres higher. Such an inverted situation is not without precedent; the Aonachs, Mor and Beag in Scotland's Lochaber region, share the same dilemma. Bera Mawr, however, offers the better views across the Lavan Sands to Anglesey and, unlikely as it may seem in such a wilderness of grass, poses the rock specialist a neat problem or two on its craggy crown.

Each year in June a number of hardy mountaineers and fell-runners gather at sea level at Aber to dip their boots in the sea at the start of the Welsh 1,000-metres Mountain Race. It is a journey of some 32 kilometres (20 miles) involving almost 3,000 metres of ascent and finishing on the summit of Snowdon. Incredibly the record for this journey (at the time of writing – 1982) is three hours and thirty-two minutes. Bera Mawr has the distinction of being the first summit crossed as competitors press on to the first 1,000-metre check-point on Carnedd Llywelyn.

Only by descending to Bera Mawr from Garnedd Uchaf on the main ridge can its conquest be considered less than toilsome, but even then one must first gain the ridge. An easy approach may be made from Gerlan (633665), near Bethesda, by the route described in the entry for Drosgl. As an alternative, those who want something energetic may follow in the footsteps of the fell-runners. Most of this approach, starting at Bont Newydd (663720), is described in the entry for Llwytmor which, like Bera Mawr, lies off the main Carneddau ridge. The only added difficulty in reaching Bera Mawr is in crossing the Afon Goch; once over, however, it is a short, steep pull to the summit.

Cadair Berwyn
28. Sheet 125. Section 10 – Berwyn Hills. MR 072327. 827 metres.

Cadair Berwyn, from which one assumes the Berwyn Hills have taken their name, is actually one foot lower in height than Moel Sych, a kilometre to the south. Both summits, however, share the same metric height. Because it lies between Moel Sych and Cadair Bronwen to the north, it is usual to ascend Cadair Berwyn along the ridge from one or other of these two summits. The only feasible direct ascent is by the broad ridge descending south-eastwards to Godor.

As if to compensate for being trapped between other similar hills, Cadair Berwyn is the only hill, in an area almost entirely of grass and peat, to be flanked north and south by a line of steep cliffs. They are not cliffs which would interest the rock-climber, but a walk along the top edge of them will provide the walker with some exhilarating views eastwards.

Cadair Bronwen
37. Sheet 125. Section 10 – Berwyn Hills. MR 077346. 785 metres.

The three highest mountains of the Berwyn Hills form a line running almost north to the south. Cadair Bronwen is the most northerly. Its summit is marked by a large cairn of stones, according to Thomas Pennant 'brought from some distant part, with great toil, up the steep ascent'. The 'erect pillar' which Pennant, one of the more reliable travellers, observed as part of the cairn, is no longer in evidence, and 'of him, whose ambition climbed this height for a monument, we are left in ignorance'.

65

Cadair Bronwen is one of many legendary sites of King Arthur's Table and, along with Cadair Berwyn to the south, is said to have an artificial road, *Ffordd Helen*, named after the daughter of Octavius, wife of the Emperor Maximus, running beneath its summit.

Roads do abound in this area, making most of the hills easily accessible. To Cadair Bronwen there is a choice of two routes, both starting at Hendwr (043385), 3 kilometres (1.9 miles) south of the village of Cynwyd, former venue of land-settlement courts dealing with claims about boundaries on the 'wastes and commons, and to take cognizances of the encroachment'. From the bridge over the Afon Llynor at Hendwr a road climbs steadily, always ahead, to a gate giving access to open pasture where a large 'No Trespassing' sign has been erected. The sign asks walkers to keep to the road, though there are two roads. One road continues ahead, climbing eventually to the col between Cadair Berwyn and Cadair Bronwen, from where either summit may easily be reached. This route is technically a byway open to all traffic and is well used by motor-cyclists, but in places the only way that traffic can make satisfactory progress is if it is amphibious or has webbed feet – that goes for walkers, too.

At the sign the second road turns left, following the line of a wall, until it breaks out onto the open hillside. This later becomes a land-rover track and leads away from the intended route which can be seen across the upper part of Afon Llynor ascending to a memorial plaque (called a memorial stone on the 1:50,000 map) at 091366. Shortly before the top of the track is reached, it is joined by a road on the left ascending from Cynwyd. From the top of the pass a path turns right, over subsidiary summits, to Cadair Bronwen, finishing in a short, steep pull. The ridge of Tomle, Foel Wen and Mynydd Tarw can be seen extending eastwards across Cwm Llawenog and can be reached from the col between Bronwen and Berwyn.

Cader Idris – see Pen y Gadair

Carnedd Dafydd
4. Sheet 115. Section 3 – Carneddau. MR 663631. 1,044 metres.

Being a little less in height than Carnedd Llywelyn and lying to the south-west of it, Carnedd Dafydd enjoys none of the im-

mense views northwards along the grassy ridge to Foel Fras. Instead it gives an intimate glimpse into the *cwms*, Tryfan, Bochlwyd and Idwal, that flank shapely Tryfan and the Glyders across the Ogwen valley. The outline of the summit, which possesses a large cairn of stones, is a prominent feature of the panorama from Bangor Mountain on the coast.

Like its higher neighbour, Carnedd Dafydd is almost certainly named after one of the last Princes native to the Principality of Wales, but while uncertainty questions which Llywelyn, the *Great* or the *Last*, has the honour of being commemorated by Carnedd Llywelyn, there is no doubt that Carnedd Dafydd owes its name to the penultimate Prince, the younger son of Llywelyn the Great, chosen as heir in preference to his elder brother Gruffydd.

Carnedd Dafydd lies two thirds of the way along the ridge which runs south-westwards from Carnedd Llywelyn and ends abruptly at Pen yr Ole Wen where the Ogwen valley meets the Nant Ffrancon. A direct but wholly uninteresting ascent of Carnedd Dafydd may be made from Tal y Llyn Ogwen (668605),

Carnedd Dafydd (Carneddau from Pen yr Ole Wen)

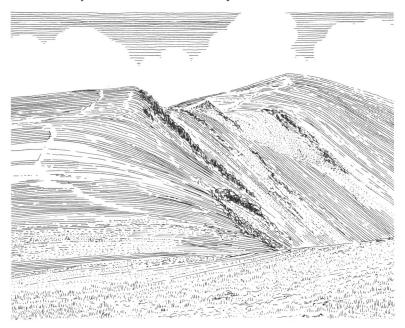

67

crossing the Afon Lloer where it turns towards the outflow from Ffynnon Lloer, and keeping to the east of the boulder slope spilling down from the summit. Such a choice of route is not worthy of the fourth highest mountain in Wales, one of the four elite 1,000-metre summits. A better way is found by taking to the spur thrown down to the east by Pen yr Ole Wen. This leads directly to the summit of that mountain. From there the line of cliffs above lonely Ffynnon Lloer defines the way, over the small intermediate top, Garnedd Fach, to the cairn on Carnedd Dafydd. A return to Ffynnon Lloer may be made from the summit, but it is infinitely better, except in poor visibility, to continue to Carnedd Llywelyn and to descend from there to Pen yr Helgi Du and the road at Helyg.

The route to Carnedd Llywelyn passes above the popular rock-climbing cliff, Ysgolion Duon, the *Black Ladders*, before it narrows considerably across Bwlch Cyfryr-Drum. Thomas Pennant in his *Tour in Wales* describes this linking ridge as 'a semilunar isthmus, which, on the side over Cwm Penllafar, is called Ysgollion Duon, or the black ladders; and forms the most horrid precipice that thought can conceive'.

Carnedd Llechwedd Llyfn
91. Sheets 124 and 125. Section 7 – Arenigs. MR 857446.
643 metres.

Carnedd Llechwedd Llyfn is a relatively minor summit north of Llyn Celyn, near Bala. It lies a little under 2 kilometres (one mile) west of Carnedd y Filiast, with which it can easily be combined.

An approach from the south, probably the easiest way, may be made by following the route described in the entry for Carnedd y Filiast until the track below Foel Boeth is reached, and then by striking west of north over rough ground of heather and rocks to pass first over a sharply pointed subsidiary summit. The highest point is not marked but lies about 100 metres south of the district boundary fence where a large cairn has been constructed.

A descent west, along the fence-line, will lead to a faint track to be found just below a rocky knoll. The track leads south to rejoin the A4212 at Ty Nant (844418).

Carnedd Llywelyn

3. Sheet 115. Section 3 – Carneddau. MR 684644. 1,064 metres.

Carnedd Llywelyn is by 20 metres the highest summit of the most extensive range of mountains in North Wales; it is certainly one of only two areas – the other being the Rhinogs – where the walker can get more than 4 kilometres (2.5 miles) from a public road. The summit is a roughly triangular plateau composed of dolerite rock, a mineral not found elsewhere in the range and which by its greater resistance to erosion gives prominence to an otherwise uninteresting grassy bulk.

It seems certain that Carnedd Llywelyn is named after one of the last native Princes of Wales, but whether it is Llywelyn ap Iorwerth (1194–1240), who became known as 'Llywelyn the Great' and held court at Aber on the coast a few kilometres to the north, or Llywelyn ap Gruffydd ap Llywelyn (1246–1282), who was the last native Prince, is not clear. Certainly Llywelyn the Great used the top of the mountain as an observation post, and he was a man who figured largely in Welsh history, so the balance of probability swings in his favour; but we shall never know.

The mountain also has another curious distinction, this time linking it with such eminent mountains as Kilimanjaro in Africa, Le Nid d'Aigle in the French Alps, Mount Tallac in the Tahoe valley of northern California, the Old Man of Coniston in the English Lake District, and others. It became, in 1960, according to a religious sect based in Los Angeles, one of the nineteen holy mountains in the world, being charged with cosmic powers. Anyone climbing to the charged rocks near the summit will receive cosmic energies which will help to give enlightenment and unselfish service to mankind.

Four ridges radiate from Carnedd Llywelyn, and each gives a quite different way of approach. The shortest ridge leads north-west to the shapely summit, Yr Elen, and folds round possibly the smallest lake in North Wales, Ffynnon Caseg, set in one of the loneliest *cwms* in the whole of Wales. To approach Carnedd Llywelyn over Yr Elen requires a start from Gerlan (633665), near Bethesda. A path follows the Afon Llafar and leads to Ysgolion Duon, the *Black Ladders*, a popular rock-climbing cliff, but the river should be crossed well below the cliff and rising ground taken to the summit of Yr Elen before tackling the short but interesting ridge to Carnedd Llywelyn.

69

South-westwards a ridge continues above Ysgolion Duon to Carnedd Dafydd and terminates abruptly above Llyn Ogwen at Pen yr Ole Wen. The approach by this ridge, delineated all the way by the steep drop into Cwm Llafar, is described under the entry for Carnedd Dafydd.

One and a half kilometres (one mile) south of Carnedd Llywelyn lies another well-known rock-climbing playground, Craig yr Ysfa, a cliff well seen from the adjoining summit, Pen yr Helgi Du. A start near Helyg on the A5 (688603), leads by a reservoir road to the lower slopes of Pen yr Helgi Du, and then upwards above Craig yr Ysfa to the summit of Llywelyn.

The last ridge radiating from the summit is by far the longest and stretches away for 10 kilometres (6.25 miles) north-east to Bwlch y Ddeufaen, the *Pass of the Two Stones*, a pass used in prehistoric times but now infested with electricity pylons. This enormous ridge, though physically of a more gentle countenance than the others, is a trap for the unwary. On a clear day it provides enjoyable walking on grass, but under snow and mist it is a ridge which calls for the utmost competence in map and compass technique if descents, steep, craggy and potentially dangerous, are not to be made into distant and unwanted valleys.

Four summits lie east of Carnedd Llywelyn – Foel Grach, Garnedd Uchaf, Foel Fras (the last, or first, of the Welsh Three Thousanders – a popular long walk that will undoubtedly and rightly persist in its popularity long after total metrication) and finally Drum. An approach by these summits is best started from Bont Newydd (663720), where there is a small car-park. A road crosses the bridge and eventually, after a short climb, becomes a rough track as it leads first round the lower slopes of a minor summit, Foel Ganol (687716), and then along the north bank of the Afon Anafon. From here a way can be found into the *cwm* above the dammed Llyn Anafon, and Drum and the ridge south-westwards easily reached.

Carnedd y Filiast
29. Sheet 115. Section 2 – Glyders. MR 620628. 822 metres.

Carnedd y Filiast, the *Cairn of the Greyhound Bitch*, is a mountain name occurring a few times in North Wales, though only two summits exceed 600 metres. The name is a commemorative link with Ceridwen, the Welsh mythological Goddess of Nature, who

had a greyhound as her symbol. Whether she would approve of what man has done to the mountains at the northern end of the Glyder range is open to doubt for both Carnedd y Filiast and Elidir Fawr to the south-west have been ravaged by the slate industry and will bear the scars for years to come. The close proximity of the Penrhyn Slate Quarry tends to steer hill-walkers away from this corner of Wales, but the quarry can be avoided and pleasant walks made across the tops.

Carnedd y Filiast is normally included in a complete traverse of the ridge from Llyn y Cwn above the Devil's Kitchen, to which an ascent is described in the entry for Glyder Fawr. From the lake a simple uphill stroll leads to the first summit along the ridge, Y Garn. Once Carnedd y Filiast is reached, a descent can be made to Nant Ffrancon down the ridge which starts immediately at the summit cairn; Cwm Graianog and an impressive wall of slabs form the right-hand (southern) edge of the descent. A short walk remains along the old road through Nant Ffrancon to Ogwen.

The ridge just described gives an alternative line of ascent with the possibility of continuing south to Mynydd Perfedd and Bwlch y Brecan, or beyond. There are still a few signs of an old pack-horse track across Bwlch y Brecan, showing that this pass, incredible as it might seem when viewed from Nant Ffrancon, was once used as a route between Ffrancon and Nant Peris. Those with only a little time will find this short circuit, descending from Bwlch y Brecan into Cwm Bual (not named on OS maps), a pleasant and quiet alternative to the more popular routes.

Carnedd y Filiast
76. Sheets 124 and 125. Section 7 – Arenigs. MR 871446.
669 metres.

The *Cairn of the Greyhound Bitch* which squats to the north of the man-made lake, Llyn Celyn, is much less ravaged by man than its counterpart in the Glyder range of hills above Nant Ffrancon. This lower summit, gazing westwards to Arenig Fach, is part of an area known as the *Migneint*, a vast bogland which has no attraction for man other than as grazing ground for sheep. At its southernmost edge, adjoining Llyn Celyn, the Forestry Commission have tentatively encroached onto the hillside, but elsewhere the land is featureless and seemingly of little interest to the walker. Yet this is one of Snowdonia's wild gems of walking,

offering, along with wet feet, an untroubled area free of tracks where nature still rules.

Walkers who wish to sample these delights should ideally approach Carnedd y Filiast and its neighbours, Carnedd Llechwedd Llyfn and Arenig Fach, from the village of Ysbyty Ifan (844488), taking whichever of the various roads and tracks from the village leads in the desired direction.

Those with a more prosaic attitude to hill-walking, or an aversion to wet feet, should start by a track, now overgrown and rather concealed, leaving the A4212 at a point about 9 kilometres (5.5 miles) west of Bala at 861410. The track rises diagonally through the forest before emerging onto the open hillside, where it joins a land-rover track. When Foel Boeth is reached (865426), an ascent can be made direct to Carnedd y Filiast over rough ground. A better alternative is to continue with the track, descending to cross Nant y Coed, before rising to within a few metres of the summit trig point which is surrounded by a large cairn-cum-shelter. This approach gives a pleasing view of attractive Llyn Hesgyn at the head of the *cwm* of the same name. There is a second cairn on the summit from which projects a slate slab bearing the initials 'CD' on one side and 'TI' on the other; this is probably a boundary marker, and there are others nearby.

Immediately west of the summit lies a lower height, Carnedd Llechwedd Llyfn, with which the ascent of Carnedd y Filiast may easily be combined. Alternatively, by returning to the land-rover track a descent into Cwm Hesgin can be made, finally emerging back at the A4212 about 2.5 kilometres (1.6 miles) east of the starting point. A little over four hours should be sufficient time to visit both summits from the southerly direction. From the north, the time, like the route, is largely a matter of choice.

Cefn Gwyntog
109. Sheet 125. Section 10 – Hirnant. MR 976266. 615 metres.

Cefn Gwyntog is not a summit to appeal to any but the most vigorous of masochistic walkers. It lies in an intractable area of heather and bog south of the National Park boundary where it crosses the high land above the Aberhirnant Forest.

The entry for Pen y Boncyn Trefeilw describes a new track ascending from the top of the road through Cwm Hirnant at 946274, and this track affords the easiest access, though it is not a

right of way. Even with the help of the track, most walkers will need half an hour to battle across very rough moorland to reach the small cairn on the summit. The highest point, it should be noted, is not within either of the two contour rings shown on the 1:50,000 map.

From Lake Vyrnwy an ascent could be made through the forest on the west bank of the Afon Cedig to Hafoty Cedig (996251) from where, for a further 2 kilometres (1.25 miles), the course of the river is the best line until it is possible to strike upwards to the summit. This way is no easier than that described above.

Cnicht
61. Sheet 115. Section 5 – Moelwyns. MR 645466. 689 metres.

The ascent of Cnicht from Croesor (631446) by the south-west ridge is a hill-walker's dream. From the car-park in this once-busy village a road leads over the Afon Croesor to a rising path at the top of which a way-marking post points to the open hillside. Ahead, the summit of Cnicht is perched on the top of a final rocky scramble, and remains in view throughout the ascent. The ascending ridge rises gradually, giving ever expanding views seaward, to the Tremadoc Estuary, north to the Snowdon massif, and south-east, across Cwm Croesor, to the Moelwyns.

The continuation along the ridge from the summit is not the easiest of places to be in misty conditions, in spite of a path and steep descents defining both sides of the ridge.

A longer approach than by the south-west ridge may be made by going up Cwm Croesor along a path which passes below Llyn Cwm y Foel and Llynnau Diffwys to the ruins of Rhosydd Quarry. From there a cairned path leads past Llyn Cwm Corsiog to a pile of stones (656477), marked on the 1:50,000 map by the intersection of the public footpath and the District boundary line. From this point a short walk south-west leads to the start of rising ground, leading on to the Cnicht ridge. This is a circuitous route, better used as a descent.

The pile of stones may also be reached by a path rising from Nanmor at 635490. This path passes Llyn Llagi, an almost circular lake in a wild setting. The path ascends steeply from here until Llyn yr Adar is reached, from where it is a short distance to the start of the Cnicht ridge.

Craig Cwm Silyn
49. Sheet 115. Section 4 – Nantlle. MR 525503. 734 metres.

Craig Cwm Silyn, better known as a mecca for rock-climbers than as a walker's mountain, lies in the centre of the Nantlle ridge and is the rockiest and highest of all the summits along the ridge. The Great Slab, for which Craig Cwm Silyn is justly famous, faces north to the Nantlle valley, towering above the two turquoise lakes in Cwm Silyn below. Eastwards the ridge descending to Bwlch Dros Bern is rocky, but not difficult, while the continuation westwards to Garnedd Goch is a simple walk, eventually following the line of a wall.

Bwlch Dros Bern, thought to be an old drove pass between Cwm Pennant and Nantlle, marks more than the lowest point on the ridge; it marks, too, a change in character. To the east of the pass the four summits are narrow, twisting and mainly grassy underfoot, while to the west the three remaining summits are broader, rockier and less meandering. Few people use the old pass as a means of ascent to the ridge, and those who do are missing out on the pleasures of a very fine, lofty walk. It is better by far to traverse the complete ridge from end to end, something obviously envisaged when the National Park Authority started their negotiations with local farmers to agree access arrangements. Details of ascents to the ends of the ridge are contained in the entries for Y Garn, for walkers starting at Rhyd Ddu, and Garnedd Goch, for those coming from Tal y Sarn.

Craig y Llyn
105. Sheet 124. Section 8 – Cader Idris. MR 665119. 622 metres.

Craig y Llyn is a westerly outlier of the main Cader Idris range, taking its name, the *Crag of the Lake*, from Llyn Cyri nestling in the wild hollow created by the encircling arms of Craig y Llyn and a lower summit, Braich Ddu. This forgotten *cwm*, in which Llyn Cyri sparkles like a jewelled eye, especially captures the attention when seen from the summit of nearby Tyrau Mawr.

Tyrau Mawr and Craig y Llyn are almost identical summits: imposing steepness is a feature of their northern faces, while the southern flanks, avoiding the simile used in describing the same characteristic in Y Garn in the Glyders range, are gentle and grassy. The two mountains enjoy such close proximity to one

another – a little more than one kilometre (0.6 miles) apart – that they can, and should, be combined.

An approach from Tyrau Mawr is described in the entry for that summit, but while Tyrau Mawr may be ascended from both north and south, Craig y Llyn is most easily climbed from Cwm Pennant. Walkers using this approach, best started from the church at Llanfihangel y Pennant (672089), should follow the Pony Path, which eventually leads to the summit of Pen y Gadair, as far as Hafotty Gwastadfryn (677123) from where a new land-rover track ascends the hillside and gives easy access to the dip between Craig y Llyn's main summit and the subsidiary summit further south.

The highest point of Craig y Llyn is marked by a small stone cairn on the very edge of the steep north face. From this summit a path, accompanied by a fence, continues both north to Tyrau Mawr and south to the second top of Craig y Llyn, crossing the fence, in the case of the latter, a short distance from the main summit. This subsidiary summit would be insignificant were it not for a curious circular mound of stones, *Twll yr Ogof*, which is found on the highest point.

On none of these westerly tops does the path, which is distinct throughout, actually cross the highest point. Twll yr Ogof is no exception, requiring a short diversion south-east from the path which otherwise would lead one around the hollow of Llyn Cyri to Braich Ddu. If this extension to Twll yr Ogof is taken, it is better to retrace one's steps to the dip and to descend by the track to Hafotty Gwastadfryn rather than attempt to follow the wall, south-east, or the tempting track apparently heading to Nant Caw-fawr. Both these possibilities lead to rough and very steep ground.

Creigiau Gleision
69. Sheet 115. Section 3 – Carneddau. MR 729615. 678 metres.

Creigiau Gleision is a rather detached Carnedd, being the most easterly, and separated from the rest of the range by Llyn Cowlyd, Snowdonia's deepest lake. The mountain lies 3.5 kilometres (2.2 miles) north of Capel Curig, and it is from Capel Curig that the best approach, by an undulating ridge, can be made. By way of compensation for its isolation Creigiau Gleision, which is really a double-topped summit, offers extensive views

75

eastwards over Crafnant, and south-westwards to the Glyders, of which Gallt yr Ogof is the nearest and most impressive.

A path to Llyn Crafnant, a small, remote lake south-east of Llyn Cowlyd, leads from the stile opposite the post office in Capel Curig. This path soon passes 'The Pinnacles', a conspicuous rock-climbing training-ground popular with nearby Plas y Brenin Mountain Centre. Just after The Pinnacles a diversion left enables access to be gained to the minor top, Crimpiau (733596). This top is an elongated, undulating ridge extending for well over a kilometre, and has on it a small lake, Llyn y Coryn, which is not shown on the 1:50,000 map. The ascent to the top of Crimpiau is not difficult, but it is not necessary to do so since there is a descending path along its north-west flank leading to a wall at an obvious col overlooking Llyn Crafnant. An ascent, almost north, leads to the minor summit Craig Wen and so across Bwlch Mignog to Craig Lwyn, from where the ascent to Creigiau Gleision is without difficulty over a mixture of grass and rock. The summit is a nice point of grass and boulders adorned by a small cairn, and reveals the whole of the ridge extending north-eastwards to the un-named subsidiary summit.

An excellent excursion may be made by continuing north-east over an intervening bump and then the subsidiary summit, and along the ridge until the dam at the end of Llyn Cowlyd can be seen. A direct descent can be made to the dam, but a less steep way can be found by following an old fence-line for a short distance towards Llyn Crafnant before leaving it and turning left, north, to reach the dam over deep heather. From the dam, which is welcome shelter, there is a steep ascent to the wide and otherwise gentle ridge running south-west to Pen Llithrig y Wrach which will make the whole trip a full day's walking. A return may be made to Capel Curig by reversing the route described in the entry for the ascent of that mountain. An easier way leaves the two buildings near the dam, one used by sheep, the other by humans (with the sheep winning in terms of cleanliness), and takes a good path along Llyn Cowlyd's northern shore, ending in a short ascent to a bridge and gate where the man-made leat turns its water to Cowlyd. From here there is a simple descent across the moor to Bron Heulog (720588) on the A5.

An alternative descent from the subsidiary summit may be made south-east to Llyn Crafnant, set in a wild and beautiful

valley, from where a climb through the woodland from the end of the road enables a return to be made to the starting point at the post office.

Crib Goch

14. Sheet 115. Section 1 – Snowdon. MR 624552. 923 metres.

Crib Goch has a reputation as something of a test piece and constantly invites comparisons with ridge walks elsewhere in the British Isles. Such comparisons, however, are entirely subjective and, therefore, meaningless as a guide for all walkers, though individuals who have tackled some of the ridges included in the

Crib Goch and Snowdon

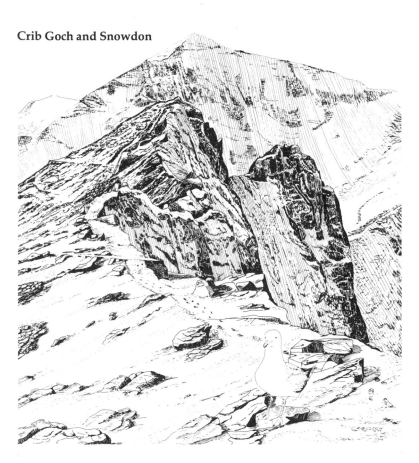

comparisons may well find some comfort in them. Even so, while the complete traverse of the Crib Goch ridge in perfect conditions, including the Pinnacles, may be technically more demanding than Striding Edge on Helvellyn, or Sharp Edge on Blencathra, roughly comparable with the Carn Mor Dearg arête of Ben Nevis, or certain sections of the Macgillicuddy's Reeks ridge in County Kerry, and significantly less difficult than Aonach Eagach (Glencoe) or the Cuillins of Skye, each assessment will be coloured by the individual walker's attitude to exposure (in the sense of agoraphobia) in general, and fear of heights, especially narrow ridges, in particular. All these ridges impart a sense of isolation and danger, heightened or diminished by prevailing weather conditions and the walker's own competence.

The ridge of Crib Goch is an imposing place to be; certainly there is nothing else like it in Wales. It is narrow, throughout its length, with long, steep drops on both sides, yet all the difficulties can be avoided by descending slightly from the crest on the side falling to Llyn Llydaw, that is, south, in the direction of the Pig Track.

The summit is not, as is generally supposed, at the northern end of the ridge, but is nearer to the middle, and marked by a small cairn directly above the steep drop into Cwm Uchaf. The structure of the ridge permits little choice of route, and approaches can realistically only be made to either end. From the west the approach over Bwlch Coch is from Crib y Ddysgl, or by a direct ascent to the Bwlch from the Pig Track, and offers a choice of descents. Steeply down east to Bwlch Moch a path leads towards Pen y Pass, while north a narrower but shorter ridge than Crib Goch itself leads into Cwm Uchaf from where careful navigation will lead into the Pass of Llanberis at Ynys Ettws (624567).

The normal line of ascent follows the Pig Track from the car-park at Pen y Pass to Bwlch Moch, the *Pass of the Pigs*, from which it takes its name. This is the route referred to above as a way down. At Bwlch Moch a way-marking post points to Yr Wyddfa (Snowdon), via the Pig Track, and to Crib Goch. The ascent to Crib Goch is scrambly in a few places but is now well marked by countless thousands of feet. One and a half to two hours should be sufficient for the ascent from Pen y Pass.

Cribin Fawr
83. Sheet 124. Section 8 – Dovey. MR 795153. 659 metres.

Cribin Fawr is a large, grassy plateau at the northern end of a small range of hills forming the north-western boundary of the Dovey Forest. The actual summit could be any one of a number of small piles of stones.

The traverse of the whole range, extending south-westwards over Waun Oer and Mynydd Ceiswyn, is a welcome alternative to more popular ridges elsewhere in Snowdonia and can be undertaken from either end. An approach from the south, however, permits the walk to be extended to include the highest hill of the range, Maesglasau, lying off the main ridge to the east. The entry for Mynydd Ceiswyn gives details of the approach from the south, and if the walk to Maesglasau is included, it is a simple matter to follow the edge of Craig Portas, the dramatic north face of Mynydd Dolgoed, to a narrow, grassy ridge linking Cribin Fawr and Mynydd Dolgoed with the higher summit. Craig Portas is not apparent in a southerly approach but is clearly marked on the maps.

Lines of descent from, and ascent to, Cribin Fawr are more numerous than is the case with the other summits in the group. The *bwlch* (pass) between Cribin Fawr and Waun Oer, which is steep in all directions and becoming a narrow ravine on the north, is approached from the south by a new forest road through Cwm Ratgoed. The road ends below the *bwlch*, and although this simplifies the approach from Cwm Ratgoed, much of the area has young trees and is better avoided.

From the north an indistinct path climbs from the parking place (804169) at the top of Bwlch Oerddrws. This can be used as a means of descent by walkers traversing the main ridge who do not either intend to continue to Maesglasau or need to return to their starting point. The same applies to a path which descends from near the summit of Cribin Fach, the natural extension northwards of the ridge, to Penantigi Uchaf (814163); this path is not shown on the 1:50,000 map and is an old track from the disused workings of the Cloddfa Gwanas quarry on Cribin Fach.

The quarry provides what is probably the best ascent (descent) of Cribin Fawr from the north, by way of another old track, wide enough to have been driven up, from Gwanas Fawr Farm, near the Cross Foxes Hotel at the junction of the A470 and A487. The

route follows the path to the farm (Bed and Breakfast available) but passes round it to gain the lower pastures through a gate. The way ahead is obvious, making for a group of trees (783163), and then to the left of the conspicuous notch on the skyline, from where it is a short distance south to the top of Cribin Fawr. The start of this track in descent is not clear, but it begins on the northern side of the fence immediately after the quarry workings (which are on the southern side).

From the Cross Foxes Hotel, which thirsty walkers will find is conveniently placed, it is less than 4 kilometres (2.5 miles) to the parking place below Craig y Llam. The circular tour, excluding Maesglasau, takes in the region of 4½ hours.

Crib y Ddysgl
2. Sheet 115. Section 1 – Snowdon. MR 611552. 1,066 metres.

Crib y Ddysgl is more correctly named Garnedd Ugain, the *Cairn of Twenty*, but only the pedantic still persist with this name. The mountain, in spite of being the second highest summit in England and Wales, not unexpectedly suffers from its close proximity to Snowdon and must seldom, if ever, be ascended for its own virtues. Inexplicably it is a neglected mountain even though the easy way up Snowdon passes only a few minutes from its summit; and though it is close enough to the descent into Cwm Dyli, it seldom tempts walkers to extend their walk to include it.

Yet apart from its expected intimate view of Snowdon, Crib y Ddysgl has among its assets the formidable rock-climbing walls of Cyrn Las hidden away in a wild and beautiful north-facing *cwm*, and a splendid scrambling route to its summit from Crib Goch. Both make Crib y Ddysgl a worthy inclusion in the famous Snowdon Horseshoe – not that it could be avoided – and many walkers are content to collapse on its summit after the effort of the walk from Pen y Pass before tackling the final few minutes to Snowdon's summit.

A trig point is the only shelter on the plateau of Crib y Ddysgl's summit, but it is not on the highest point, as is often the case.

Cyfrwy

31. Sheet 124. Section 8 – Cader Idris. MR 704133. 811 metres.

Cyfrwy is the arm of the Chair of Idris, *Cadair* Idris, to give it its correct spelling. The rocky summit of Cyfrwy has little merit of its own except for the detailed insight it affords of the north face of Pen y Gadair seen across the *cwm* containing Llyn Gadair. This small summit is less than a kilometre (half a mile) from Pen y Gadair and perches at the top of steep cliffs, one section of which has shattered in such a way as to create, below half height, a pedestal of rock known as Idris' Table. It used to be a popular climb to the Table, followed by a scramble to the shelter and cairn on the summit, but this way has suffered a number of rock-falls in recent years and is now to be avoided.

Its closeness to Pen y Gadair means that Cyfrwy is generally passed by in ascents from Ty Nant and Cwm Pennant, and included instead in the descent, a much easier undertaking. Walkers ascending by the Minffordd Path will need to detour to reach Cyfrwy either from the col between Pen y Gadair and Mynydd Pencoed, or by descending from the higher summit. Either way should require no more than an extra twenty minutes.

Details of the ascents from Ty Nant, Cwm Pennant and Minffordd are given in the entry for Pen y Gadair.

Cyrniau Nod

78. Sheet 125. Section 10 – Hirnant. MR 988279. 667 metres.

The hills along the high ground south of the Aberhirnant Forest, of which Cyrniau Nod is the highest, are not for the casual walker. The whole area is a vast upland of peat bog and heather, impassable to all but the most determined. At least, so it was until a new track was bulldozed across the tops from the highest point of the road through Cwm Hirnant at 946274. The track is there to facilitate the grassing of this wild area, not for walking, but it now provides an easy ascent, over Pen y Boncyn Trefeilw and Stac Rhos, to Cyrniau Nod.

An ascent can also be made through the forest from 953312, at the highest point of which the new track is now met and follows the line of a public footpath to the watershed where, inexplicably, it ends.

The top of Cyrniau Nod is a large plateau, and the summit,

crossed by a fence (and the National Park boundary), is marked by a large cairn built around a tall wooden post. The mountain overlooks the attractive valleys leading to Lake Vyrnwy, and the *cwms* at the head of the Tanat valley. It is not beyond the bounds of possibility to reach Cyrniau Nod from Tanat or by the route along the Afon Cedig described in the entry for Cefn Gwyntog.

Dduallt
80. Sheets 124 and 125. Section 7 – Rhobells. MR 811274. 662 metres.

Writing in the 1930s, Patrick Monkhouse described Dduallt as a kind of hog's back, though he had never heard of anyone ascending it. Jim Perrin in 1982, writing in *The Classic Walks*, portrays it as 'a superb little peak like a smaller version of Tryfan' and 'an esoteric pearl of a hill'. The similes may be appropriate according to one's point of view, though no one contests that Dduallt is a mountain strictly for the fit and bog-loving individuals of the hill-walking fraternity. The difficulties of Dduallt are in no way eased by the activities of foresters which have obscured or diverted paths and generally added a new dimension – probability – to the art of navigation.

The mountain itself looks particularly impressive from Arenig Fawr or Moel Llyfnant to the north, being steep on its eastern face and rugged on its west, and it does have a certain attraction when viewed from its near neighbour, Rhobell Fawr, across the intervening forest.

Fortunately, the forest, which has otherwise confused the lines of access, also serves to take some of the aggravation out of the situation by the provision of the necessary forestry roads. From the south, for example, an approach can be made by ascending the minor road which leaves the A494 at 799216 all the way to Ty Newydd y Mynydd, which is now in ruins. It is not advisable to bring cars this far since there is nowhere that they may be parked, and in any case to do so would detract from the pleasure of a walk through the forest plantations with Rhobell Fawr growing ever larger on the left skyline.

The space between the two main forests is now filled with young trees, and though pathways exist through them, their use is not recommended. It is better to continue further north along the track to reach the edge of the northerly forest at 800264. From

here a faint path follows the forest boundary without encroaching on the new plantation, and leads to a small knoll at 806259 from which it is advisable to make straight for the southern end of the Dduallt ridge. The intervening tract of land is a mess of bog, tussock grass and rocky outcrops which is very tiring. A fence will be found to ascend Dduallt from the east about halfway along the ridge, and this passes within a few metres of the highest point, a neat cairn on top of an outcrop. The western view is filled with the whole range of the Rhinogs, while south lies the escarpment of Cader Idris from Tyrau Mawr to Gau Craig.

A difficult and no less wet ascent can be made of Dduallt from the north over Mynydd Bryn-llech and the higher ground west of Waunygriafolen, but shorter and marginally easier is an approach from the west through Cwm yr Allt-lwyd. There are tracks along both the north and south banks of the Afon Mawddach that later join on the north bank at Allt Lwyd and from there lead to a new track which crosses the north ridge of the mountain. The north ridge is no easier than the south and, with the problems of getting to them generally, makes Dduallt one of the most arduous mountains in Snowdonia to capture.

Diffwys
46. Sheet 124. Section 6 – Rhinogs. MR 661234. 750 metres.

The mountains at the southern end of the Rhinog range are generally much easier going than those further north, and Diffwys is no exception to this. It forms part of a horseshoe of grassy hills which, though including Y Llethr, the highest summit of the Rhinogs, is predominantly lower country. The complete horseshoe also takes in Moelfre (626245), a rounded grassy dome north-east of the coastal village of Tal y Bont (590218), and the long ridge of Llawlech (632211) running west and then south from Diffwys.

The most enjoyable way to approach Diffwys is as part of this horseshoe, starting from the car-park in Tal y Bont (near the toilets and telephone kiosks), when, since Y Llethr (or Moelfre) will be visited first, Diffwys will be reached across the short, undulating ridge of the minor summit, Crib y Rhiw. This is the sort of walking one wants to go on for hours, but which, alas, does not. From the end of Crib y Rhiw, which is traversed by a wall extending all the way back to Y Llethr, the wall continues to

be a guide until a meaningless, but obviously well-used, path chops off five minutes of effort by heading straight for the final steep, rocky scramble to an elongated summit.

There is a nice ascent to Diffwys through Cwm Hirgwm from Bontddu (673189) on the A496, 8 kilometres (5 miles) east of Barmouth. An approach along the minor road, and then by a path to Hafod Uchaf (659211), leads to steep and broken ground around Craig Aderyn, followed by a short pull to the summit.

From the same starting point a longer, but slightly easier, way is to continue ahead from the end of the minor road by a track ascending the conspicuous ridge ahead. This track, which continues over the ridge of Llawlech and down to Pont Scethin, is the old Harlech track used on the journey from London to Harlech. From the highest point of this track, where it now passes through a wall (near which there is a cairn), it is simply a matter of turning right (east) and following the wall across easy ground to the summit.

Also from the south a shorter walk, finishing steeply, can be started from Borthwnog (690191) along the road through the forest, and then by the left fork shown on the 1:50,000 map to leave the forest at 676234 from where a path ascends steeply past disused mines to the southern end of Crib y Rhiw. It is then only a matter of a few minutes to the summit.

The following two alternative ascents are described as descents since they are better used as such. Both leave the summit and follow the wall west until the cairn is reached at the junction with the Harlech track. (Note: from the summit the wall starts off south for a short distance before turning west.)

From the cairn walkers making for Barmouth can continue ahead and over a stile to follow the fine ridge of Llawlech until, after the highest point of the ridge is reached, it is possible, at Bwlch y Rhiwgyr, to descend south-east to join a minor road at Sylfaen (632185). There are many paths in this area, most of which do exist on the ground, and their destinations are obvious from the map.

Walkers undertaking the horseshoe walk from Tal y Bont will have started by either of the alternatives described in the entry for Y Llethr. The key to this approach is the old cottage, Lletty-lloegr (not named on the 1:50,000 map), which is near Pont Fadog (607225). The cottage can be reached from the cairn on the Llawlech ridge by a pleasant walk first north and down along the

Harlech track to Pont Scethin and then by joining a wide, graded track leading to a road, and then back to Lletty-lloegr. There is room to park a car just before the cottage is reached.

A better descent from the ridge is to leave the Harlech track before Pont Scethin is reached and to take a path, indistinct at first, past Llyn Irddyn. The lake remains hidden until the last moment and is a peaceful, secluded place to rest. This alternative path leads directly to the road over Pont Fadog.

Drosgl
43. Sheet 115. Section 3 – Carneddau. MR 664680. 758 metres.

Drosgl lies at the top of the ridge rising north-east from Gerlan (633665), near Bethesda, which passes first over the small summit of Gyrn Wigau. The distance from Gerlan is a little over 3 kilometres (1.9 miles) in an almost straight line and climbs 500 metres in height. The ridge continues beyond Drosgl to the twin bumps of Bera Mawr and Bera Bach before turning south-east to join the main Carneddau ridge at Garnedd Uchaf.

The ascent from Gerlan allows a pleasant and predominantly peaceful circuit to be made over Drosgl to Garnedd Uchaf, Foel Grach and the highest summit of the range, Carnedd Llywelyn, before returning to Gerlan over the neat summit of Yr Elen. The way from Carnedd Llywelyn to Yr Elen and down to Gerlan is described in the entry for Carnedd Llywelyn as an ascent.

The large cairn on Drosgl is all that is left of two robbed Bronze Age cists containing cremated bones.

Drum
41. Sheet 115. Section 3 – Carneddau. MR 708696. 770 metres.

Drum is the true northern terminus of the twisting central ridge of the Carneddau range which stretches south-westwards from its summit for 16 kilometres (10 miles) to end at Pen yr Ole Wen above the Ogwen valley. Apart from a circular stone shelter and a fence, both nevertheless welcome in adverse weather conditions, Drum is superficially a featureless summit, infrequently visited, but enjoying extensive views across the Vale of Conwy. The summit name, however – Carnedd Penydorth Goch – hints at more than the immediately obvious. This is the site of a Bronze Age platform, roughly circular and about 18 metres (60 feet) in

diameter, with a marked terrace on the east side. The modern cairn is slightly west of the centre.

There is a pleasant ascent from Bont Newydd (663720), where there is room to park a few cars, taking in lonely Llyn Anafon, a small reservoir feeding Llanfairfechan. This ascent is described in the entry for Carnedd Llywelyn, while the notes for Pen y Castell describe an ascent from the opposite direction, starting in the Vale of Conwy.

An alternative route from Bont Newydd follows the path which starts at 676716 at the end of the metalled road. The path, ascending initially over a metal stile and then along a wall, soon joins a wider track leading eventually to Bwlch y Ddeufaen, the *Pass of the Two Stones*, but this should be left at 693722 at a junction of tracks. From here the way skirts around Foel Ganol and the shoulder of Drosgl – not to be confused with the summit of the same name near Bera Mawr – before it ascends to within only a few paces of the summit of Drum.

An easy return to Foel Ganol can be made along the ridge north of Drum and follows a vague path close to a post and wire fence. This way passes over the minor summit of Carnedd y Ddelw, at the second top of which the fence turns abruptly north-east towards Bwlch y Ddeufaen. Leave the fence at this point and descend to cross the stony track used on the ascent, following which there is a short, undulating rise to Foel Ganol. This is all easy walking on grass, and such boggy ground as there is can easily be avoided.

Carnedd y Ddelw, the *Cairn of the Image*, although not significant enough to include as a separate summit, is said to be a Bronze Age cist or burial chamber where a small golden image, five inches long, was found in the eighteenth century.

Elidir Fawr
13. Sheet 115. Section 2 – Glyders. MR 612613. 923 metres.

Elidir Fawr projects from the northern end of the Glyder range rather as Tryfan projects from the southern end, but unlike Tryfan, which is easily accessible, the route to Elidir Fawr calls for some study of the map first. Seen end on, *Big Elidir* has a distinctive, pointed shape not unlike Cnicht further south, but from most normal viewpoints it is a massive wall. It is for purposes of ascent nearer to Llanberis (578601) than Ogwen. But

the way up from Llanberis, which involves taking in the minor summit, Elidir Fach, is now so hopelessly and unattractively embroiled in the Dinorwic Slate Quarries and the more recent works of the Central Electricity Generating Board that there can be no justification, other than curiosity, for an ascent from this side.

Although slate quarrying has been a principal activity on Elidir Fawr for many years, the mountain has recently been found another use, this time as part of a hydro-electric power station using the waters of Marchlyn Mawr, a lake hidden in the recesses behind Elidir, and Llyn Peris in the valley of Llanberis. Pedestrian access to Marchlyn Mawr will, in spite of the works, continue to be freely available, though walkers should avoid resting too close to the lake, the level of which varies by as much as 33 metres during each operational cycle of the power station. The level of the lower lake, having a much larger surface area, will only vary by 12 metres.

If Llanberis is one's base and transport to Ogwen cannot be arranged, the horror of what man has done to the mountain can be to some extent avoided by starting an ascent further up the Pass of Llanberis at Nant Peris (605584). The route follows the Afon Gafr until it is possible to cross into the valley drained by the Afon Dudodyn. From this direction the mountain looks enormous, towering above the valley. But the going, over grass dotted with boulders, is not so difficult, and it is only near the top, among the rocks and boulders which fringe the summit, that any awkwardness is encountered.

From Ogwen the easiest ascent is by the Devil's Kitchen to Y Garn. The route is described in the entries for Y Garn and Glyder Fawr. From Y Garn it is an easy walk along the ridge north, passing over Foel Goch to Bwlch y Brecan and from there ascending the ridge to Elidir's summit. A return, avoiding the long trek to the Devil's Kitchen, can be made down Y Garn's northerly ridge or by continuing north from Bwlch y Brecan over Mynydd Perfedd to Carnedd y Filiast and descending from there to join the old road through Nant Ffrancon near Ty'n-y-Maes. On a clear day an alternative is to follow the ridge descending south-eastwards from Foel Goch into Cwm Cywion: because the point of descent from Foel Goch is easy to miss, this should not be attempted in mist.

Elidir Fawr was once known as Carnedd Elidir, commemorat-

ing Elidir Mwynfawr, son-in-law of Maelgwm, Prince of Gwynedd, who on Maelgwm's death laid claim to the right of succession in the absence of any other legitimate heir (Maelgwm had a bastard son, Rhun). Elidir's disadvantage, despite having been commander of Maelgwm's army, was that he was English, and many Welshmen felt, as they still do, that there should be no Englishman as a Prince of Wales. In a fierce battle over the issue Elidir was killed, but such was his esteem that, English or not, his followers commemorated him by building a pile of rocks on a high mountain, naming the pile Carnedd Elidir. It seems a more preferable name.

Erw y Ddafad Ddu
21. Sheets 124 and 125. Section 9 – Arans. MR 865234.
872 metres.

The grassy dome of Erw y Ddafad Ddu, the *Acre of the Black Sheep*, is an inconsequential bump lying between the two high summits of the Arans, Fawddwy and Benllyn. It is along the line of the agreed access across the main Aran ridge and so can be reached easily from either of the mountains which flank it.

The summit is marked by a small cairn, though there is nearby a much larger and more prominent cairn overlooking the eastern face of Aran Fawddwy and Craiglyn Dyfi, the source of the River Dovey.

Esgeiriau Gwynion
74. Sheets 124 and 125. Section 9 – Arans. MR 889236.
671 metres.

East of the impressive faces of the main Aran ridge lie a small group of rounded, grassy, boggy hills that truly belong neither to the Arans nor to the more distant Berwyn Hills; Esgeiriau Gwynion is one of these. There are no paths over its summit, which is not named on the 1:50,000 map, but it lies close to the named top, Foel Rhudd.

There is an attractive walk into Cwm Ffynnon, the long valley lying to the west of Esgeiriau Gwynion, which starts from the south-west near Blaen Pennant (905214) at an awkward bend in the road. This approach allows Esgeiriau Gwynion to be tackled from the top of the pass at Bwlch Sirddyn, from where a fence-

line climbs steeply upwards and leads to a wide, boggy plateau and a junction with two other fences. One of the fences continues round to Foel Rhudd while the other turns south to Llechwedd Du. The highest point in this rolling landscape is the raised mound of peat and tussock grass just to the east of the junction of the fences.

As an alternative, which avoids the steep climb from Bwlch Sirddyn, Esgeiriau Gwynion may be reached over the adjoining summit, Llechwedd Du, by starting from the viewpoint at Bwlch y Groes (913233) at the top of Cwm Cynllwyd.

All routes in this moorland area are pathless and wet. Only fences break the monotony of the landscape, but in mist they are the only reliable guide.

Foel Boeth

108. Sheets 124 and 125. Section 7 – Arenigs. MR 779345.
619 metres.

Foel Boeth, 3 kilometres (1.9 miles) west of Moel Llyfnant, is a double-topped hill with the higher, northern top taking the name Gallt yr Daren. This is not so much a mountain as an upland elevation amid an ocean of wet, tussocky ground. The only advantage Foel Boeth can offer the walker over other hills is solitude.

The summit may be reached without difficulty by a short walk from the spot height (531) at 784334 on the minor road which crosses this wild area. A longer approach from Pont y Gain (752327) can be made by following a track along the west boundary of the forest which here lies on both sides of the road. The path later circles back towards Foel Boeth.

Although the Romans are said to have passed through this area, there is little else of interest.

Foel Cwm Sian Llwyd

88. Sheet 125. Section 10 – Hirnant. MR 996314. 648 metres.

Foel Cwm Sian Llwyd is the last of a semicircle of hills forming the high ground south of the Aberhirnant Forest, and lies close to the road from Llangynog (053262) to Bala. It is best ascended from this road because the link with the rest of the semicircle is extremely hard going across a pathless tract of bog and heather.

From the milestone – Milltir Cerrig – at the top of the road a track leads on to the south-east ridge and passes a short distance from the summit, which is marked by a trig point. Slightly easier going may be found by starting a short way north of Milltir Cerrig, between the spot heights 486 and 476 shown on the 1:50,000 map. There is a derelict building, offering a little shelter, at the north-eastern end of the summit plateau.

Foel Fras
11. Sheet 115. Section 3 – Carneddau. MR 696682. 942 metres.

Foel Fras is the first, or the last, of the famous fourteen peaks of North Wales that make up the 'Welsh Three-Thousanders', a classic walk of just less than 40 kilometres (25 miles) well described by Harold Drasdo in *The Big Walks* compiled by Ken Wilson and Richard Gilbert. With the coming of metrication, 3,000 feet will have little significance, but it will be many years before this superb traverse of three mountain ranges slips into oblivion, if at all.

The summit of Foel Fras is unimpressive and lies close to a stone wall that crosses the plateau of boulders adorning the highest point. Views into the distance may stretch as far as Cumbria, but closer at hand there is nothing to be seen except from the very edge of the plateau.

Since it lies at the northern end of the central ridge of the Carneddau, Foel Fras can easily be included in a walk from Carnedd Llywelyn, and this form of descending 'ascent' is, in this instance, to be recommended. The alternative, an ascent from Aber at sea level, or Bont Newydd a short way inland, requires a toilsome trek to and above the Aber Falls and into the trough gouged out by the Afon Goch, with nothing but seaward views for company. Some visual respite may be found by taking to the slopes of Llwytmor, a grassy lump extending north-west from the summit of Foel Fras. A better route lies over Bera Mawr, south of the Afon Goch, but this subsidiary ridge connects with the main ridge 1.5 kilometres (one mile) south-west of Foel Fras.

A wholly non-conformist approach, but one with the advantages of solitude and wild scenery, would be to continue along the track from the Vale of Conwy described in the entry for Pen y Castell, instead of ascending by the wall, until the tributaries of the Afon Garreg-wen are encountered, and then to ascend direct-

ly to the summit. A return journey could do worse than include Drum and Pen y Castell itself.

Foel Goch
26. Sheet 115. Section 2 – Glyders. MR 628612. 831 metres.

The Foel Goch which lies 1.5 kilometres (one mile) north of Y Garn in the northern section of the Glyders' range is the highest of four Foel Gochs that appear in these Tables; the other three, much lower summits, are found in the Arenigs, in the Berwyns and in the Moel Eilio group of summits north of Snowdon.

This highest summit is not especially difficult to attain once the north Glyders' ridge has been gained, requiring little in the way of re-ascent if travelling north. There is, however, a short pull of 140 metres from Bwlch y Brecan for those heading south. An approach along the ridge is described in the entry for Y Garn.

Those who do not object to steepness and the exertion that goes with it will find better routes to Foel Goch's summit starting from Nant Ffrancon, to which Foel Goch sends down two ridges. One ridge, from just south of the summit, leads into Cwm Cywion and to Blaen y Nant (643608) in the valley, while the other, Yr Esgair, drops very steeply from north of the summit. Either of these ridges used in ascent will place one only a short distance from the summit, but care is needed in locating their start, particularly in mist, if they are intended for descent. Yr Esgair especially needs great care, having poor and unstable rock.

Foel Goch
112. Sheet 125. Section 7 – Arenigs. MR 953423. 611 metres.

Being a solitary mountain and surrounded on all sides by roads, this Foel Goch is more academically than physically linked with the Arenig group, and offers an assortment of approaches to a summit that is predominantly grass and bracken.

The highest point is marked by a trig point, a small cairn and a boundary stone, and marks the dividing line between the old parishes of Llangwm to the north and Llanfor to the south. The whole area is, on the map at least, well served by footpaths, though some of them are now obscure on the ground. Any of them afford an easy line of ascent, with the highest point being in doubt only along an approach from the west when for a short

while the summit is obscured by the minor, intermediate top, Garnedd Fawr.

This is a hill for a short afternoon on which it would be difficult to spend more than three hours. From Llangwm a minor road leading to Cwm-llan (961430) enables the north-east slopes of the hill to be gained, and so the summit. Alternatively one can head for the obvious col to the east of the summit, with easy grassy slopes leading upwards. An approach from the south can be made by taking a path which leaves the minor road from Cefn-ddwysarn to Dinmael at 966405 and crosses the low ridge to the west to gain a path ascending along the Nant Cwm Du, with the option of making for the col ahead or, after crossing the river by a bridge, making directly for the broad ridge climbing straight to the summit.

As a day's objective this Foel Goch of the four in this book is likely to be insufficiently rewarding in itself. A traverse of the hill, preferably east to west, offers a little more.

Foel Goch
115. Sheet 125. Section 10 – Hirnant. MR 943291. 610 metres.

Cwm Hirnant ascends in a southerly direction from the north-eastern end of Bala Lake to join, across the watershed, Nant Nadroedd Fawr and eventually Lake Vyrnwy. On the west of the *cwm* rises a short ridge along which there are three minor summits in quick succession. Foel Goch – not named on the 1:50,000 map – is the most northerly of the three.

The summit is marked by a small cairn on the southernmost of two heathery knolls, but ascents to it are difficult. From Cwm Hirnant all possible routes are barred by a fence alongside the road, except at Maesfallen (948307) from where a path – shown on the map – passes through a gate and across a meadow to a stile and into the woodland above. The way through the woodland is sketchy and overgrown, but the general objective is the north-east ridge of Foel Goch. This can be reached by following first the forest fence and then a boundary fence. The latter, however, does not actually continue to the summit but can be used as a guide in all but the most misty conditions.

The long western slopes of Foel Goch are newly planted with trees, and the eastern slopes, while not beyond the ability of strong walkers, are very steep. From the south an approach may

be made over Foel y Geifr from the top of the road (946274) or by using a faint path below that summit on the eastern side leading to Trum y Gwrgedd, the middle one of the three summits.

Foel Goch
121. Sheet 115. Section 1 – Eilio. MR 571563. 605 metres.

Foel Goch is a mountain name, meaning simply *Red Hill*, that occurs frequently throughout Wales. There are four Foel Gochs in Snowdonia of more than 600 metres in height, and there are quite a few of lesser height. This Foel Goch, in the Moel Eilio range of hills north of Snowdon, is typical of the whole range, gentle, though not without steepness, and grassy. Foel Goch compensates for its lack of height by sending down towards Llanberis a substantial ridge which encircles, with Moel Eilio, a wild and beautiful lake, Llyn Dwythwch. By starting from Brithdir (576583) near Llanberis, it is possible to ascend Foel Goch easily by this ridge.

Undoubtedly the best approach, however, is to include Foel Goch in a traverse of all the four hills which make up this small range. Details of this traverse are given in the entry for Moel Eilio, though care is needed in the descent to the col between Foel Goch and the next mountain, Moel Cynghorion. The route is steeper than on any other part of the traverse, and it is not direct. The safest guide in mist is to follow the fence which crosses the summit, having first used the stile to surmount the fence. The fence-line appears to lead in the wrong direction, but it soon turns and descends to the col, Bwlch Maes-gwm, which is not named on the 1:50,000 map.

An alternative ascent may be made from the south-west, from Llyn Cwellyn, by taking the Snowdon Ranger Path for about one kilometre (half a mile) until it is possible to ascend to Bwlch Maes-gwm, from where it is a short, steep pull to the summit. The ascent from Llyn Cwellyn is uphill all the way.

Foel Grach
8. Sheet 115. Section 3 – Carneddau. MR 689659. 976 metres.

No one is likely to make Foel Grach the sole objective of a day's excursion; it is a summit of little merit. Normally it will be included in a walk along the central ridge of the Carneddau

range. Perhaps it is best described in an approximate translation of its name: *Foel* as well as *hill* can also mean *rough*, and *Grach* equates to *scab*.

For the walker who has reached the highest summit of the range, Carnedd Llywelyn, by travelling along the ridge from the Ogwen valley, the continuation to Foel Grach involves 90 metres of descent and 45 metres of ascent in little more than one kilometre of grassy walking amid sporadic outcrops of rock. Just below Foel Grach's undistinguished summit, Wardens of the National Park have constructed a Mountain Refuge Hut, a haven, and the only certain point of reference, for anyone caught in the mists that so frequently capture these mountains. A line of stone markers leads to the hut, yet even this place of safety seems fated to be a mecca for walkers whose standards of hygiene and respect for other people's property leave a great deal to be desired.

On the plus side of this imbalanced equation an approach to Foel Grach from the north, achieved by starting from Bont Newydd (663720) and following the route described in the entry for Carnedd Llywelyn, gives a distinctly more enticing view of the highest summit than can be seen from other directions. And in Craig Dulyn, carved from the east shoulder of Foel Grach, is a fine example of a cliff overhanging and encircling a deep, crater-like lake. This lake, Llyn Dulyn, fed by waters pouring from the steep slopes above, is genuinely black no matter how blue the sky, and a great attraction for anyone seeking remoteness.

> I dream of you, my unknown lake
> Filled by the torrents from the hills
> Which cascade in a way that thrills
> And now move slowly for my sake,
>
> For in your waters, quiet and deep,
> Without the sea's ne'er ending tides,
> An air of peacefulness abides
> Which calms me in my waking sleep.

<div align="right">John Henshall</div>

The whole area east of Foel Grach is known to have been the site of a Bronze Age settlement, traces of which can still be found in the vicinity of Llyn Dulyn at a spot called Pant y Griafolen, the *Hollow of the Rowan Trees*. This spot is not named on the 1:50,000 map though the location is marked by a cross. The name must also be of some antiquity for there are no rowan trees there now.

Approaches from the east, not only to Foel Grach but to the whole range also, tend not to be so popular as those from other directions, yet there is much reward for the effort of getting there, and by using the road to Llyn Eigiau reservoir the distances can be considerably shortened. In addition to the obvious routes to the two lakes, Llyn Dulyn and Melynllyn, from where an ascent can be made by the broad ridge south of Melynllyn to Foel Grach, there is a higher, more northerly approach described in the entry for Foel Fras. This can just as easily serve Foel Grach.

Foel Gron

99. Sheet 115. Section 1 – Eilio. MR 560569. 629 metres.

Foel Gron is a minor summit with two tops in the range of four grassy hills north of Snowdon of which Moel Eilio is the highest. It is due north of Llyn Cwellyn in Nant y Betws, an area of Snowdonia that is often neglected.

Despite its relative unimportance, Foel Gron possesses an impressive east face of shattered rock and steep, imposing gullies. The higher summit of the two is un-named, the Ordnance Survey giving the name *Foel Gron* to the second top, 593 metres in height at 564566.

It is normal to include Foel Gron in a walk traversing all four hills, and ascents are detailed in the entries for Moel Eilio and Moel Cynghorion.

Foel Hafod Fynydd

63. Sheets 124 and 125. Section 9 – Arans. MR 877227. 689 metres.

Foel Hafod Fynydd, which is not named on the 1:50,000 map, lies one kilometre (0.6 miles) east of Craiglyn Dyfi, the source of the River Dovey, beneath the towering heights of the main Aran ridge. It is a grassy summit and marks the southern terminus of Cwm Ffynnon. The path through Cwm Ffynnon, across Bwlch Sirddyn and into the valley of Llaethnant, is one of the most picturesque in North Wales, reminiscent of Alpine and Pyrenean valleys, and is a delight to walk. Foel Hafod Fynydd may be reached as a diversion from this path.

Alternatively, the mountain can be reached by the spur, Braich yr Hwch, extending northwards into Cwm Ffynnon. With the

exception of the path between the two valleys, mentioned above, there are no other paths over this mountain and no rights of way.

Foel Lwyd
124. Sheet 115. Section 3 – Carneddau. MR 720723. 603 metres.

Foel Lwyd is not named on the 1:50,000 map, though it is shown as a small top west of Tal y Fan with a height of 598 metres. Recent surveys, however, give this insignificant summit slightly more height, but it is no more than a rocky extension of the Tal y Fan summit ridge. The ascents described in the entry for Tal y Fan apply equally to Foel Lwyd.

Foel Wen
60. Sheet 125. Section 10 – Berwyn Hills. MR 099334. 691 metres.

There is a short range of three grassy hills, not without the occasional wet spot, which extends eastwards from the principal Berwyn heights; Foel Wen is the middle hill of the three. It is most easily ascended as a continuation from Tomle to the west, or Mynydd Tarw to the east. Either way is easy, and details are given in the entries for those hills.

Foel y Geifr
100. Sheet 125. Section 10 – Hirnant. MR 937275. 626 metres.

Foel y Geifr is the highest and most southerly of a short ridge of hills forming the upper western part of Cwm Hirnant, near Bala. It is easily reached from the top of the road which passes through Cwm Hirnant, at 946274. A boggy hollow is crossed to a fence, and then slopes of heather and grass ascend gradually to an attractive raised platform of slate and quartz on which the Ordnance Survey have positioned their trig point.

Walkers ascending first to Foel Goch at the northern end of the ridge, then following a fence south across Trum y Gwrgedd, the central hill, will find that the fence, which is otherwise a reliable guide, veers away to the west before reaching the summit of Foel y Geifr.

The whole of this ridge, though generally laborious walking, gives a grandstand view of the Arans.

Gallt yr Ogof

42. Sheet 115. Section 2 – Glyders. MR 685586. 763 metres.

Gallt yr Ogof, the *Slope of the Cave*, in spite of its casual dismissal by George Borrow as 'the first . . . of the hills which stood on the left', is an enormous bulk of craggy ground when viewed from the A5, along the line of which Borrow was walking. It is an even more impressive sight from the mountains, Creigiau Gleision and Pen Llithrig y Wrach, on the opposite side of the valley. The mountain rises steeply from the valley, and the cave of its name is clearly seen from the road.

There are three approaches to the mountain, each with its own charms. From the north, starting at Gwern-gof-isaf Farm (685602), a path leads east to the foot of the cliffs above the Afon Llugwy, and from here a pleasant scramble up the obvious diagonal gully ends about one kilometre (0.6 miles) from the summit. From the south-west any approach must come first over Nameless Peak, the short distance between the two being without difficulty.

The longer ascent from the east, starting at Capel Curig, is in many ways a finer walk than the other two. The route is simple enough, beginning along the lane near the post office (721581) until, after the last cottage, the steeper ground can be reached. There are several rocky outcrops along the top of the ridge, Cefn y Capel, but all of these can be easily bypassed. This ridge gives excellent views into Nantgwryd, across which looms the mass of Moel Siabod. Steepening ground leads around the rim of Nant y Gors to the summit.

Gallt yr Ogof is a mountain which can be included in a pleasant circuit from the Ogwen valley by way of Tryfan, the Miners' Track to Llyn Caseg-fraith, and the Nameless Peak. It is better, at the end of such a circuit, to descend from Gallt yr Ogof by continuing along the summit ridge, north-east, until it steepens dramatically and then leaving it by easier ground into Nant y Gors, east. The ease is relative, and care is still needed on this descent. The alternative, west into the wide valley, Nant yr Ogof, while apparently more direct and preferable, is rarely dry and can be trying at the end of a day.

Gallt yr Wenallt

107. Sheet 115. Section 1 – Snowdon. MR 642533. 619 metres.

Gallt yr Wenallt is, for walkers undertaking the Snowdon Horseshoe in an anti-clockwise direction, the last nail in the horseshoe. Most walkers, however, choose to ignore this last summit and to descend from Y Lliwedd to the Miners' Track. The omission, which in some respects is a sad one, is largely due to the fact that the descent from Gallt yr Wenallt to rejoin the Miners' Track is successively steep, down grassy slopes to the Afon Glaslyn, then boggy, until the pipe-line is reached, and thereafter tiring, as one climbs around the eastern end of Clogwyn Pen-llechen, a minor but obvious rock outcrop not named on the 1:50,000 map.

Reaching Gallt yr Wenallt from Y Lliwedd involves a detour from the cairn at which the well-marked Horseshoe Path dives towards Llyn Llydaw. A faint path wanders up and down over a series of grassy bumps until, at the head of the ridge rising from Nant Gwynant, the summit cairn is reached.

Gallt yr Wenallt may also be ascended from Pen y Pass by its north-east ridge, which narrows near the top. An easier and more interesting way, however, starts from the car-park near the Bethania Bridge in Nant Gwynant (627506) and follows the Watkin Path for a short distance until, just above the waterfalls marked on the map, a descent may be made to the footbridge over the Afon Cwm Llan. From here a miners' track leads to old workings in Cwm Merch. This is a boggy path now, and a diversion from it to cross the stream, the Afon Merch, falling down the obvious *cwm*, enables the ridge rising above Llyn Gwynant and better ground to be reached and followed to the summit.

Garnedd Goch

56. Sheet 115. Section 4 – Nantlle. MR 511495. 701 metres.

Garnedd Goch is the penultimate summit in an east-west traverse of the Nantlle ridge, lying 3.5 kilometres (2 miles) due south of the village of Nantlle which gives its name to both the ridge and the valley. Some walkers consider that after Craig Cwm Silyn there is nothing of any interest further west along the ridge. They are mistaken. The walking is pleasant and easy, there are extensive

views, and the north flank of the mountain, overlooking the Llynnau Cwm Silyn, is impressively steep and rocky, being an extension of the crags of Cwm Silyn.

Ascents to Garnedd Goch, which facilitate a west-east traverse of the ridge, start at either Nebo (478505) or Tal y Sarn (494526). From Nebo a road leads across the outflow of Llyn Cwmdulyn Reservoir, and then a path, marked by upright stones, continues to the lower slopes of Garnedd Goch. This route makes for the obvious low-point on the skyline, Bwlch Cwmdulyn, below which the path meets a wall ascending steeply to the summit. Slightly more direct is the road east from Nebo to Hafod y Llyn (493503), and then by the marked path just described.

From Tal y Sarn the way is more complicated and longer. Way-finding is not helped by the fact that many of the paths shown on maps are no longer there, at least not on the ground. Just south of Tal y Sarn is the village of Dolbebi from where a minor road leads to Llanllyfni. A short distance down this road a signposted path leads past a quarry lake (491523) to a road ascending to some small slate quarries. From the quarries the way across enclosed fields can still be worked out by obvious gates in the walls, though it is a little confusing. The immediate objective is a gate across the track to Cwm Silyn leading onto the open hillside. The gate, at 496511, can be reached by road by leaving the Dolbebi-Llanllyfni road at 481521. The way is obvious, and there is room to park near the gate. From the gate a wall can be seen climbing to Garnedd Goch, and an ascent by this wall should be made until, where this and a higher wall meet (505503), it is possible, by passing through a gap in the upper wall, to pick up yet another path marked by standing stones. This later joins the path ascending from Nebo.

It is better to descend *to* Tal y Sarn and ascend *from* Nebo – unless one likes spending time trying to find paths that local people would seem to want everyone to forget about, or which may never have existed in the first place. Whichever way is chosen, it is infinitely easier to find one's way where man has not cluttered it with the improvements of civilization, on the tops.

Garnedd Uchaf

12. Sheet 115. Section 3 – Carneddau. MR 687669. 926 metres.

Garnedd Uchaf lies a kilometre (0.6 miles) north of Foel Grach on the central ridge of the Carneddau. It is a minor elevation with no significance other than as a link between the two Foels, Grach and Fras, and as the point at which ascents to the ridge from the coast at Aber finally end. Even as part of the ridge it has come to be neglected, with a more direct path being forged to the east of its summit, but a diversion from this path will at least avoid some of the wettest parts of the direct route.

This summit is sometimes, mistakenly, referred to as Yr Aryg, but the name properly belongs to a small rocky outcrop one kilometre to the north-west.

Garnedd Ugain – see Crib y Ddysgl

Gau Craig

66. Sheet 124. Section 8 – Cader Idris. MR 744141. 683 metres.

Gau Craig is the extreme eastern terminus of the long, north-facing escarpment of Cader Idris, and is the most prominent feature of the range in the view of travellers approaching from the direction of Bala. It presents an impressively bold front to the east, but on closer inspection is completely over-shadowed by the much higher mountain, Mynydd Moel, further west.

From Mynydd Moel it is a short descending ridge walk to reach Gau Craig, keeping until the last moment the splendid view down its cliffs. Ascents from the east, leaving the A487 at 756140, are described in the entry for Mynydd Moel.

Glan Hafon

118. Sheet 125. Section 10 – Berwyn Hills. MR 078274. 608 metres.

Glan Hafon lies 3 kilometres (1.9 miles) north of east of the village of Llangynog (054263), in the heart of the Berwyn Hills. It is most easily ascended from Pistyll Rhaeadr (074295), one of Wales' most famous waterfalls, at the head of Cwm Rhaeadr on the north side of the hill. A track ascends to the col between Glan Hafon and Post Gwyn to the north-west, and from the col it is an easy pull to

the summit plateau. The trig point at 607 metres does not mark the highest point. A short distance west of the trig point, across a fence, is a conspicuous rocky outcrop, and beyond this a fence continues between two more smaller outcrops. The outcrop on the north of the fence is the highest point of this plateau and could easily be missed in cloudy conditions.

An alternative ascent can be made, without too much difficulty, through the *cwm* to the east of the prominent Craig Rhiwarth. A good track leads into the *cwm* from the road at 066263, but it is not clear in the upper reaches.

Glasgwm
39. Sheets 124 and 125. Section 9 – Arans. MR 837194. 780 metres.

Glasgwm is high, wide and handsome, being a summit of great bulk, with its highest point adorned by a magnificent cairn and two peaceful lakes, Llyn y Fign and Llyn Bach. The eastern slopes end in impressive crags, the most famous of which, Craig Cwm Cywarch, is not only the rock-climbers' playground which has given rise to so much access difficulty in the Arans generally, but also the scene, within the last hundred years, of one local inhabitant's attempt to fly.

From Cwm Cywarch there is a right of way over the main ridge coming down from the high Aran summits to Rhydymain. This ascends beneath Craig Cwm Cywarch, and from the highest point of the path it is possible to follow a new fence-line upwards, steeply, to the summit. This diversion from the path is not a right of way.

Glyder Fach
6. Sheet 115. Section 2 – Glyders. MR 656583. 990 metres.

Looking across from the summit of Glyder Fawr, it is difficult to believe that Glyder Fach is 5 metres lower; indeed it is a hard fact to accept from any vantage point for the lesser summit is in many ways a superior mountain. From Nant Ffrancon it is Glyder Fach which is the more prominent in view, while from the Snowdon range the eye is drawn not to the nearer Glyder Fawr but to the more distant Glyder Fach with its strange configuration of up-turned rocks, the Castell y Gwynt, the *Castle of the Winds*, which

dominates the col between the two Glyders – Bwlch y Ddwy Glyder – as if barring entrance to the sanctuary of the lower mountain.

The summit of Glyder Fach, to which Thomas Pennant climbed in 1781, has an unreal, artificial feel about it. On the highest part of a large summit plateau, not dissimilar to the summit of Glyder Fawr, someone, it seems, has tipped an enormous load of broken rocks. They form two piles: one, the actual summit, is difficult to ascend and surprisingly easy to miss completely in mist since the path passes not over its top but along its northern flank. The other pile sports the famous cantilever, still exactly as described by Pennant two hundred years ago: 'The tops are frequently crowned in the strangest manner with other stones lying on them horizontally. One was about twenty-five feet long and six broad. I climbed up, and on stamping it with my foot felt a strong

Castell y Gwynt (Glyders)

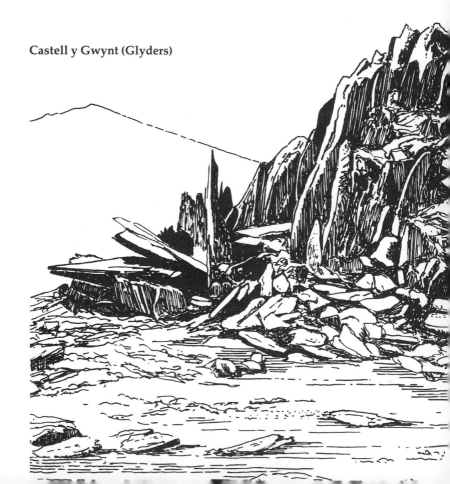

tremulous motion from end to end.' Pennant may well have been the first of a long line of travellers who have stepped warily out to the very end of the cantilever and jumped up and down to feel the slight but solid response.

If the strange summit of Glyder Fach gives pleasure, the normal ways to it will be found equally enjoyable. Three routes are especially popular. All three start at the Ogwen Outdoor Pursuits Centre (651603) and follow the path leading to the Idwal Nature Reserve until, as it turns sharply right towards Idwal, it can be left and a direct line taken to the conspicuous track ascending beside the falls from Llyn Bochlwyd. From here one route, by the ridge known as Y Gribin, is described in the entry for Glyder Fawr. This is an airy walk, on grass to start but turning to rock at the top, where care is needed, and ends at a large cairn on the edge of a plateau a short distance west of the Castell y Gwynt. The Castell

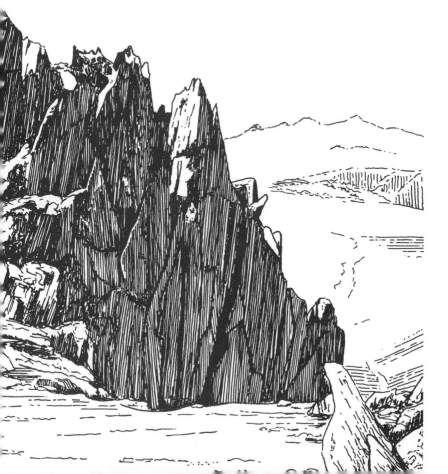

can safely be scrambled across, and from the other side a track followed to the summit of Glyder Fach. To avoid the Castell it is necessary to pass it on its southern side, which entails a slight loss of height and re-ascent, but the way is now well trodden.

The two other routes both ascend together the Miners' Track to Bwlch Tryfan, which eventually leads to Penygwryd. The track continues quite clearly from Bwlch Tryfan, across the head of Cwm Tryfan, until it scrambles to a plateau near Llyn Caseg-fraith, the *Lake of the Piebald Mare*. The line of the track is not always clear across the plateau, but for the ascent of Glyder Fach it is not needed. From the plateau an ascending line due west rims around the edge of Cwm Tryfan until a direct line can be taken to the summit.

As an alternative way from Bwlch Tryfan, those who enjoy scrambling *par excellence* will find the Bristly Ridge the best of all the ascents to Glyder Fach. On the east side of the wall at the *bwlch* a track ascends through rocks and leads up a short final scree slope to the foot of the cliffs at an obvious gully. The gully starts the ascent of the Bristly Ridge, and the route thereafter is obvious from the passage of countless thousands' boots. The Bristly Ridge ends a mere five minutes from the summit. The long screes to the east of the Bristly Ridge, although an alternative for those who do not enjoy scrambling, are better in descent than ascent.

There is yet another way to Glyder Fach which for the photographer is quite simply magnificent. Even so, it is only infrequently used. It is by the ridge which starts at Gwern Gof Isaf Farm (685602) on the A5 and ascends to Llyn Caseg-fraith, where it joins the route from across Cwm Tryfan described above. The ridge is a series of grassy ledges interspersed with rocky outcrops, and steepens just before reaching the plateau and the lake. The interest for the photographer is never in doubt, for across the hollow of Cwm Tryfan the precipices of the mountain itself rise majestically from the valley floor, a view which on a clear and still day can be doubly pleasurable by virtue of the images reflected in the pools of Llyn Caseg-fraith.

Glyder Fach can also be ascended from the south by the track which leaves the A4086 near the Pen y Gwryd Hotel (661559) – The Miners' Track – until, as the ground levels, a diversion west leads to the summit.

Glyder Fawr
5. Sheet 115. Section 2 – Glyders. MR 642579. 999 metres.

Glyder Fawr may be higher by 5 metres than its companion, Glyder Fach, but it is the lesser summit – less in height only – which receives all the attention, all the eloquent prose of writers as far back as Thomas Pennant, who ascended the Glyders in 1781. Even Esme Firbank, now Esme Kirby (Chairman of the Snowdonia National Park Society), who lives at Dyffryn Mymbyr on the lower slopes of the Glyders, and whose farming experiences were excellently related by her first husband, Thomas, in the best-selling book *I Bought a Mountain*, comments that 'the rounded shaley sides of the big Glyder cannot compare with the little Glyder's dramatic summit.' Much of the attention is justified; Glyder Fach *is* in many ways more impressive than Glyder Fawr, but this highest top of the whole range is not without its own charms; they are simply more elusive, more susceptible for their full appreciation to the vagaries of the weather.

Perhaps too there is less popularity for Glyder Fawr because it is more difficult to reach; it cannot be seen to good advantage from any direction, save from the mountains of the Snowdon range, nor is it encircled like its neighbour by a variety of interesting and spectacular lines of ascent. Glyder Fawr is simply a big mountain, and though the nearest point on a road is only 2 kilometres (just over one mile) away in the Pass of Llanberis, any route to or from it from this direction is completely out of bounds to the ordinary walker. The slopes down to the Pass meet the road in a formidable array of rock-climbing cliffs of the utmost severity – Dinas Gromlech (one of the first cliffs with climbs formerly graded 'Exceptionally Severe'), Carreg Wastad, Clogwyn y Grochan, Craig Ddu and Craig Nant Peris – through which it is virtually impossible to find a safe and comfortable way.

But there are ways to this summit which have an attraction, especially if solitude and ruggedness are sufficient compensation for effort. There are four, and three of them start in the Ogwen valley at the Outdoor Pursuits Centre (651603). All three take the new track leading to the Cwm Idwal Nature Reserve which now ascends behind the Youth Hostel and joins the original track just after the initial steepness.

The first of these three routes is more frequently used as the means of descent from Glyder Fawr, and passes into the recesses

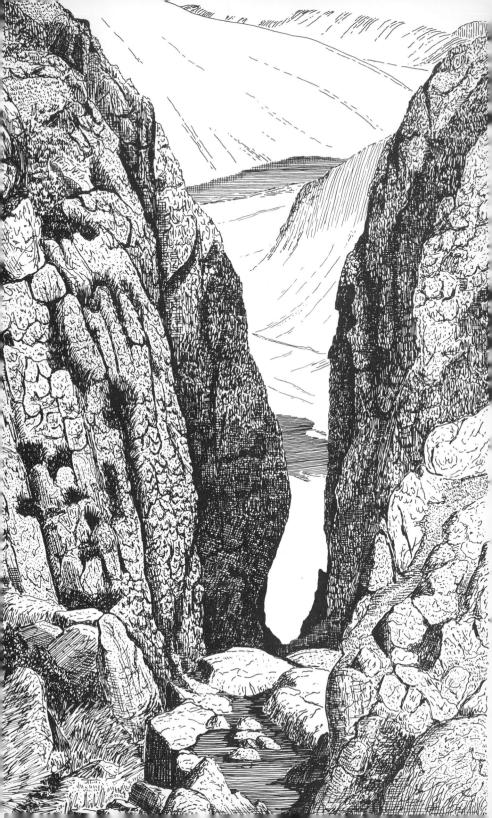

of Cwm Idwal by the well-worn path that leads to the Idwal Slabs. Beyond the Slabs the path, in places resembling a man-made staircase, climbs to the foot of the debris spilling from the cliffs of the east side of the enormous black chasm known as Twll Du, the *Black Hole*. Twll Du is frequently, and mistakenly, referred to as the Devil's Kitchen, which, more accurately, is the name for the whole of this vast amphitheatre. Various notions have been put forward to explain this name, but the one generally accepted is attributed to sailors, who, passing by out at sea, gazed landward, saw the immense black cliffs of Glyder Fach and the swirling mist and likened it to the Devil's Kitchen. Twll Du itself, both the bottom and top of which can be reached with ease, is not a place for the walker, though the view from the top to Llyn Idwal and Llyn Ogwen is without doubt one of the finest views in the whole of Snowdonia.

A track ascends along the base of the cliffs to the east of Twll Du, becoming more distinct with height. This leads directly to a lake, Llyn y Cwn, the *Lake of the Dogs*, one of the most peaceful and relaxing spots in the Glyders, and so named from the tradition of hunting in this area. To the east of Llyn y Cwn the bulk of Glyder Fawr ascends steeply up a slope which in winter could be lethal to anyone without proper equipment and the knowledge to use it. Even on the most perfect of days the slope requires caution and a good deal of effort before the long line of cairns leading to the castellated summit of Glyder Fawr is reached. Descending by this route in mist can be hazardous since the line of cairns in the vicinity of the summit is not obvious and later changes direction. If it is essential to descend this way in mist, it is safer to keep slightly east of a direct line between the summit and Llyn y Cwn in order to avoid the cliffs which fall steeply above the lake.

The second approach to Glyder Fawr is not for the weak-hearted, physically or mentally, and involves a little airy scrambling. From the foot of the Idwal Slabs a broken path ascends steeply beneath the East Wall of the Slabs to a gully normally used as one of the descents from the Slabs. This gully, or the steep grassy slopes before it, leads into Cwm Cneifion, the *Nameless Cwm*, where the scenery is one of impressive crags and ridges. The upper part of the *cwm* is a steep slope, which in winter gives excellent climbing. This leads on to the summit plateau of Glyder Fawr halfway between the summit and Castell y Gwynt, the

107

Castle of the Winds. From here it is a simple stroll to the top.

The last of the routes from Ogwen takes the popular ridge called Y Gribin. This ridge is most easily reached by ascending beside the falls issuing from Llyn Bochlwyd until it is possible to move right to the foot of the ridge. The lower part of the ridge is grassy but becomes rocky higher up and requires care. The view, particularly to the left as one ascends, is very impressive and shows the shattered cliffs of Glyder Fach and the Castell y Gwynt in great detail. This ridge, the top of which is marked by a large cairn, is a safe and easy way down in mist once the upper rocky section has been negotiated.

The fourth approach to Glyder Fawr, and without doubt technically the easiest, ascends from the south either from the top of the Pass of Llanberis by a route which climbs steeply behind the Youth Hostel (647556) until the slopes leading to the summit can be reached, or from the Pen y Gwryd Hotel (661559). A stile a short distance to the north of the hotel leads to a path which crosses the outflow from Llyn Cwm y Ffynnon. Go towards the lake, avoiding the temptation of the more obvious path (the Miners' Track) which ascends to the right and leads eventually across to Cwm Tryfan, and ascend instead by the stream coming down from the wide opening ahead, Heather Gully. The going by either of these routes is rough but not so steep as it seems. It is certainly of greater simplicity than any of the other routes described, but lacks a lot of the interest. It is also highly unlikely that anyone else will be encountered along this route.

Godor
68. Sheet 125. Section 10 – Berwyn Hills. MR 094308. 679 metres.

Godor is little more than a squat grassy lump on a bifurcated ridge extending south-eastwards from Cadair Berwyn. It is not as high as the top of the ridge due west of it, but it does have a little more re-ascent and is more prominent when seen from the main Berwyn ridge.

It can be reached from almost every point of the compass, requiring only steady uphill plodding and avoidance of the wettest areas, but is of little interest. If included as a circuit of the main hills, starting and finishing at Tyn y Ffridd (117308) and travelling anti-clockwise, Godor is an easy end to the day.

Gwaun y Llwyni

65. Sheets 124 and 125. Section 9 – Arans. MR 857205.
685 metres.

Gwaun y Llwyni is not named on the 1:50,000 map but is the wedge-shaped summit a little over 2 kilometres (1.3 miles) south of Aran Fawddwy. It presents an imposing front of rock, scree and bracken to the trough of Hengwm leading into Cwm Cywarch.

An ascent can be made from the bridge in Cwm Cywarch (853187) by the route across the slopes of Pen yr Allt Uchaf described in the entry for Aran Fawddwy, part of the agreed access route to the Arans. Once the minor top of Drws Bach has been reached, a down-and-up walk around the edge of the drop into Hengwm will lead direct to the summit. There is a narrow path around this edge but it is not a right of way. The summit, crossed by a dilapidated fence, is marked by a small slate cairn.

It is possible to ascend to or descend from the col between Drws Bach and Gwaun y Llwyni by an obvious path through the valley of Hengwm.

Llechwedd Du

110. Sheets 124 and 125. Section 9 – Arans. MR 894224.
614 metres.

The *Black Hillside*, Llechwedd Du, is possibly the easiest summit to reach in the whole of Snowdonia, involving little more than 65 metres of ascent in a distance of 2 kilometres (1.25 miles). The route to it, however, from Bwlch y Groes (913233) at the top of the road through Cwm Cynllwyd, is trackless, tussocky and very wet. From this direction, as from the north, the unmarked summit can be found safely in mist by following a fence-line, though care needs to be taken where fences meet. The highest point, where the fence across the summit turns north, is probably the peaty top-knot nearby.

By comparison with its northern and eastern slopes, the southern and western aspects of Llechwedd Du are extremely steep and in places scarred by shattered cliff faces.

Llwytmor

24. Sheet 115. Section 3 – Carneddau. MR 689692. 849 metres.

Llwytmor is an insignificant grassy lump lying on a broad ridge extending north-westwards from the summit of Foel Fras on the main Carneddau ridge. It can be ascended, though not without some effort, from above the Aber Falls where the Afon Goch plunges 60 metres into the lower valley.

A tenuous path, exhilarating in one or two places, works its way across the foot of Llwytmor to the sheltered trough above the falls. It is better to follow the trough southwards for at least one kilometre (0.6 miles) before any attempt is made to ascend to the summit. Some of the steep scree just before Aber Falls are reached can be avoided by a path through wooded plantations which leaves the normal path to the falls, starting at Bont Newydd (663720), near the stone cottage, Nant (665714). The path enters the woodland immediately behind the cottage and gradually rises to bring one out at a stile near the top of the scree.

Maesglasau

71. Sheets 124 and 125. Section 8 – Dovey. MR 823152. 674 metres.

Maesglasau is a predominantly grassy hill due west of Dinas Mawddwy, and its highest point, Maen Du, overlooks a steep northern face which breaks into crags as it curves south and east. It forms a part of a small horseshoe of hills starting in the west with Cribin Fawr and passing over Mynydd Dolgoed and a narrow grassy ridge before ascending to the summit. An ascent from this direction, starting by the route described in the entry for Cribin Fawr, gives pleasant walking with good views of the Arans to the north. It is mainly over grass, and wet in places.

An alternative approach, serving equally as well as a descent, is by a path starting behind the Dinas Mawddwy Youth Hostel at Minllyn (858141). A forest track ascends the steep hillside, finally emerging on the minor summit, Dinas, from where a walk along the forest boundary and skirting the cliffs of Craig Maesglasau leads to the summit.

A longer traverse, probably unsuspected by many walkers, and with a good deal to commend it, is possible here. The entry for Mynydd Ceiswyn gives a start from the top of Bwlch Llyn

Bach by a stile at 756138, and from here an excellent ridge walk can be made over that summit, Waun Oer, Cribin Fawr, Mynydd Dolgoed and finally to Maesglasau, descending to the Youth Hostel; about 13 kilometres (8 miles).

Manod Mawr

82. Sheet 124. Section 5 – Ffestiniog. MR 724447. 661 metres.

Llyn y Manod, lying in an elongated hollow between Manod Mawr and the lower Manod Bach, is an effective deterrent in good weather against the ascent of the higher, or either, mountain, both of which seem to rise interminably above the lake. Walkers reaching the shores of the lake, from where the scars of quarry workings are not so easily seen, will find ample temptation to spend the rest of the day there. It is, amid the ravaged hills of Ffestiniog, an oasis of tranquillity.

To reach the lake, which will not deter the more resolute walkers, it is necessary to start at the southern end of Blaenau Ffestiniog, along a secondary road at the junction of the A470 and the A496 where there is a small car-park (705444). The road passes some cottages before reaching a gate, after which it degenerates into a farm track. In a short distance, just before the farm buildings are reached, the path to Manod forks left and crosses a small stream. Manod Bach, on the left, appears much higher than it is. Follow the true left bank of the stream until, at the top of the field through which it flows, it is possible to ascend, right, by a wall into a higher pasture. Once across the pasture a fence climbs to a gate near the lake; there is no need to risk damaging the fence by crossing it lower down.

To continue to Manod Mawr there is a choice of either following the obvious track across the bottom of the hillside and then doubling back from the col to the summit, or testing one's stamina up the conspicuous quartz diretissima. The summit trig point is locked in a circle of stones and a garden of nettles, and lies just outside the boundary of the Snowdonia National Park.

Moel Cynghorion

72. Sheet 115. Section 1 – Eilio. MR 586564. 674 metres.

Moel Cynghorion, the *Hill of the Councillors*, when viewed from the Llanberis Path to Snowdon is a rugged mountain. It lies at the

southern end of a group of four hills, all of them grassy domes, a few kilometres north-west of Wales' highest mountain, and is an excellent vantage point for the black severity of nearby Clogwyn du'r Arddu, the rock-climbing cliff which figured largely in the development of the sport at its highest standards.

On parts of its northern side Moel Cynghorion is craggy, giving it its rugged appearance, but elsewhere it is a sham of rounded grassy shoulders, with a large, flat summit in the middle of which there is a small cairn.

It is usual to include Moel Cynghorion in a traverse of all four hills, starting from Llanberis and ascending to Moel Eilio first, finally descending from Moel Cynghorion by its steep northern slopes to Helfa (583574). From Helfa there is an easy return to Llanberis by the metalled road leading to Hafotty Newydd.

Between Moel Cynghorion and Clogwyn du'r Arddu lies Bwlch Cwm Brwynog to which the Snowdon Ranger Path ascends from Llyn Cwellyn. It is possible to divert here from the Path and reach the summit by an uphill plod.

Moel Druman
70. Sheet 115. Section 5 – Moelwyns. MR 671476. 676 metres.

Moel Druman is the centre of a horseshoe ridge of mountains enclosing the wide *cwm*, Cwm Fynhadog Uchaf, which (unnamed on the 1:50,000 map) lies south-west of Dolwyddelan. The ridge extends from Yr Arddu at its north-western end to the Crimea Pass in the east, and includes *en route* the two summits of Ysgafell Wen, Moel Druman and Allt Fawr. The Crimea Pass, well known locally, is not identified on the maps but is the highest point of the A470 on its journey between Dolwyddelan and Blaenau Ffestiniog, coinciding with the Snowdonia National Park Boundary as does Moel Druman.

Its location in the centre of the ridge makes Moel Druman an awkward summit to get at, but it can be reached from Tan y Grisiau (687451) by the path through Cwmorthin to the Rhosydd Quarry described in the entry for Allt Fawr.

The complete traverse of the ridge can only be accomplished if there is no need to return to the starting point, or, omitting Yr Arddu, by including it in a long walk over Cnicht from Croesor, finishing on Moelwyn Bach. Such a walk, which would give eight summits in all – Cnicht, Ysgafell Wen (2), Moel Druman, Allt

Fawr, Moel yr Hydd, Moelwyn Mawr and Moelwyn Bach – plus the craggy minor summit, Craig Ysgafn, requires at least eight hours but is a tremendously rewarding day.

Moel Eilio

51. Sheet 115. Section 1 – Eilio. MR 556577. 726 metres.

George Borrow considered Moel Eilio to be 'a noble hill', viewed as he journeyed from Caernarvon to Beddgelert. It is, however, better viewed from the popular Llanberis Path to Snowdon from which the red screes tumbling from the summit are seen particularly well. It lies in a small range of four hills north of Snowdon, all of them grassy domes, and the easiest ascent to it is by the northern ridge, which extends down to Bwlch y Groes (556598). This can be reached by road from Groeslon (526601), near Waun Fawr.

A better way, allowing an entertaining circuit to be made, is to leave Llanberis by the road leading to the Youth Hostel and to ascend to the north-east ridge beneath which lies sparkling Llyn Dwythwch. A new fence ascends the north-east ridge to the summit, the highest point of which is marked by a large round stone shelter. It is an easy matter to continue on a faint path across the complete range of hills, but the summit of Moel Eilio lies well back from the edge of its plateau, precluding onward views, and a compass bearing is more helpful than a nearby line of stones which head off in the wrong direction. A descending path, through a hole in a wall, leads eventually and without undue difficulty over the two tops of Foel Gron, and Foel Goch to a steep descent before the final climb to Moel Cynghorion. From this last hill a descent, steeply, northwards leads to the ruins of Helfa (583574), and from there a bridge across the Afon Arddu gives access to the metalled roadway, and so back to Llanberis, ending opposite the Royal Victoria Hotel.

Walkers ascending Moel Eilio from the south at Nant y Betws will find it easiest to follow the Snowdon Ranger Path to Bwlch Cwm Brwynog, and to make first for Moel Cynghorion, reversing the route described above. The return to Nant y Betws from Moel Eilio is simply a case of following the ridge back to the final col, between Moel Eilio and Foel Gron, and descending from there to the road near the northern end of Llyn Cwellyn.

Moel Fferna

96. Sheet 125. Section 10 – Berwyn Hills. MR 116398. 630 metres.

Moel Fferna is the most northerly of the Berwyn Hills and lies 5 kilometres (3 miles) south-east of the town of Corwen. The hill is densely covered with heather, and these are obviously well-used grouse moors calling for caution and consideration in season. To the south lie the main Berwyn Hills peering over the un-named summit just north of the old pass from the valley of the Dee to Llanarmon Dyffryn Ceiriog. An approach from this direction is simply a case of finding one's way through the heather along the highest ground, but there is little of interest.

There are other routes to Moel Fferna from a number of directions, but that most commonly used starts at Llidiart y Parc (119433) on the A5, 4 kilometres (2.5 miles) east of Corwen. Directly opposite the B5437 two lanes leave the A5; the right-hand lane should be followed until a stream is reached, and then a track, on the left, will lead to the path marked on the map. This is difficult to follow in places but heads for a cleared area of old forest which has been re-planted, and from there to the forest boundary. The summit of Moel Fferna can be seen ahead and is easily reached by a good path which only needs to be left just below the summit of the hill. A faint land-rover track runs from there to the trig point on the summit.

A return can be made by heading for the quarry at 126398, and then along the lane through Nant y Pandy until a path, left, leads to Carrog (128429). The path shown on the map to the north-west of Moel Fferna, and which crosses Foel y Gwynt, is not recommended. It is not a clearly defined path and can be difficult to locate in mist.

Moel Hebog

38. Sheet 115. Section 4 – Hebog. MR 565469. 783 metres.

Moel Hebog, the *Hill of the Hawk*, dominates Beddgelert, more so than nearby Snowdon, yet for many walkers Snowdon is the main reason for visiting this stone grey village at the confluence of the Afon Glaslyn and the Afon Colwyn. Regrettably, because it is a fine mountain to climb, Moel Hebog no longer enjoys the popularity it once did, when people walked from as far away as Criccieth to enjoy the views it offers. Nowadays bigger and

higher seem synonymous with better and more enjoyable, and so most boots turn their heels to Hebog's rugged shape.

Walkers seeking hills away from the popular scene will, however, find much reward in taking to Moel Hebog. The customary approach, from Beddgelert, starts alongside the northern gable of the Royal Goat Hotel and climbs through a small, modern housing development. The apparent intrusion of hill-walkers into the midst of a housing estate, though walkers were there long before the houses, instills an out-of-place feeling and an inclination to take quickly to the nearest field which must be resisted. A pedestrian way-marker between the houses at the highest part of the estate is not conspicuous but shows the way to a bridge over the disused Welsh Highland Railway, and then to a walled path leading into more comfortable surroundings. The way thereafter is generally marked by stiles until, at 581478, a boggy path crosses a field to the broad ridge descending from the summit. This ridge is the normal line of ascent, leading through rockier ground to the top of Diffwys, the prominent cliff facing north-east to Snowdon.

There is something unreal about the view of Yr Aran and Snowdon which opens up as the ascent is made of Moel Hebog. It is actually nothing more than the fact that it is a view not commonly seen, but it conveys the impression that one is looking at a completely new range of hills. The view across Aberglaslyn, however, is familiar enough, with Cnicht, the Moelwyns and their outlying hills restricting views any further south.

The summit of Moel Hebog is marked by a trig point near a stone wall. The wall descends north-westwards to Bwlch Meillionen, to which it is possible to ascend from Cwm Pennant, so gaining the mountain from the west. This way, starting near Cwri-isaf (540464) and following the course of the Afon Cwm-llefrith, though having the advantage of beginning in one of the most beautiful valleys of North Wales, has none of the ruggedly attractive features of the ascent from Beddgelert.

The ridge south and then south-west has no special attraction other than as an easy line of descent to Llyn Cwmstradllyn, but there are so many walls to cross that it is better to avoid this route.

Moel Lefn
92. Sheet 115. Section 4 – Hebog. MR 553485. 638 metres.

Moel Lefn is the most northerly of the three hills along the west side of Nant Colwyn, the valley extending from Beddgelert to Caernarvon, and down which George Borrow travelled on his journey through 'Wild Wales'. North of the summit this line of hills is separated from the splendid walking country of the Nantlle ridge by a narrow pass, Bwlch y Ddwy Elor, the *Pass of the Two Biers*, signifying that this is an old corpse road from Cwm Pennant to Rhyd Ddu. This route may still be used, though hopefully no longer as a way of the dead, by walkers ascending Moel Lefn from Rhyd Ddu. The way from Rhyd Ddu is as marked on the map, leaving the B4418 at 566526 and taking a way-marked route towards the obvious low point on the skyline. At the top of the pass is a heathery hill, Y Gyrn (553501), which should be passed around before ascending steeply through rocks to the summit, with an optional diversion *en route* up some scrambly slabs.

Walkers descending from Moel Lefn to return to Beddgelert should head for the corner of the forest which lies due south of Y Gyrn, noting that Y Gyrn is not named on the 1:50,000 map. Through the forest there is a path leading on to forest roads. The path is obvious enough, but the forest roads are not exactly as marked on the map and can lead to confusion. A general down-hill trend is the safest way here, making for the camp site at 576491. At the camp site a track southwards will lead back to Beddgelert; alternatively the A4085 can be reached simply by leaving the camp site by its main entrance. This puts one on the main road 1.5 kilometres (1 mile) from Beddgelert.

Moel Llyfnant
45. Sheets 124 and 125. Section 7 – Arenigs. MR 808352. 751 metres.

Moel Llyfnant, attached to the higher Arenig Fawr by a broad col of marshy ground, is an excellent vantage point; it also has the advantage of being infrequently visited. To the west, between Moel Llyfnant and the lower summit of Foel Boeth, lies the quiet valley of the Lliw, whose waters rush south and east to Bala Lake. The Lliw valley is a pass into this wild, mountainous region once

116

used by the Romans in making the road which linked their fort near Ffestiniog, Tomen y Mur, with that at Caer Gai at the head of Bala Lake.

The shortest ascent of Moel Llyfnant simply climbs upwards over grass and bog from the minor road at 806335, though there is little to commend this way. A better way is to link Moel Llyfnant with an ascent of Arenig Fawr, crossing the marshy col, from where, if one is travelling towards Moel Llyfnant, it is a short upwards walk to the fence which crosses the summit plateau, the highest point of which is marked by a cairn.

For walkers who want to make for Moel Llyfnant alone, however, a start is recommended from Nant Ddu on the A4212 at 806385. A track leads to Amnodd Bwll (810369) from where the broad north shoulder can be gained, or an indistinct path followed to the marshy col with Arenig Fawr and an ascent made from there.

Moel Meirch
119. Sheet 115. Section 5 – Moelwyns. MR 661504. 607 metres.

Moel Meirch lies in an area of wild and rugged beauty on the southern side of Nant Gwynant. It is an area not unlike the Rhinogs, with undulating ground, knuckles of rock outcropping everywhere, and numerous small lakes and streams fed by largely marshy ground. It makes a perfect training ground for map and compass work, especially in mist.

Although it is possible to reach Moel Meirch by a footpath from the A498, near Pont Hafod Rhisgl (657527), climbing first to Bwlch Ehediad and then over the lower top, Cerrig Cochion, there is a better alternative. This starts along the single-track road which leaves the A498 shortly after the Bethania Bridge at 626503. It is possible to park at a few places along the minor road, but it is less intrusive to use the car-park near the Bethania Bridge, normally used by walkers heading for Snowdon by the Watkin Path, and where there are toilets. The road ascends gradually for 1.5 kilometres (about one mile) until, at a sharp right turn, a descending farm track can be taken to Hafodydd Brithion (640494). Careful map-reading will show that the footpath signposted at the right turn in the road is not the one to take for Moel Meirch.

At Hafodydd Brithion the path is way-marked – Llyn Edno – but even so the route is not immediately obvious. The objective is

the general vicinity of Llyn Edno, and the way passes through the conspicuous rocky gorge down which cascades the Afon Llynedno. It is an interesting walk, closer to the edge of the stream than the maps suggest, sometimes, to make progress, actually on rocks in the middle of the stream, and later, whenever the torrent permits, actually crossing it. Moel Meirch appears on the left skyline, opposite impressive pinnacles of rock which guard Llyn Edno, and beneath which a path leads to the watershed and an old iron fence. The fence-line leads towards Moel Meirch but does not ascend to the summit. To shorten the distance the summit can be tackled once the rather more level ground at the top of the Afon Llynedno is reached. This entails working a rough way through a maze of outcrops, with up being the safest way in doubt.

The watershed fence-line continues south in the direction of Ysgafell Wen: it is a guide in mist but keeps just to the east of the highest ground.

Moel Penamnen
104. Sheet 115. Section 5 – Ffestiniog. MR 716483. 623 metres.

This summit lies to the north-east of Blaenau Ffestiniog in a little-visited area of heather and bog which makes its capture more of an academic exercise than a search for beauty and pastoral reflection.

The shortest route is by a shepherds' track from just below the summit of the Crimea Pass (698484) to the two lakes, Llynnau Barlwyd. From the lakes it is easier to gain the ridge, north, marked by a fence-line, until higher up the fence changes direction away from the summit, leaving a short walk south across the top of a craggy rim to the small slate cairn which marks the highest point.

The inclusion of Moel Penamnen in a walk from Manod Mawr takes one through wet, heathery ground with few sheep tracks, and is not recommended, especially in summer, when the area is infested with flies of the persistent variety.

Moel Siabod

20. Sheet 115. Section 5 – Siabod. MR 705546. 872 metres.

Lying so close to higher and more extensive ranges of mountains, and having the disadvantage that it is an isolated mountain virtually incapable of being linked with any other, Moel Siabod might well be expected to be neglected, but it is not. Its popularity is not only that it commands the whole of the south side of Nantgwryd, probably better known as the Dyffryn valley, but also the striking profile it presents to travellers along the road to Capel Curig from the direction of Betws y Coed: it is a captivating image, compelling attention.

H. R. C. Carr in *The Mountains of Snowdonia* comments on the fact that Moel Siabod may be ascended from Capel Curig – a route described below – but prefers 'to traverse it on the way over from Dolwyddelan to Pen y Gwryd' even though he admits there is plenty of bogland. It is through this valley, beyond the Roman Bridge Station, that the legendary monster – the *avangc* – was drawn, secured by chains, by a pair of oxen, to be dumped in Glaslyn below Snowdon's summit – see entry for Yr Wyddfa. This fabulous caravan crossed to Pen y Gwryd over the pass between Moel Siabod and Y Cribau, now named Bwlch Rhiw yr Ychain, the *Pass of the Hill of the Oxen*. Such was the strain for the oxen, so the legend tells us, that one of them lost an eye in a field, now known as Gwaun Lygad yr Ych, the *Field of the Ox's Eye*, and its tears formed a pool, Pwll Lygad yr Ych, which allegedly never dries up, though there is no stream flowing either into it or out of it.

Normally Moel Siabod is ascended from Pont Cyfyng (734572), near Capel Curig, where the Afon Llugwy cascades through a mass of huge rocks. Once across the bridge the way becomes obvious, taking the second turning on the right and then climbing by a quarry road to the main ascending ridge. Instead of going immediately for the ridge, it is possible to continue ahead to Llyn y Foel and then to ascend to the summit by the short ridge of Daear Ddu, not named on the 1:50,000 map, but obvious. Whichever of these two ways is used in ascent, the other makes a satisfactory descent.

A variation start and finish may be made from Plas y Brenin (716578), by crossing the footbridge behind the centre and following a series of paths through the forest to Pont Cyfyng, and then

119

ascending by the above routes. For a direct descent back to Plas y Brenin it is possible to head downhill from the eastern end of the rocky summit ridge, aiming for the right-hand end of Llynnau Mymbyr, a route which though pathless at first soon leads to a cairned path.

Plas y Brenin, now the National Centre for Mountain Activities, has an interesting history, having been constructed in 1800 –1801 by the Bethesda quarry owner Richard Pennant as the Capel Curig Inn to serve the tourist trade. No doubt observing the passage of his namesake Thomas Pennant, the Reverend Kingsley and others, Richard Pennant must have had keen foresight not only in anticipating George Borrow but also in catering for his taste in beer; Borrow found the inn 'a very magnificent edifice'. Seventy years after it was finished, the inn, having witnessed a procession of royalty from Queen Victoria to King George V, was renamed the Royal Hotel, and in just less than another seventy years it saw service during World War II as a training centre for mountain warfare. It became the Snowdonia National Recreation Centre in 1955, following its purchase a year earlier by the Central Council of Physical Recreation, itself now replaced by the Sports Council under whose control Plas y Brenin still remains.

Moel Sych
27. Sheet 125. Section 10 – Berwyn Hills. MR 066318. 827 metres.

On metricated maps Moel Sych, the *Dry Hill* – which it is – is no higher than nearby Cadair Berwyn, and there is a strong temptation to give Cadair Berwyn superiority over the former, especially since it gives its name to a whole range of hills and to do so would seem fitting. Alas, non-metricated maps show that Moel Sych is higher by one foot, and so stands as the highest of the twenty-one summits making up the Berwyn Hills.

Except for one third of their number, all the Berwyn Hills lie outside the Snowdonia National Park, with the principal heights, Moel Sych, Cadair Berwyn and Cadair Bronwen, forming a short escarpment facing south-east. The 'outside' hills are, however, close enough to justify inclusion along with the rest, and can still be considered in any event to be part of Snowdonia in its widest sense.

Moel Sych is most easily climbed from Milltir Cerrig at the top of the road from the village of Llangynog to Bala. At this point

(018303), where a track descends towards Llandrillo, a long grassy arm ascends north-east bearing a narrow path for 5 kilometres (3.1 miles) to a summit marked by a large pile of stones.

Directly south of the summit another broad ridge, though not as lengthy, descends steeply, bounded on its southern side by the Afon Disgynfa. It is this small river which, 2.5 kilometres (1.6 miles) south of Moel Sych, plunges vertically for 60 metres in one of Wales' best-known waterfalls, the *Pistyll Rhaeadr*. From Tan y Pistyll (075295), near the waterfall, it is possible to follow a path to Llyn Lluncaws, and from there to ascend steeply by a short ridge to Moel Sych.

It is an easy kilometre (0.6 miles) on grass to the trig point on Cadair Berwyn, and both summits can be included in a walk from the Dee valley by a route described in the entry for Cadair Bronwen. Alternatively, the three highest hills can be linked with the hills to the east forming the north and south sides of Cwm Maen Gwynedd, in a walk from Tyn y Ffridd (117308) 5 kilometres (3.1 miles) north of the village of Llanrhaeadr ym Mochnant.

Moelwyn Bach
54. Sheet 124. Section 5 – Moelwyns. MR 660437. 710 metres.

The lower of the two Moelwyns has its view northwards restricted by its higher neighbour, but in all other directions the land- and sea-scape of this part of Wales is seen to good advantage.

The normal ascent starts from the car-park in the village of Croesor (631446) and returns to and over the nearby crossroads to take a road (with gates at intervals) climbing to a small afforested area. Shortly after leaving the forest a track bears left, followed almost immediately by a less distinct path ascending the obvious west ridge of Moelwyn Bach. This path later divides, with one path going to Bwlch Stwlan on the north of the mountain, while the other continues up the ridge to the cairn on the summit. If this ridge is used to descend in mist, care should be taken to avoid the small outcrop in the upper part of the ridge which has an unexpected drop on one side.

Moelwyn Bach, however, is usually climbed in conjunction with Moelwyn Mawr at least, or with other hills in this range. A

good day's walk, for example, being one which starts over Cnicht from Croesor, and then, by routes described in the entries for the respective mountains, over Moel yr Hydd and Moelwyn Mawr. It is also possible to make a longer walk by continuing north from Cnicht to take in the two summits of Ysgafell Wen, Moel Druman and Allt Fawr, before making for Moel yr Hydd through the disused Rhosydd Quarry, and so on to the Moelwyns to finish. Such a walk would require about eight hours for the average walker, being 21 kilometres (13 miles) in length.

The ascent of Moelwyn Bach from Bwlch Stwlan, as a continuation from Moelwyn Mawr, follows a slate track, loose in its upper reaches, across Moelwyn Bach's north-east face, until a standing stone, marking the start of this route in descent, appears on the skyline. It is then a short walk north of west to the summit.

Moelwyn Mawr
40. Sheet 124. Section 5 – Moelwyns. MR 658449. 770 metres.

There is some justification for the claim that Moelwyn Mawr has the most extensive view of any of the peaks of North Wales. It is the highest summit of the surrounding group of hills, and from it the whole panorama north is of the high mountains of the Carneddau, the Glyders, and the Snowdon massif. The western horizon is filled by the sea, while east and south stretch the Berwyn Hills, the Arans, the Cader Idris range and even part of Plynlimon in Central Wales.

The easiest ascent of Moelwyn Mawr is from Croesor (631446), where there is a convenient car-park, and returns from the car-park to the nearby crossroads, continuing ahead to Pont Maesgwm (635439), shortly after which a path ascends across the Afon Maesgwm to Braich y Parc. Once this ridge has been reached, it is a simple matter to follow it to the trig point on the summit.

Both Moelwyns are summits easily attained from the village of Croesor, but unless time is short they should be included in a round of hills starting with Cnicht, and then by the disused Rhosydd Quarry to Moel yr Hydd, details of which are contained in the entries for those mountains. The continuation from Moel yr Hydd to Moelwyn Mawr makes for the prominent open quarries which occupy the plateau between the two mountains, and then climbs to the craggy rise on the ridge which extends north from

the summit of Moelwyn Mawr. At this point an alternative ascent, through Cwm Croesor, meets the north ridge and follows a line of small standing stones along the upper part of the ridge to the summit.

In mist it is tempting to think that the obvious ridge leading on from the summit is the way to Moelwyn Bach; it is not. The continuation, following another line of small standing stones which look too frail to remain in place for any length of time, is in quite the opposite direction and leads steeply down a series of rock steps to the intermediate craggy top, Craig Ysgafn, before dropping again to Bwlch Stwlan.

Moel y Cerrig Duon
101. Sheet 125. Section 10 – Cwm Cynllwyd. MR 923242. 625 metres.

Moel y Cerrig Duon is a domed, grassy hill along the eastern side of Cwm Cynllwyd south of Bala Lake, and should present no difficulty to the average walker.

The easiest ascent is from the top of the road through the *cwm*, at Bwlch y Groes (913242), where there is room to park. From here a fence-line ascends an easy slope until it joins the broad south-west ridge of the mountain where a left turn, north-east, following the fence all the way, leads to the summit cairn. There is no continuous path along this route, and no right of way, but an ascent along the north side of the fence will avoid having to cross fences higher up.

An alternative ascent can be made from just south of Craig yr Ogof, the conspicuous rock and scree slope near the top of the *cwm*, from where a footpath (marked on the map) ascends to below the summit and continues across into the valley leading down to Lake Vyrnwy. There is slightly more ascent involved in this route, and the ground rather wetter, but there is little difficulty, and not much of interest for the walker.

Moel yr Hydd
89. Sheet 115. Section 5 – Moelwyns. MR 672454. 648 metres.

In spite of the industrial dereliction which surrounds it, Moel yr Hydd, the *Hill of the Stag*, is an attractive mountain. It is sufficiently far from its nearest, and higher, neighbour, Moelwyn Mawr,

not to be dominated by it, and is seen to good advantage both from Moelwyn Bach, to which it displays steep cliffs, and from the path descending to the Rhosydd Quarry from the ridge north of Cnicht.

The best way to appreciate Moel yr Hydd is to include it in a round of Cnicht and the Moelwyns from Croesor. This approach saves until the very last moment the sudden tremendous views over Cwmorthin, Ffestiniog and the Tan y Grisiau and Trawsfynydd hydro-electric monstrosities. The summit is small and neat with a number of rocky outcrops, any one of which could be the highest point. The approach from Cnicht, especially in mist, requires some care in navigation until the quarry is reached. From the quarry a slate ramp, near an old and wet underground entrance, can be followed to the upper levels from where Moel yr Hydd is reached easily.

The Rhosydd Quarry ceased working in the 1920s, and though it still intrudes in an otherwise wild and beautiful landscape, one can hope that some day nature will take it all back.

> High
> among encircling hills
> whose hearts you tore for gain
> Remnants
> gaunt and grey still stand
> their walls hard
> against the changing hand
> Time
> slowly taking back, concealing
> what you stole, or left behind
> to scar this once proud land
> Time
> will bring only lovers of the hills
> to pass peacefully in your forgotten midst.

Moel yr Hydd may also be reached from Tan y Grisiau (687451) by a path which ascends across its craggy southern face to the *bwlch* between Moel yr Hydd and Moelwyn Mawr, from where it is a short walk uphill, east, to the summit. This path starts at Pant y Friog (683454), a little way beyond the end of the metalled roadway leading from Tan y Grisiau.

An alternative route from Tan y Grisiau to the quarry is described in the entry for Allt Fawr, and passes through Cwmorthin before climbing amid piles of slate waste.

Moel yr Ogof
85. Sheet 115. Section 4 – Hebog. MR 556478. 655 metres.

Moel yr Ogof, the *Hill of the Cave*, though for many centuries known by this name, has only recently come to be acknowledged by the Ordnance Survey. It commemorates the ubiquitous Owain Glyndwr who was compelled to seek refuge in a cave, still to be found, on the eastern flank of the mountain.

This summit lies north-west of Moel Hebog, being the middle of three hills (the other, most northerly, is Moel Lefn) which form the downward stroke of a T-shaped group of hills having its northern extremity marked by the declivity of the Nantlle valley. It is a small, compact mountain with interesting rocky outcrops on its summit among which fossils may still be found, confirming that this area was once completely under the sea. Normally it is included in a traverse of all three hills, the continuation to either of which is direct and presents no problems.

The ascent to Owain Glyndwr's cave is signposted through the Beddgelert Forest and climbs through Cwm Meillionen.

Moel Ysgafarnogod
102. Sheet 124. Section 6 – Rhinogs. MR 658346. 623 metres.

Moel Ysgafarnogod is the northernmost summit of the Rhinog range and lies amid a mess of crag and bog, scattered pools and old tracks. If inaccessibility and the difficulties of progress were measured on a scale of one to ten, Moel Ysgafarnogod would score fifteen! Patrick Monkhouse in his book *On Foot in North Wales* describes the possibility of walkers continuing north from Rhinog Fawr along the remaining part of the ridge. He sums up the difficulties in one sentence: 'They will eventually arrive at Maentwrog, but I would not care to say when.' The northern part of the range is no less typical than the rest in its haphazard distribution of crags and heather-concealed boulders, and in its tracklessness.

If there is an easy ascent at all, it is that which leaves the A470 just south of Trawsfynydd at Cefn Gallt y Cwm (711346). The minor road is followed to Cefn Clawdd (679337) from where a track ascends to below the summit. The choice of ways upwards then depends on one's energy. This is not a particularly interesting way.

A better choice starts at 654396 and takes the road leading first to the falls of Rhaeadr Du and then to Llyn Trawsfynydd. From there it is possible to gain the north ridge and, over Diffwys and Foel Penolau, the summit.

From the car-park in Cwm Bychan a way-marked path (white arrows) ascends diagonally across the southern bracken-covered slopes of Clip, from which it is possible to join the main ridge and continue north to Moel Ysgafarnogod. The whole northern section of the ridge, between Moel Ysgafarnogod and Rhinog Fawr, is 6 kilometres (3.75 miles) of the most testing walking to be found in Britain.

Mynydd Ceiswyn
122. Sheet 124. Section 8 – Dovey. MR 773139. 604 metres.

Mynydd Ceiswyn is the most southerly of a small group of hills on the northern edge of the Dovey Forest, and is the introduction to an excellent short excursion along an undulating grassy ridge. The whole area is due east of the Cader Idris massif and gives excellent views of the impressive crags of Gau Craig and the higher bulk of Mynydd Moel beyond.

There is a large car-park at the top of Bwlch Llyn Bach (753136) below the towering rocks of Craig y Llam. These cliffs originate geologically in the area now occupied by Tal y Llyn lake and were forced to their present position by the upheaval that created the Bala fault.

From the car-park it is a short walk to a stile at 756138 from where a slate path ascends a hollow gully and leads to a small, marshy plateau. This is an old public footpath across the hills to Cwm Ratgoed, ascending, indistinctly, by the true left bank of the stream flowing in to the plateau from the lower top, Mynydd y Waun. At the watershed there is a new fence and a stile, across which the footpath descends into Cwm Ratgoed, passing beneath the broken cliffs of Mynydd y Waun. From the stile it is a short walk north-east following the line of the fence to Mynydd Ceiswyn. A clear path follows the fence along the whole length of the ridge to Cribin Fawr.

The summit of Mynydd Ceiswyn is not marked but lies on the north side of the fence.

Alternative ascents are possible from Cwm Ratgoed, by using the public footpath to the stile, or by first ascending Mynydd y

Waun from Waen Llefenni (762124). There are, however, new forest plantings and the inevitable forest road (not marked on the current 1:50,000 map) along the southern slopes of Mynydd Ceiswyn and Waun Oer, and for this reason an ascent from this direction is best avoided.

The ridge continues north-eastwards over Waun Oer and Cribin Fawr before turning south-eastwards, over Mynydd Dolgoed, and then by a narrow grassy ridge north-eastwards again to the summit of Maesglasau. This is a delightful ridge to walk, reminiscent of the Howgill Fells to the east of the English Lake District.

Mynydd Craig Goch
117. Sheet 115. Section 4 – Nantlle. MR 497485. 609 metres.

Mynydd Craig Goch is the final summit, in an east to west traverse, of the Nantlle ridge, lying in a direct line 9 kilometres (5.5 miles) from the village of Rhyd Ddu. It is usual, and recommended, to include Mynydd Craig Goch in a complete traverse of the ridge, ending on this strange summit of castellated and gnarled rocks. Except in looking back along the ridge, there is a wide-sweeping panorama stretching from Anglesey, over the Lleyn Peninsula with the Rivals rising straight from the sea, and down as far as Harlech. To add to the attraction, it is most unlikely that there will be many walkers at this extreme western edge of Snowdonia to disturb the peacefulness.

The continuation from Garnedd Goch to Mynydd Craig Goch descends steeply by a wall which lower down must be crossed at a convenient gap which gives access to the col between the two mountains, Bwlch Cwmdulyn. It is then simply a gently rising stroll to the summit, for which, in mist, a compass bearing will be found useful.

As an alternative ascent, and by no means the only other possibility, the summit can be reached from Nasareth (472501) or Nebo (478505) by the north-west ridge, using the road leading to the Llyn Cwmdulyn reservoir. The southern side of the mountain is bad going and boggy, and not recommended.

Mynydd Dolgoed

123. Sheets 124 and 125. Section 8 – Dovey. MR 802142.
604 metres.

Mynydd Dolgoed is an elongated, triple-topped hill rising from
Cwm Ratgoed in the Dovey Forest and ending in the dramatic
broken precipice of Craig Portas. This northern end of the moun-
tain forms part of a horseshoe link between Cribin Fawr to the
north-west and Maesglasau, north-east, and is largely an area of
tussock grass and bog that is seldom visited.

It is most easily reached either from Dolgoed (779125), by
following the line of the Nant Ceiswyn until it is possible to gain
the ridge a little way north of the summit, or by ascending first
over Cribin Fawr from Bwlch Oerddrws (804169) by the route
described in the entry for Cribin Fawr. This latter approach is
preferable since much of Ratgoed is newly afforested.

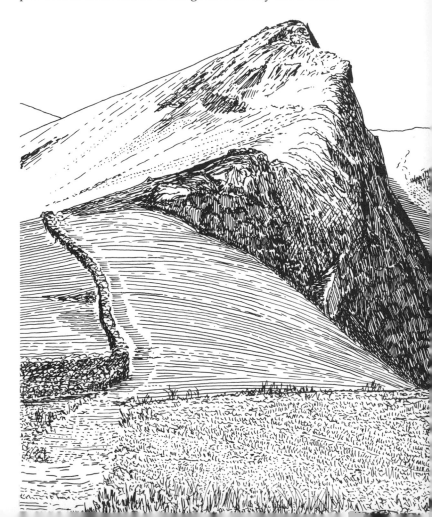

Mynydd Drws y Coed

59. Sheet 115. Section 4 – Nantlle. MR 549518. 695 metres.

Mynydd Drws y Coed, taking its name from the farm immediately below its craggy summit, lies at the eastern end of the range of seven mountains separating the pastoral recesses of Cwm Pennant from the quarried Vale of Nantlle. It is a slender mountain in profile, connected to adjoining mountains by steep, narrow ridges, that leading north to Y Garn being by far the trickiest and the rockiest, and providing the only section of the entire Nantlle ridge where the use of hands becomes more than optional. The summit, a grassy elevation marginally raised above the adjacent rocks, is without a cairn but lies a few metres south of a stile surmounting a seemingly out-of-place fence ascending from the east.

The ascent of Mynydd Drws y Coed becomes infinitely more

Mynydd Drws y Coed and Trum y Ddysgl (Nantlle ridge)

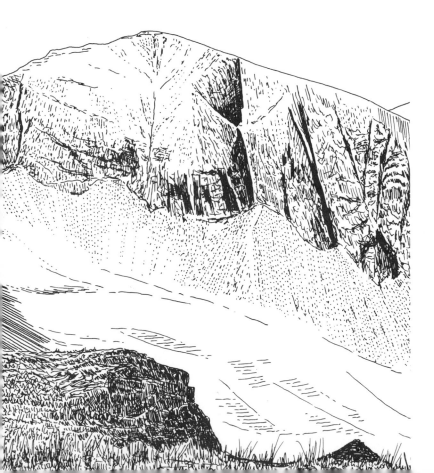

worthwhile if it is taken as part of a traverse of the whole ridge, when it will contribute largely to the measure of pleasure derived from a walk which would not be unwelcome in Scotland.

Since the ridge has in recent times been a no-go area for walkers, and now only existing on the strength of access arrangements agreed with the local farmers by the National Park Committee, it is recommended that Mynydd Drws y Coed be only ascended along the ridge from adjacent mountains. The start from Rhyd Ddu to the east is described in the entry for Y Garn, and that from Tal y Sarn, much further to the west, in the entry for Garnedd Goch.

Mynydd Mawr

57. Sheet 115. Section 4 – Nantlle. MR 539547. 698 metres.

The ascent of Mynydd Mawr, the *Big Mountain*, is no more than a short day's excursion, but it is well worth the effort. There are extremely impressive views, especially from the top of Craig y Bere along the mountain's southern face, where it overlooks the beautiful Nantlle valley and the enticing ups and downs of the Nantlle ridge.

The customary ascent starts from Planwydd Farm (568539), near the end of Llyn Cwellyn, and takes a Forestry road through the plantations until the south-east ridge can be gained and followed up the steep, grassy slopes of Foel Rudd (not named on the 1:50,000 map). From Foel Rudd a track continues above Craig y Bere (the crags being reached by a short diversion), and round to the summit cairn of the mountain.

Once the lower ridge has been reached, upon leaving the forest, it is possible to look down upon a shapely lake, Llyn y Dywarchen. This lake is one of only two given particular mention by Giraldus Cambrensis in his book *The Journey through Wales*, published in 1188, and is famous for its mysterious floating island. Alas the island is no longer there, though it is tempting to think that the existing island is the one about which so much is written and told. There is in existence a painting of a man ferrying himself across the lake on the floating island, and tales of a fairy, forbidden to walk the earth, who would meet her mortal husband on the island. Giraldus describes the island as being 'driven from one side to the other by the wind, shepherds beholding it with astonishment, their cattle while feeding carried to the distant

parts of the lake'. The famous astronomer Halley set out in 1698 to prove the island's existence, and swam out to it 'to be satisfied that it floated'. Thomas Pennant describes it as 'only a piece of turbery, undermined by the water, torn off, and kept together by the close entangling of the roots', but says nothing about the 'small willow tree growing upon it' observed by the Reverend Bingley. Whatever the island was, it appears to have remained intact for six hundred years, if all the contemporary learned authorities are to be believed.

Mynydd Mawr, however, has endured much longer, and this 'sleeping elephant', as it has often been described, in spite of its impressive southern face, if anything, presents an even better, more shapely aspect, to the north, especially well seen from the Moel Eilio range of hills across the valley to the east.

Mynydd Moel
22. Sheet 124. Section 8 – Cader Idris. MR 728137. 863 metres.

Mynydd Moel lies a little under 2 kilometres (about 1 mile) north of east from Pen y Gadair and, except for the continuation to the lower summit, Gau Craig, forms the eastern terminus of the main Cader Idris range. The northern and eastern faces of Mynydd Moel are shattered and broken precipices, while, in contrast, its southern flanks are simple grassy slopes descending steeply towards Minffordd (730114).

It is usual to include Mynydd Moel in a circuit around the high boundaries of the Cader Idris Nature Reserve, taking in en route Mynydd Pencoed and the highest summit, Pen y Gadair. Yet Mynydd Moel, as a spot away from the crowds, has a quiet attraction of its own. The connecting ridge between Pen y Gadair and Mynydd Moel is broad and grassy with steep descents on both sides, but there is a good path between the two summits. In fine weather, however, an indistinct path along the very edge of the north-facing escarpment is much more rewarding and gives excellent views over Dolgellau to the Mawddach Estuary in the west and to the Arans in the east.

Walkers who wish to ascend Mynydd Moel either for itself or as a precursor to the circuit described above should start at Minffordd, taking the well-marked route through the old oak woods of the Idris Estate. It is worth noting that this old wood is a good example of 'relict' oak, having been there since the end of

131

the last period of glaciation about ten thousand years ago. After a short climb through the woodland it is left behind and a path starts to ascend away from it. This is the path into Cwm Cau. Almost level with the highest point of the wood, however, it is possible to cross the stream on the right and gain a grassy ramp climbing along the edge of the wood. This soon leads onto the open hillside, and to a path which follows a dilapidated stone wall upwards. The wall does not lead all the way to the summit of Mynydd Moel, but an imaginary projection of it does, in the process crossing a path westwards which leads across the connecting shoulder to Pen y Gadair.

If the above route is used in descent, care should be taken not to follow too far the cairned track which head south-east from the summit of Mynydd Moel; this takes one onto the ridge running out to Gau Craig. The cairned track can be used for a short distance, but then a bearing east of south should be followed until the stone wall is reached.

An alternative approach to Mynydd Moel can be started from the signposted footpath (Llwybr Cyhoeddus) at 756140 and a

Mynydd Pencoed and Cwm Cau (Cader Idris)

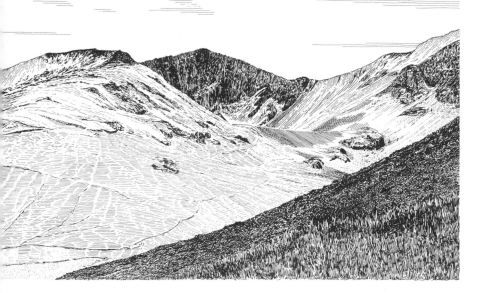

direct ascent made over the grassy shoulder of Mynydd Gwern-graig. The upper part of this shoulder is steep and broken and care should be taken in choosing a line of ascent. A better alternative from the same starting point is to continue along the signposted footpath, beneath the crag of Gau Craig, until its north ridge can be ascended. From the top of Gau Craig's north ridge a path continues westwards to the summit of Mynydd Moel.

Mynydd Pencoed
36. Sheet 124. Section 8 – Cader Idris. MR 711122. 791 metres.

Mynydd Pencoed is probably better known as Craig Cau. It is the top of an impressive wall of rock rising vertically from Llyn Cau, south-east of Pen y Gadair. The Ordnance Survey choose not to give this obvious summit a name on any of their maps, and in fact reserve the name Craig Cau for the cliffs much nearer to the summit of Pen y Gadair. Local knowledge and established opinion among mountaineers assert that Craig Cau is the abrupt terminus of the long ridge rising from Nant Pencoed and Cwm Pennant which is named both Mynydd Pencoed and Daear Fawr. *Craig Cau* means the 'enclosed crag', which clearly it is, but a crag as such is not a summit. *Daear Fawr*, the 'large ground', may refer to the size of this ridge, but *Mynydd* clearly means 'mountain'. So, Mynydd Pencoed, a name supported by at least one other writer, would seem to be the name not only of the tumbled mass of rocks and grass which form the summit but also of the whole grassy ridge extending south-westwards.

The most impressive ascent of Mynydd Pencoed is undoubtedly that which starts at Minffordd (730114), through the wrought-iron gates of the old Idris Estate. This is the popular Minffordd Path to Cader Idris which passes over Mynydd Pencoed and is distinct for most of its length. Only as the cradle of Cwm Cau is reached does the certainty of the path waver as it crosses occasionally boggy ground. But it is well cairned, and even in misty conditions no difficulty should be experienced finding the route out of the *cwm* up the south face.

A short detour deeper into the *cwm* is well rewarded, for it is only then that the sombre beauty of Llyn Cau, the *Enclosed Lake*, can be fully appreciated. Behind the lake the almost vertical cliffs of Craig Cau rise directly to the summit of Mynydd Pencoed, split

133

only by the Great Gully which separates Pencoed Pillar from the rest of the cliff. It is possible to reach the summit by a path along the northern shore of the lake and then by the obvious stone shoot rising to the *bwlch* between Mynydd Pencoed and Pen y Gadair, but this is loose and badly eroded. It is better to return to the path which continues across the top of the ridge forming the southern wall of the *cwm*. It is an easy walk, after the short initial steepness to get out of the *cwm*, with excellent views back into the *cwm*, especially near Pencoed Pillar and the Great Gully. A short rocky rise finally leads to the summit, possibly one of the most dramatic summits in the whole of Wales. An approach to the brink of the cliffs on any section of this final ridge is not recommended to anyone suffering from even the least degree of vertigo.

Mynydd Pencoed can also be reached from the route up Pen y Gadair which starts at Llanfihangel y Pennant (672089), details of which are given in the entry for Pen y Gadair. It is a simple diversion from the upper part of this ascent, after passing the subsidiary summit, Cyfrwy, to the *bwlch* immediately north of Mynydd Pencoed, from where it is an easy ascent to the top.

As an alternative an approach savouring exclusively the charms of Mynydd Pencoed can be made by leaving the path from Llanfihangel y Pennant at Mary Jones' Cottage (674095) and taking the path which winds around Craig Ysgiog until the open hillside and the ridge north-east can be gained. This same approach can be started from Pentre Dolamarch (716103) from where a path zigzags up the hillside below Graig Ddu. As soon as more level ground is reached, it is possible either to make for the western end of the ridge or to head for the un-named subsidiary top of Mynydd Pencoed (705116) by the western ridge of Cwm Amarch. A new fence leads from the subsidiary top towards Mynydd Pencoed but turns north before the final rise, leaving an old and broken fence to show the way through the rocks.

The summit has a small cairn of stones amid a profusion of rocks. Except for the stone shoot into Cwm Cau, any of the ascents described may safely be used in descent also.

Great Gully, Pencoed (Cader Idris)

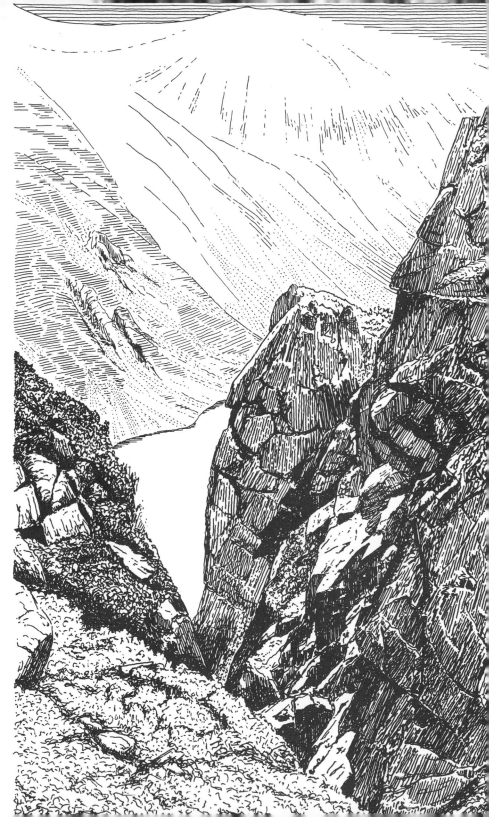

Mynydd Perfedd
30. Sheet 115. Section 2 – Glyders. MR 623619. 813 metres.

Mynydd Perfedd lies along the north ridge of the Glyders at a point where the route to Elidir Fawr departs westwards. It is an unimpressive, stony summit immediately north of an old pack-horse route from Nant Ffrancon to Nant Peris which crosses the ridge at Bwlch y Brecan.

Any ascent of Mynydd Perfedd must include one at least of the other summits along the ridge, and details are given in the appropriate entries. It is probably this centrality which provides the name, *Central Mountain*, though 'Perfedd' has other translations which are less attractive.

In common with Elidir Fawr and Carnedd y Filiast to the north, Mynydd Perfedd gives an impressive view of Marchlyn Mawr reservoir which is now used by the Central Electricity Generating Board in such a way that the level of the lake can vary by as much as 30 metres each day.

Mynydd Tal y Mignedd
87. Sheet 115. Section 4 – Nantlle. MR 535514. 653 metres.

The lack of summit cairns on neighbouring mountains Trum y Ddysgl and Mynydd Drws y Coed is more than amply compensated for by the towering, chimney-like obelisk marking the summit of Mynydd Tal y Mignedd. It is a unique structure, constructed to celebrate Queen Victoria's Jubilee and showing no signs of deterioration – a tribute to the quarrymen who built it.

On a clear day it is possible to see, from Mynydd Tal y Mignedd, the castles of Caernarfon, Criccieth and Harlech, three of many built by Edward I during the golden age of castle-building in the thirteenth century, following victories which did nothing to endear the English in the eyes of the Welsh people.

Between Mynydd Tal y Mignedd and the next mountain to the west, Craig Cwm Silyn, lies the col, Bwlch Dros Bern, thought to be an old drove pass between Cwm Pennant and Nantlle, though there is no evidence to that effect on present-day maps, and very little on the ground. As such it provides an access to the Nantlle ridge, particularly from Cwm Pennant to the south, but one which should be shunned in favour of a complete traverse of the ridge.

Details of ascents to the ends of the ridge are given in the entries for Y Garn, for an ascent from Rhyd Ddu, and Garnedd Goch, for the way up from Tal y Sarn. The descent to Bwlch Dros Bern, from where a rocky ascent leads to Craig Cwm Silyn, is initially south, by the line of a fence, and then south-west. Two stiles will be encountered; one at the top of the steep descent to the *bwlch*, and the other at the bottom. Both should be used to avoid minor crags.

Mynydd Tarw
67. Sheet 125. Section 10 – Berwyn Hills. MR 113324. 681 metres.

Mynydd Tarw, the *Hill of the Bull*, lies at the eastern end of a range of three hills extending eastwards from the main ridge of the Berwyn Hills. It may be ascended from Tyn y Ffridd (117308) at the mouth of Cwm Maen Gwynedd. The continuation westwards, eventually gaining the main ridge south of Cadair Bronwen, is not difficult and is a fine introduction to the round of the principal Berwyn Hills ending in a descent from the highest summit, Moel Sych, to the outlying mound of Godor, and then down again, to Tyn y Ffridd. It is an uncomplicated walk of 14 kilometres (8.75 miles) which, if the short diversion to Cadair Bronwen is included, takes in seven summits.

Nameless Peak
33. Sheet 115. Section 2 – Glyders. MR 677582. 805 metres.

The Nameless Peak, in reality an un-named summit, has become so called by tradition in the same way that the un-named *cwm* above Idwal became Cwm Cneifion, the *Nameless Cwm*. Perhaps this is because hill-walkers, who depend on positive information, have an in-built dislike of anything negative. The summit, however, is featureless and uninteresting, save for the exception mentioned below, and this may explain why there is no name. Yet all around are features with names – the Slope of the Cave, the Ridge of the Chapel, the Valley of the Swamp, the Three Peaks, the Lake of the Piebald Mare – many it seems of tenuous or obscure derivation. But in the middle of it all the nameless peak remains, officially, un-named.

If there is one redeeming feature of the Nameless Peak, it is the superb view it affords of the east-face buttresses of Tryfan seen

across the ridge rising to Llyn Caseg-fraith from the Ogwen valley. It is by this ridge, starting at Gwern Gof Isaf Farm (685602) on the A5, that Nameless Peak is best ascended. The route requires a diversion east when Llyn Caseg-fraith is reached, and the summit is easily combined with the more northerly Gallt yr Ogof.

An alternative approach is to include the Nameless Peak in a circuit starting up the North Ridge of Tryfan, down the South Ridge to the Miners' Track, and then by the Nameless Peak to Gallt yr Ogof. The round trip could be completed comfortably within four to five hours. The entry for Gallt yr Ogof should be consulted for descents from that peak to the A5.

Pen Llithrig y Wrach
34. Sheet 115. Section 3 – Carneddau. MR 716623. 799 metres.

Pen Llithrig y Wrach, the *Slippery Hill of the Witch*, is the last outpost of the ridge descending south-eastwards from Carnedd Llywelyn. It is a fine mountain with a strong profile whether seen from north or south. Across the moor north-west of Capel Curig it appears as a squat pyramid, but from the north it is a hunched shoulder turning its steep eastern face to the undulating ridge of Creigiau Gleision. It gives excellent views of Moel Siabod, the eastern Glyders, the estuaries of Conwy to the north and Tremadoc to the south, and the dark waters of Llyn Cowlyd, the deepest lake in Snowdonia, that lie at its feet.

An approach across the moor can be started along the track from Bron Heulog (720588) at Capel Curig, though this route is frequently wet and boggy. After 2 kilometres (approximately one mile) the track crosses the leat linking Llyn Cowlyd with Ffynnon Llugwy, and from here a more or less direct ascent, avoiding minor rocky outcrops, can be made to the summit via the south ridge.

The ridge westwards to Pen yr Helgi Du, from which direction Pen Llithrig y Wrach may also be ascended, becomes more distinct west of Bwlch Trimarchog, with steep descents on both sides. Pen Llithrig y Wrach and Pen yr Helgi Du may easily be combined in a short day's walk. Or for a longer day both mountains may be linked with Creigiau Gleision, starting at the post office in Capel Curig and following the route described in the entry for Creigiau Gleision, and ending at Helyg on the A5. This

route, which also includes the un-named summit on Creigiau Gleision, is probably too much for the short days of winter, but that decision can always be left until the summit of Pen Llithrig y Wrach is reached, then leaving, if a return is needed, only a straightforward descent by the south ridge.

Pen y Boncyn Trefeilw
90. Sheet 125. Section 10 Hirnant. MR 963283. 646 metres.

Until the farmer from Rhos y Gwaliau, near Bala, bulldozed a road from the top of Cwm Hirnant (946274) across the highest part of his land, the ascent of Pen y Boncyn Trefeilw was nothing short of purgatory; now it is an easy walk, with the new track passing just 100 metres north of the summit. The track has been made to facilitate the grassing of what is a vast, intractable area of bog and heather, an experiment which on the evidence of an area of 'reclaimed' land just south of the summit can only be described as valiant. Not everyone would agree with that sentiment, but in its present state the land is virtually useless, except as a habitat for wildlife, and quite impassable.

The top of Pen y Boncyn Trefeilw, marked by a small standing stone and crossed by a fence, can also be reached by a track through the Aberhirnant Forest, starting at 953312. The track later becomes a faint path ascending the north ridge of the mountain, though it does not pass over the highest point.

Pen y Bryn Fforchog
64. Sheets 124 and 125. Section 9 – Arans. MR 818179.
685 metres.

The *Top of the Forked Hill* probably derives its name from the fact that when seen from the direction of Dinas Mawddwy this most westerly summit of the Arans does have a cleft appearance due to the proximity of a lower companion summit a short distance above the A470. Though there are no rights of way over or to it, Pen y Bryn Fforchog can be reached from the top of the A470 at Bwlch Oerddrws (804169) by passing first over the lower summit. A longer approach is possible from Cwm Cywarch, crossing first over the bulk of Glasgwm, but again there are no paths or rights of way legally or on the ground, and this approach is rather dreary and wet. On the other hand it is peaceful and would need

careful navigation in mist even with the forestry fence as a guide.

The highest point, giving distant views of the Arans, Cader Idris and the Rhinogs, is marked by a small slate cairn. This summit is not named on the 1:50,000 map.

Pen y Castell
103. Sheet 115. Section 3 – Carneddau. MR 722689. 623 metres.

The summit of Pen y Castell feels as remote a spot as anyone might wish to find in the Carneddau, yet it can be ascended in much less than an hour by even the most dilatory of walkers. A road with qualities that would do Switzerland proud leaves Tal y Bont (767688) in the Vale of Conwy and climbs past The Olde Bull Inn at Llanbedr y Cennin to a fork at 749699. The left fork leads to a place at 744693 above Bwlch y Gaer farm where a few cars can be parked. Although the objective is Pen y Castell, a diversion at this point to Pen y Gaer (750694) will provide a unique example of an elaborate Iron Age defence system around a hill fort with stone circles.

From the parking place a track ascends gently through two gates until after 1.5 kilometres (approximately one mile) at a third gate it meets a wall descending from below the summit of Pen y Castell. This is an easy line to follow especially in mist, but pass through the gate first to avoid having to cross the wall higher up the hillside. The wall does not continue all the way to the summit, however, but abruptly changes direction after the initial steepness. From this change of direction it is a short, easy walk to the neat, rocky top.

The views southwards are to the rocky crest of Creigiau Gleision, the most easterly of the Carneddau, and the hunched shoulder of Pen Llithrig y Wrach, the *Slippery Hill of the Witch*, which contain between them the deepest lake in Snowdonia, Llyn Cowlyd.

From Pen y Castell it is a steady rise to Drum at the northern end of the central Carneddau ridge from where it is possible to follow a grassy, if occasionally boggy, ridge across the minor tops of Carnedd y Ddelw and Drosgl to Bwlch y Ddeufaen, the *Pass of the Two Stones*. The pass, now cluttered with electricity pylons, is the line of a Roman road forced through to the North Wales coast at Aber from the Roman fort of Canovium (Caerhun) in the Vale of Conwy. The two stones, of indeterminable date, which give

140

the pass its name can still be found just below the summit of the pass. To continue from the top of the pass to the summit of Tal y Fan requires only a short extension, passing first over the subsidiary summit, Foel Lwyd, at 721723. An ascent along the north side of the wall from the top of the pass will avoid having to cross the wall later.

The round of these relatively neglected summits is a prospect which will appeal to walkers who enjoy solitude, but it is complicated by the lack of space to park cars. The Bwlch y Gaer parking space is a long walk, some of it uphill, from the descent from Tal y Fan, and there may well be some advantage in starting the walk from Llanbedr y Cennin.

Pen y Gadair
18. Sheet 124. Section 8 – Cader Idris. MR 711130. 893 metres.

The name Pen y Gadair, like Yr Wyddfa to the north, is a name 'invented to adorn a legend', as W. M. Condry puts it. Similarities with Yr Wyddfa continue, for both mountains have common names derived from the collective name of a range of mountains – Cader Idris and Snowdon – and both are associated in legend with giants – Idris and Rhita Gawr. Some would say that there the similarities end, but both mountains are enormously popular, both have a history of refreshments being served on the summit, both are girt with impressive crags, and both have extensive views. But if anyone is looking for that extra merit mark to justify the slight superiority attributed by many walkers to Pen y Gadair, perhaps they need look no further than the fact that Pen y Gadair has no railway crawling up its spine to plague its summit with day-tripping itinerants who are as much out of place on Snowdon summit as a fully equipped mountaineer would be on a beach.

Pen y Gadair is the highest summit of a range of hills stretching from Craig y Llyn in the west to Gau Craig in the east. It is, in spite of its similarities with Snowdon, a highly individual mountain, named after a historical person killed in battle against the Saxons around the year 630. At one time it was also considered to be the highest mountain in Britain, but though its true stature is somewhat less, its attraction to travellers and hill-walkers, ancient and modern, has gone from strength to strength. Until the beginning of this century it was possible to engage a guide to take one to the summit of the mountain, something which a certain Robin Ed-

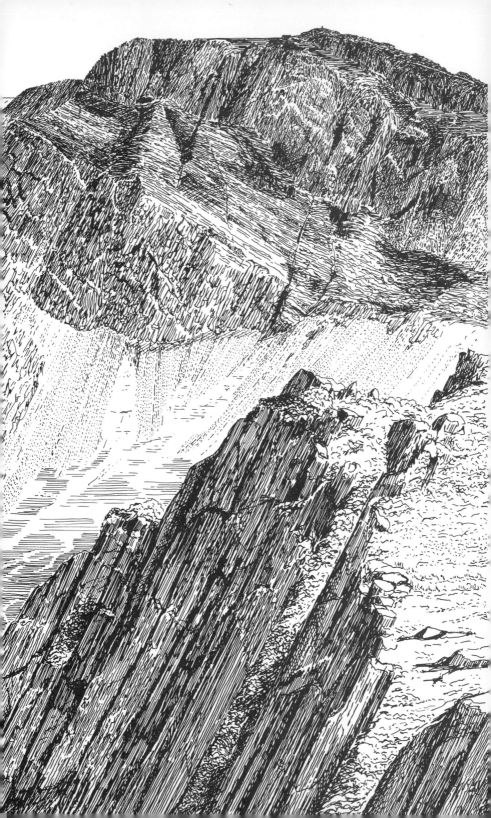

wards of Dolgellau had, in 1784, already been doing for some forty years. The year 1800 still found Robin Edwards, then an ageing man, guiding timid clients up the mountains. The town of Dolgellau, above which Cader Idris towers majestically, produced yet another enterprising inhabitant in Richard Pugh, who set about the construction of the stone hut (now a shelter) on the summit of Pen y Gadair. Here, according to one contemporary writer, visitors could have all convenient refreshments 'while waiting for the dispersion of the misty clouds in order to enjoy the exquisite prospect'.

Undoubtedly the feature which gives Cader Idris as a whole, and Pen y Gadair in particular, its individuality is its long northern escarpment, a complete traverse along the edge of which is a fascinating walk with unrivalled views. Such a walk, however, is only possible if there is no need to return to one's starting point. For most walkers it is necessary to ascend and descend by one of the three conventional routes. These start, from the south at Minffordd and Cwm Pennant, and from the north at Ty Nant, a short way from Dolgellau. There are other ways to the top of Pen y Gadair which traverse adjoining summits, over Mynydd Moel for example, or Tyrau Mawr, and there is the well-known Fox's Path ascending from Llyn Gwernan, near Ty Nant. The upper reaches of this path, however, are now so badly eroded as to be quite dangerous in all conditions and at all times of the year. It is a route to be admired for the severity of its finish, but it is advisable to avoid it completely.

The ascent from Minffordd (730114) starts through the wrought-iron gates of the old Idris Estate, and though there is not much room to park cars, this is unquestionably the finest way. It is also the shortest and the steepest. The route, which begins by passing through ancient oak woods, is seldom in doubt and, in the lower part, is marked by barriers erected by the Nature Conservancy. Only after the route has turned west, leading towards a gradually increasing backdrop of the cliffs of Mynydd Pencoed, is there any uncertainty about the way, but by heading into the *cwm*, which will be found to contain Llyn Cau, the *Enclosed Lake*, it is possible to pick up the route again as it ascends the southern wall of the *cwm*. Along the ridge above the *cwm* the route is clearly marked, crossing the top of Mynydd Pencoed and continuing up a final rocky section to the summit of Pen y Gadair. To pass quickly along it, however, is to deny oneself a series of

Pen y Gadair (Cader Idris) from Cyfrwy

impressive views into Cwm Cau which occur all along the ridge until the path starts the final climb to the summit.

There is also much to commend an ascent from Cwm Pennant. It is less popular, perhaps because it involves the longest approach with very little of interest *en route*, but it is quiet, easy, well-marked throughout its length and facilitates an excellent return over the summits of Tyrau Mawr and Craig y Llyn. Details are given of the return over these summits in their respective entries. For convenience of parking it is better to start the ascent through Cwm Pennant from the hamlet of Llanfihangel y Pennant (672089) and to follow the road leading to Mary Jones' Cottage, *Tyn y Ddol*. The cottage is now in ruins, but in the centre of it stands a monument telling the tale of Mary Jones' 25-mile barefoot walk over the mountains to Bala to buy a Welsh Bible from the Reverend Thomas Charles. She returned with Charles' own Bible, leaving behind a lasting impression which grew into the British and Foreign Bible Society.

From Tyn y Ddol the way into the higher parts of the *cwm* is along a graded roadway as far as Hafotty Gwastadfryn, shortly after which it becomes a grassy track leading to Rhiw Gwredydd, the high-level pass to Dolgellau. From here the route up the final slopes to Pen y Gadair, passing by the subsidiary summit, Cyfrwy *en route*, is simply a stony trek. Two to two and a half hours should be sufficient for average walkers from the church in Llanfihangel y Pennant.

The recommended route from the north starts at the entrance to Ty Nant Farm (697152), about 4.5 kilometres (3 miles) south-west of Dolgellau on the minor road. Ty Nant is not shown on the 1:50,000 map, but the National Park car-park is. A track lined by stone walls leads to a way along a rocky route, once a serious erosion problem but now improved by the National Park Committee. The efforts which have been made to combat and prevent erosion on this very popular route mean that the way is never in doubt. Eventually it climbs steeply, a route marked by standing stones, to Rhiw Gwredydd where the path meets the Pony Path coming from Cwm Pennant. The highest of these standing stones is a useful guide on the descent to Dolgellau in mist or when the route is under snow. Two hours will suffice for the ascent by this route.

Pen yr Allt Uchaf

113. Sheets 124 and 125. Section 9 – Arans. MR 869196. 610 metres.

Pen yr Allt Uchaf, not named on the 1:50,000 map, is the prominent shoulder of grass at the north-eastern end of Cwm Cywarch. It is bounded on the north by the trough of Hengwm, and on the south by Cwm Terwyn. Approaches can be made through either of these valleys. That through Hengwm starts at the bridge in Cwm Cywarch (853187) and takes the path across the lower slopes of the mountain until the path swings northwards towards the Aran ridge; thus far it is part of the agreed access route to the Arans. The start of the ridge out to Pen yr Allt Uchaf is marked by a large quartz cairn, and an approach from this direction passes first over the minor summit of Waen Goch (also un-named on the 1:50,000 map). The ground here is very boggy and tussocky. There is no path and no right of way.

By starting from Ty'n y Maes (860180) it is possible to follow a path through Cwm Terwyn across the southern slopes of Pen yr Allt Uchaf, which turns back on itself once the top of the ridge is reached. This passes only a short distance from the summit. The highest point is marked by a peaty hollow from which the last nine inches of a fence post emerge.

Pen yr Helgi Du

25. Sheet 115. Section 3 – Carneddau. MR 698630. 833 metres.

Pen yr Helgi Du, the *Hill of the Black Hound*, is a natural auditorium for the spectacle of rock gymnastics which takes place on the precipitous crags of nearby Craig yr Ysfa, a cliff that has been popular as a climbers' playground since the turn of the century. The summit overlooks, and gives a detailed insight into, this vast amphitheatre.

Three ridges lead to Pen yr Helgi Du which, if the contours of the former One Inch maps were any guide, would be denied any presence in this book. However, recent metric maps clearly show that this sleeping whale is more than worthy of inclusion; it would be a pity if it were not.

The main ridge extends southwards for 3 kilometres (approximately 2 miles) and provides the normal and easiest approach to Pen yr Helgi Du, starting on the A5 road near Helyg (691602), the

145

Climbers' Club Hut. From here one either takes immediately to the long grassy ridge at Tal y Braich or follows the newly constructed reservoir road until the ridge can be reached by a diversion to the right to avoid fences and walls. An alternative route heads directly for Bwlch Eryl Farchog (known to climbers as 'The Saddle') between Pen yr Helgi Du and Craig yr Ysfa, from where the summit can be reached without difficulty in a few minutes by a short, narrow, scrambly ridge. The ascent to The Saddle, once unpleasantly loose, has been improved by the use of netting to stabilize the screes and prevent further erosion.

The ridge eastwards leads to Pen Llithrig y Wrach, allowing the two summits to be combined in a short walk, by way of a pleasant descending ridge to Bwlch y Trimarchog from where there is a re-ascent of 200 metres.

The rising ground to the north-west of Pen yr Helgi Du leads over Craig yr Ysfa to Carnedd Llywelyn, the highest summit of the Carneddau range.

Pen yr Ole Wen (Carneddau) from Carnedd Dafydd

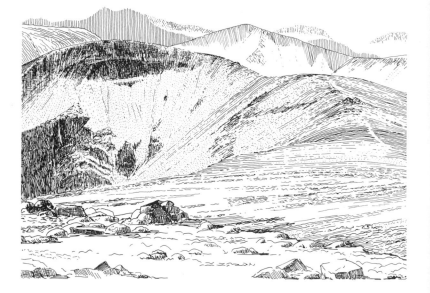

Pen yr Ole Wen

7. Sheet 115. Section 3 – Carneddau. MR 656619. 978 metres.

Pen yr Ole Wen is the southern terminus of 16 kilometres (10 miles) of convoluted ridge which forms the central backbone of the Carneddau. Abruptly, in little more than one kilometre, the ridge plunges 670 metres down to the Ogwen Falls where they spill over the great step at the head of Nant Ffrancon. To ascend this broad, bare, exposed shoulder of rock and scree is a test of one's fitness, but it is a challenge rewarded by supreme views of sparkling Ffynnon Lloer, the central ridge twisting away to Carnedd Llywelyn, and of the Glyder range on the opposite side of the valley. But it is an ascent which misleads one into thinking that it ends when a prominent cairn and shelter are reached. Not so; there is a short way further to go before the highest point is reached. A cruel sting in the tail!

An alternative and easier ascent can be made from Tal y Llyn Ogwen (668605), and this is described in the entry for Carnedd Dafydd.

Post Gwyn

86. Sheet 125. Section 10 – Berwyn Hills. MR 048294. 655 metres.

The road from Llangynog to Bala is flanked on its northern side by the steep slopes of Post Gwyn, a minor summit isolated from the main range of the Berwyn Hills. If its ascent did not entail tackling steep ground or a tiring session of heather bashing, Post Gwyn would be a pleasant alternative to the higher hills nearby. Its summit, a small rocky oasis in a vast sea of tough heather, is a nice viewpoint and a peaceful place to be. Unfortunately the easiest way of reaching it, from Milltir Cerrig (018303), though eased considerably by starting along the path bound for Moel Sych, still involves finding a way through at least 2 kilometres (a very long mile) of knee-deep heather.

The continuation to Glan Hafon is easier going but involves a short, steep descent to the col between the two hills. This may be used in reverse as a means of ascent to Post Gwyn, starting from Llangynog by a route detailed in the entry for Glan Hafon. The choice is one of either uphill work or ankle-twisting heather.

Rhinog Fach

53. Sheet 124. Section 6 – Rhinogs. MR 665270. 712 metres.

The key to the ascent of either of the Rhinogs is the narrow pass called Bwlch Drws Ardudwy. It can be reached from both east and west, though the approach from the west through Cwm Nantcol is shorter. The whole area is one that lovers of solitude, who are not averse to a little effort to achieve it, will find delectable. Early travellers, however, had quite a different view: Thomas Pennant in his *Tour in Wales*, describing his visit at the end of the eighteenth century, said: 'I was tempted to visit this noted pass, and found the horror of it far exceeding the most gloomy idea that could be conceived of it. The sides seemed to have been rent by some mighty convulsion into a thousand precipices, forming at their tops rows of shelves. The bottom of this passage is covered with a deluge of stones, which have streamed from the sides.' The Reverend Bingley, travelling a few years later, was no more favourably impressed, calling Drws Ardudwy, the *Pass of the Maritime Land*, 'a place well calculated to inspire a timid mind with terror'.

It is to this place of horror and terror, in the upper reaches of Cwm Nantcol, that walkers must go for one of only a few practical lines of ascent to the summit of Rhinog Fach. From the farm, Maes y Garnedd (642269), where cars may be parked, the start of the path to the top of the pass is signposted. This farm was the birthplace of John Jones, later to become a colonel in Cromwell's army, who married Cromwell's sister and, in signing the death warrant of King Charles I, committed the crime for which he was to be hanged, drawn and quartered in 1660.

The pass between the two Rhinogs is probably little changed since it was used in prehistoric times, and ascends gradually to the cairn marking the highest point. There are possibilities to deviate from it and to take directly to the hillside, but this is not recommended. The going underfoot anywhere but on the path is a dangerous mixture of boulders and deep heather. From the top of the pass the view eastwards takes in a wide panorama, improving as one ascends the very steep flank of Rhinog Fach, but it will be half an hour of upward toil before the finer points of the scenery will become impressed on one's mind. This is an arduous ascent, with little respite until the northern end of the summit ridge is reached, but the effort is well rewarded, and the

148

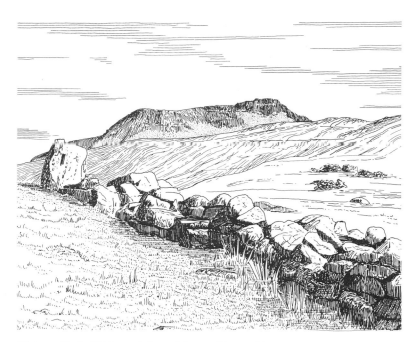

Rhinog Fach (Rhinogs) from Maes y Garnedd

southwards stroll to the cairn overlooking Llyn Hywel is easy.

A slightly easier ascent of Rhinog Fach can be started from the farm, Cil-cychwyn (634258) in Cwm Nantcol, and takes a sign-posted path past Craig Isaf and Craig Uchaf to meander upwards to Llyn Hywel. The lake is supposedly the home of monocular fish, but since they seldom swim near the surface of the impressive lake with its tilted slabs, the truth of the supposition is difficult to lay. Giraldus Cambrensis, who travelled around Wales in 1188, observed of the lake: 'It abounds in three different kinds of fish, eels, trout and perch, and all of them have only one eye, the right one being there but not the left.' But there is no evidence that he ever went to see for himself.

From the lake a track ascends steeply up a shattered buttress to the north, at the top of which lies the summit cairn. Alternatively a walk along the north shore of the lake leads upwards to the col between Rhinog Fach and Y Llethr from where a wall may be followed northwards and upwards to the summit. This latter alternative is preferable to the buttress, which is very loose.

Walkers making for Bwlch Drws Ardudwy from the east will find the walk-in much longer; to the top of the pass 5.5 kilometres (3.4 miles) compared with 2.5 kilometres (1.6 miles) from Maes y Garnedd. This approach, however, is much less used and likely to afford total solitude. A start along the minor track from Gelli Goch (715287) on the A470, 6 kilometres (3.75 miles) south of Trawsfynydd, leads to Ffridd Bryn Goch and then into the Coed y Brenin Forest at 683283, emerging near the top of the pass.

Rhinog Fawr
52. Sheet 124. Section 6 – Rhinogs. MR 657290. 720 metres.

One might reasonably expect Rhinog Fawr to be the highest of the Rhinog range, but that distinction is reserved for Y Llethr; even Diffwys further south intervenes in the table of heights before the higher of the two Rhinogs is encountered. Yet anyone seeing the whole range from the east, along the Trawsfynydd – Dolgellau road (A470), will understand why the Rhinogs, separated by what appears to be an immense defile, the Bwlch Drws Ardudwy, give their name to this fine group of hills. This is excellent walking country, but it is also some of the most difficult. Part of the ascent of Rhinog Fawr from Cwm Bychan is described by Patrick Monkhouse in *On Foot in North Wales* as exacting 'more perspiration to the yard than any other mile in Wales, with the possible exception of the other side of the same mountain'. He wrote that in 1933; fifty years later nothing has changed. The Reverend Bingley at the turn of the eighteenth century found the landscape 'as black and dreary as imagination can draw'; Thomas Pennant simply found it 'most august scenery'.

For the modern walker the going is everywhere rough in the whole range until going south the summit of Y Llethr is reached when the ruggedness of heather and boulders gives way to grass and much easier walking.

The shortest ascent of Rhinog Fawr starts, like the ascent described in the entry for Rhinog Fach, at Maes y Garnedd (642269), the birthplace of Colonel John Jones of Cromwell's army. Both mountains share a fascinating route into the prominent gap of Bwlch Drws Ardudwy, with the mountains growing ever larger as one progresses nearer. It is not difficult, with these wild slopes towering above, to imagine the fear and dread with which early travellers viewed these hills. From the top of the

bwlch, where there is a prominent cairn, the path followed thus far continues ahead into the Coed y Brenin Forest, later joining minor roads which lead east to the A470. For Rhinog Fawr a turn left, north, is necessary at the cairn, taking a faint path which leads shortly to a wall with a large hole at its base; some walkers may find it easier to scramble through the hole rather than risk damaging the wall. From the wall it is possible to follow a sketchy path upwards to the summit. Any diversion from the path simply leads into trouble of the most exhausting and sweaty kind.

At the end of Cwm Bychan, beyond the lake, stands the farm once occupied by Ieunan Llwyd who claimed lineal descent from Welsh lords living in this region as far back as 1100. Beyond the farm (648314) a track heads southwards, climbing through woodland to the summit of the pass known as Bwlch Tyddiad. This route passes over an obvious causeway of paving stones, repeated less obviously further south in Cwm Nantcol. These are set in the form of a flight of steps and are reputed to be Roman steps on the way from Llanbedr on the coast towards Trawsfynydd, but later research shows this not to be so, and the steps were more likely built in medieval times to improve trade between the east and coastal districts. From the top of the pass an ascent southwards, steep in places, and following a wall, will lead to the summit of Rhinog Fawr.

There is a marginally easier ascent of Rhinog Fawr to be made by starting at Cwm yr Afon (623301) and taking a track to an old manganese mine before heading south to gain and follow the easier west ridge of the mountain. This is better used as a descent.

Rhobell Fawr
50. Sheet 124. Section 7 – Rhobells. MR 787257. 734 metres.

Patrick Monkhouse, author of *On Foot in North Wales*, writing in the early 1930s, describes Rhobell Fawr as 'a noble mountain. It is not steep and shapely, but its slow curve has power and serenity.' And it is those qualities of power and serenity which impose themselves on the mind as the mountain is approached. From whichever direction it is seen, Rhobell Fawr is a strong, rugged, inviting shape set in a remote and wild landscape. It can be combined with its equally rugged neighbour, Dduallt, in an excursion of some navigational ingenuity now that the intervening moorland has been extensively re-afforested.

151

By far the easiest ascent of Rhobell Fawr follows the route described in the entry for Dduallt, leaving the A494 along the minor road at 799216 until the ruined Ty Newydd y Mynydd is reached. This approach is along a metalled or graded forest track, though it is better to leave cars at the end of the minor road and to continue on foot through the forest plantations with Rhobell Fawr growing ever larger on the left.

At Ty Newydd y Mynydd a gate on the opposite side of the track gives access to a small ridge above a boggy depression. The depression should be crossed and the eastern slopes of the mountain ascended. In mist a wall can be followed to the rocky top, though it does not continue all the way to the highest point, which is marked by a trig point and a cairn.

Ty Newydd y Mynydd can also be reached from the north through Cwm yr Allt-lwyd from where a signposted path ascends into the forest. Again there is here a good deal of new forestry work, and the paths shown on the map no longer exist. Those that do, far from being an adequate replacement, are sketchy and, despite the signposting, difficult to follow.

Walkers who do not need to return to their starting point will find an enjoyable descent along Rhobell Fawr's south-west slopes, making for the end of the minor road at Cors y garnedd (766230).

Snowdon – see Yr Wyddfa

Stac Rhos
97. Sheet 125. Section 10 – Hirnant. MR 969279. 630 metres.

Stac Rhos, not named on the 1:50,000 map, lies on the National Park boundary one kilometre (0.6 miles) south-east of Pen y Boncyn Trefeilw. It can be reached by a struggle across virgin ground from the new track mentioned in the entry for Pen y Boncyn Trefeilw. The highest point is not marked and could be any one of numerous tussocks of heather.

Tal y Fan

114. Sheet 115. Section 3 – Carneddau. MR 729727. 610 metres.

Lonely Tal y Fan and Foel Lwyd are isolated from the rest of the Carneddau by a weakness in the main ridge that has been exploited since prehistoric times. More recently the Romans used this pass, Bwlch y Ddeufaen, the *Pass of the Two Stones*, to avoid the difficulties of Penmaen Mawr and Penmaen Bach, but there is little visible evidence of their road today. The track which does remain now shares the pass with a different kind of invader – technology, in the form of unsightly electricity pylons. The two stones, however, are prehistoric monoliths of uncertain date and may still be found standing proudly below the summit of the pass.

Tal y Fan may be ascended easily from the top of the pass which can be reached both from Llanbedr y Cennin in the Vale of Conwy and from Aber on the coast to the north. At the top of the pass there is a gate through a stone wall, and an ascent along the north side of the wall will avoid having to cross it higher up and will take one first to the subsidiary summit, Foel Lwyd. The continuation to Tal y Fan is without difficulty.

Alternatively Tal y Fan may be ascended from Llanfairfechan, starting along the minor road from the traffic lights and later following the Afon Ddu to beyond its fork with Afon Maes y Bryn. From here a direct line can be taken over mostly dry grass to the col just west of the summit.

There is a longer approach to Tal y Fan over the summits of Pen y Castell and Drum, details of which are given in the entry for Pen y Castell. If this pleasant and easy option is taken, it is possible to descend from the summit of Tal y Fan, using new wooden stiles to cross walls, to the Roman road in the vicinity of Cae Coch Farm (732714).

There are many ways up and down Tal y Fan from the east and north, all of which are marked on the Ordnance Survey map, but the Druids' Circle (723746), possibly dating from the end of the Stone Age, is worth a diversion. The Circle is of the type commonly known as a 'cromlech' and is one of the few surviving examples in North Wales, though the connection with Druids is entirely imaginary. Their local name is Y Meini Hirion, *the Long Stones*. Nearby, on the small hill, Moelfre, stand three stones, one red, one white and one blue, which local tradition would have us

153

believe represent three women who were turned to stone for winnowing corn on a Sunday.

Tarrenhendre
93. Sheet 135. Section 8 – Tarren Hills. MR 683041. 634 metres.

The Tarren Hills are a small range of mountains, almost entirely grassy throughout, lying south of Cader Idris, and north of the Dovey Valley; only two of the summits exceed 600 metres in height, and of the two Tarrenhendre is the lower. Strictly it is tautological to speak of the Tarren *Hills*, since 'Tarren' means 'hill', but there are more than just these two summits, and the collective English noun fits nicely with the Welsh.

From the north Tarrenhendre can be ascended from the former quarryman's village, Abergynolwyn, by ascending steeply south out of the village by a metalled track leading to the disused Bryneglwys Quarries. As far as the quarries the route is pleasant, wooded on the right across the Nant Gwernol, and with Tarrenhendre forming the upper end of the *cwm*. Beyond Bryneglwys the going becomes less distinct due to wide-scale re-afforestation which has significantly re-routed the paths. A way does still exist, however, marked by upright wooden posts, and ascends to a col between Tarrenhendre and an un-named minor top. From the col, which gives a superb view of the Dovey Estuary, it is an easy ascent along a fence-line to the summit plateau. On the edge of the plateau two fences meet, and nearby there is a large cairn, but this is not the highest point. The true summit lies about 200 metres north and is marked by a cairn from which projects a wooden post.

From the summit it is possible to descend north-west along the upper edge of the forest until a path into the forest can be found and a return made along forest trails. Alternatively, a descent can be made south-west into Nant Dolgoch beneath Mynydd Esgairweddan to the upper part of which a forest track has now been constructed: this is not shown on the maps. This route leads to Dolgoch (651046), from where a walk of about 2.5 kilometres (1.6 miles) along the road leads back to Abergynolwyn.

There is, however, a much better ascent of Tarrenhendre which, if linked with Tarren y Gesail, will give a superb day's walking. This leaves the minor road west of Pennal in the Dovey Valley at 668997 and ascends a rough track until a diversion north

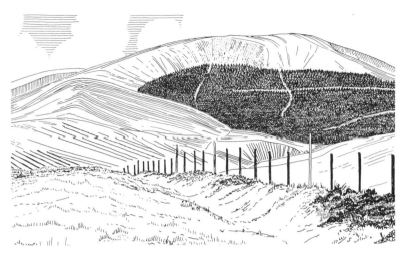

Tarrenhendre (Tarrens)

leads onto the long, twisting ridge over Trum Gelli, Tarren Cwmffernol and Mynydd Esgairweddan to the summit. The continuation to Tarren y Gesail is along the fence to the col above the Bryneglwys Quarries (described above), and then, staying with the fence, across the minor summit Foel y Geifr and so on to Tarren y Gesail. A return over Foel y Geifr and Mynydd Rhydgaled (703041) will lead to a steep descent to Pennal Isaf and back into the Dovey Valley.

Tarren y Gesail
79. Sheet 124. Section 8 – Tarren Hills. MR 711059. 667 metres.

Tarren y Gesail, the highest of the Tarrens, lies south-east of the village of Abergynolwyn. Like its lower neighbour, it is a domed, grassy hill on which there has been extensive forestry work, and this in places has caused uncertainty over lines of access.

The easiest approach is from Abergynolwyn, along a road running south from the village which ascends very steeply to overlook a wild, wooden ravine. As soon as level ground is reached, it is possible to ascend, left, onto a lower summit, Foel Pandy (not named as such on the 1:50,000 map, but which has its north-east face, Graig Wen, prominently marked). A continuation south-east up grassy glopes leads to the trig point on the summit.

A longer, easier route is to continue along the track from Abergynolwyn instead of climbing left. The track leads to the disused Bryneglwys Quarries, among the remains of which there are some fine waterfalls. There is a local tradition that this route through the Nant Gwernol is a pilgrims' way over the hills from Machynlleth to Tywyn, and it is spoken of as a pilgrims' road to the holy island of Bardsey. There is, too, a claim that the same pass across the watershed is a Roman road and that Pont Llaeron is of Roman origin.

From the quarries it is possible to ascend through small spoil heaps to a vague track leading into the eastern arm of the upper *cwm*. This route leads across Pont Llaeron and past a small un-named lake. The lake, despite its prominence on maps, is now no longer there, the dam wall which kept it in place having been breached, presumably when the quarry ceased operations. By crossing the bridge it is possible to follow a path running parallel with the stream, and occasionally marked by wooden posts, to the col between Tarren y Gesail and the minor summit Foel y

Pont Llaeron (Tarrens)

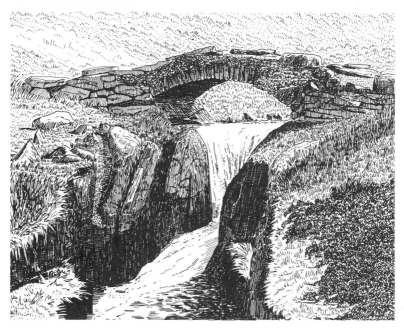

156

Geifr. From the stile at the col it is a simple uphill plod to a large collapsed cairn, following the line of a fence. At the cairn a left turn is necessary to reach the highest ground.

Instead of keeping left at the quarries, it is possible to cross the stream and ascend a faint path through new plantings, which later divides, with one way leading towards Tarrenhendre and the other towards Foel y Geifr. This higher route, which is the link between the two main hills, is much better than the lower route through the valley bottom. There are wide and impressive views southwards over the Dovey Valley to Plynlimon.

Ascents of Tarren y Gesail from the west are made difficult by the forests, but there are ways through the forest, particularly from Pantperthog (768043: on Sheet 135) which, with perseverance and not too much determination to stick to paths which no longer exist, will lead to the col between Tarren y Gesail and Foel y Geifr.

Whichever route is chosen, forestry and more forestry will be encountered. But by keeping to the forest tracks it is invariably possible to reach all the summits, high and low, in this excellent group of hills.

Tomle
48. Sheet 125. Section 10 – Berwyn Hills. MR 085335. 742 metres.

Tomle is a small grassy dome at the start of a broad ridge of three hills running eastwards from the main Berwyn Hills. It is easily reached from Cwm Maen Gwynedd, a long valley to the south, by following a track which continues from Blaen y Cwm (095322) at the end of the minor road from Llanrhaeadr ym Mochnant. The track deteriorates into a path and leads over the col between Cadair Berwyn and Cadair Bronwen, then descending west to meet the B4401 in the Dee valley at Hendwr (043385), 3 kilometres (1.9 miles) south of the village of Cynwyd, and only a short walk from the River Dee. This path, taken in reverse, gives easy access to the whole Berwyn range east of Hirnant, and so, across the col, to Tomle.

The continuation eastwards to Foel Wen is grassy and occasionally wet, but the entry for Mynydd Tarw gives details of an approach from the east along the ridge for anyone wishing to reach Tomle from this direction.

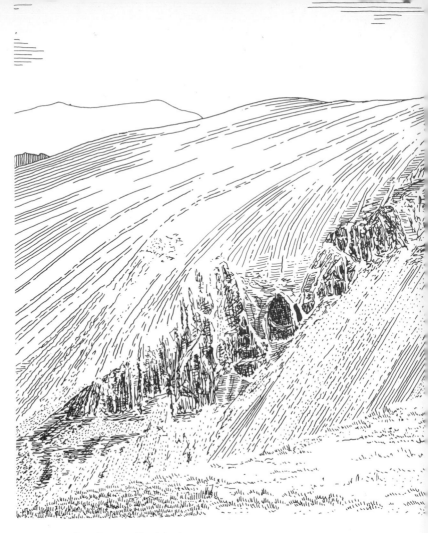

Trum y Ddysgl (Nantlle ridge)

Trum y Ddysgl

55. Sheet 115. Section 4 – Nantlle. MR 545516. 709 metres.

Trum y Ddysgl, the *Ridge of the Dish*, lies in the range of mountains forming the southern wall of the Vale of Nantlle. It derives its name from the obvious configuration of its northern cliffs and ridges when viewed from the valley. Like the whole of this splendid ridge, it was once an area with access problems, now happily resolved, but only by diligent effort between farmers and

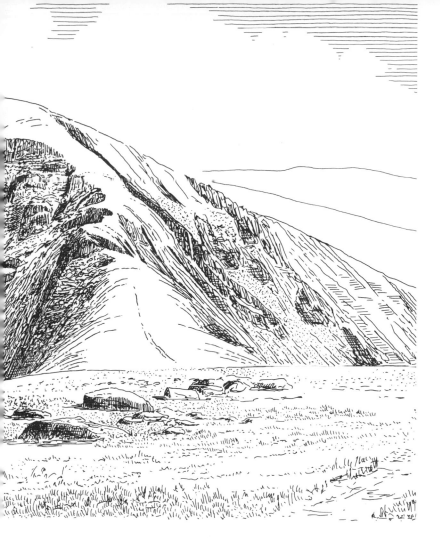

the National Park Committee. The result of the effort is freedom
for the walker to wander amid – above would be a better word –
spectacular scenery with a charm and a beauty of its own; the
effort and the concessions it produced are to be respected by
everyone.

The summit is a small, elongated ridge in itself, grassy through-
out its short length and without a cairn to mark its highest
point – which, for the record, is at the eastern end. Trum y
Ddysgl offers an unrestricted view across its 'dish' to the steep

western face of Mynydd Drws y Coed, called Clogwyn Marchnad.

A long, descending ridge is thrown southwards from Trum y Ddysgl to Bwlch y Ddwy Elor – an old corpse road between Cwm Pennant and Rhyd Ddu. As a means of escape in the event of adverse weather, this south ridge can be used to descend quickly to the head of Cwm Pennant. Used in reverse, an ascent to the main ridge from Cwm Pennant is not without its attractions, though these are mainly in what the ascent leaves behind. The preferred ascent, however – to Y Garn from Rhyd Ddu and then by the ridge to Trum y Ddysgl – has the unassailable advantage of revealing suddenly and dramatically a view of the eastern part of the ridge, the Nantlle valley, the cliffs of Craig y Bera and Mynydd Mawr, and ultimately Cwm Pennant itself, that is breathtaking. It is also the agreed line of access. The ascent from Rhyd Ddu is described in the entry for Y Garn, while for a west-east traverse starting details are given in the entry for Garnedd Goch.

From Trum y Ddysgl the ridge continues to Mynydd Tal y Mignedd by a narrow grassy connection, eroded badly at one place, with steep descents south into Cwmdwyfor, and north into Cwmyffynnon.

Trum y Gwrgedd
111. Sheet 125. Section 10 – Hirnant. MR 941284. 612 metres.

This summit is at the centre of a small ridge of three hills forming the upper western wall of Cwm Hirnant, near Bala. There is no cairn to mark the highest point, but it is crossed by a fence by the side of which sheep have found the best ground in a laborious walking area of deep heather and bog.

Ascents are by continuation from Foel Goch (north) or Foel y Geifr (south), details of which are given in the entries for those summits. The notes on Foel Goch also refer to a faint path from the top of Cwm Hirnant (946274). This passes below the top of Foel y Geifr and ends conveniently near the summit of Trum y Gwrgedd.

Tryfan

15. Sheet 115. Section 2 – Glyders. MR 664594. 915 metres.

Tryfan has been called 'a mountain that caters for everybody', 'a model mountain', 'a small, Gothic cathedral of a mountain which seizes upon our imagination so as almost to exaggerate the effect of its own shapeliness', and simply, the 'second of the hills which stood on the left'. This last tribute flowed from the pen of George Borrow, who spent some time travelling around Wales in 1854. Such a vague description is typical of Borrow, who just as summarily dismissed Gallt yr Ogof as the *first* hill on the left, and Carnedd Dafydd as 'a huge long mountain on the right'. Earlier, however, the Reverend W. Bingley undertook 'A Tour round North Wales during the Summer of 1798' and actually stood on the summit of Tryfan at the culmination of the first recorded ascent of the mountain. Even before then, Thomas Pennant had gazed down on Tryfan from the Glyders in 1781, observing: 'In the midst of the vale far below rises a singular mountain *Trevaen*, assuming on this side a pyramidal form, naked and very rugged.' It has also been called the highest dustbin in Britain, and while that particular accolade would be more fitting for Ben Nevis, Tryfan is without doubt the recipient of the title for Wales.

Whatever may be said of it, Tryfan is still a remarkable mountain with an extraordinary feeling of height. Its summit lies a mere kilometre (little more than half a mile) from the A5 road, yet requires the better part of two hours to reach it, being 600 metres above the Ogwen valley at its feet. There are four conventional ways up the mountain, one from each point of the compass, but the best is undoubtedly that of one's own choosing, ignoring the other four. Such freedom, to wander in and out of rock faces and buttresses, round corners and up grassy ledges, requires a certain amount of familiarity with rock-climbing, or at least rock-scrambling, techniques. Of the four 'normal' routes, the ascent by the north ridge is far superior to the other three.

There is now a convenient car-park adjoining the A5 at 658602 from which to start the ascent, and the route passes through the gate at the eastern end of the car-park. Looking ahead, the most prominent feature is Milestone Buttress, an obvious, clean buttress of rock which has long been popular with the rock-climbing fraternity. To the left of this a wall ascends from the road to the very edge of the buttress. There are stiles over the wall, and

161

beyond lies a short, steep downfall of scree and shattered rocks which is climbed to a plateau of heather and bilberry. The route up the north ridge is now obvious and well marked and leads to a small platform with a large cairn known, since it is the meeting place of a number of routes, as Piccadilly Circus. Above the platform the next prominent feature is the Cannon, a large block of rock canted at an angle, that can be seen from the car-park. The ascent of the Cannon is decidedly easier than the descent, but it is only a diversion and lies off the route. Higher up, a small, level platform is met just below a steep, but not difficult, rock face which leads to the notch at the top of Nor' Nor' Gully. The notch feels more exposed than it is, and poses less of a problem if it is tackled from the Gully which can be gained by a diversion east and down (only about 10 metres) from the level platform. After the notch an exhilarating scramble will lead to the top of the north peak, from where it is only a few minutes to the famous monoliths of Adam and Eve on the summit. At one time the summit was famous as the highest habitation of mice in Wales, obviously

Tryfan

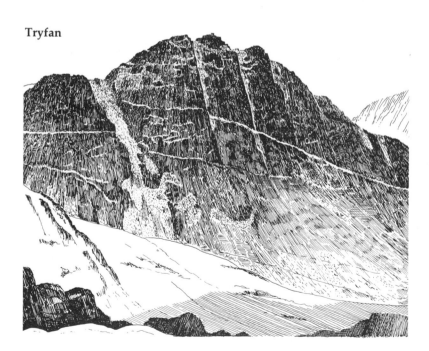

162

feeding on scraps of food. The scraps remain, though the mice do not.

The quickest way down is also the least attractive and most tiresome of the four ways up. This requires a return to the gap between the north and central peaks, from where steep scree and paths lead down the west face of the mountain back to the car-park. This route is not recommended except to walkers with very strong knees and little time; viewed from the car-park it is a daunting prospect.

An easier way down (or up), and for those continuing to the Glyders the only way down, is by the south ridge. This is quite tame by comparison with its northern counterpart but still needs respect and caution, more so in descent than in ascent. The south ridge descends to a wall crossing Bwlch Tryfan where the Miners' Track from Ogwen ascends from the west and disappears across the head of Cwm Tryfan to the east. The Miners' Track is distinct in both directions and may be used either to descend west into Cwm Bochlwyd and the peaceful waters of its lake, or to travel east to Llyn Caseg-fraith (670583), the *Lake of the Piebald Mare*, and the summits of the Nameless Peak (by which name it is generally known) and Gallt yr Ogof.

The ascent of Tryfan by the fourth route takes the Heather Terrace, a conspicuous line crossing the entire east face of the mountain. This route starts at Gwern Gof Uchaf Farm (673605) on the A5 and takes a path beneath the slabs of Little Tryfan, the scene of many a rock-climber's introduction to the sport. Then by a steep little gully the end of Heather Terrace can be gained and followed across the face to the south ridge route. The Terrace is primarily a means of access to the many fine rock climbs on the east face of Tryfan, the starting points of which are frequently scratched into the rock face. As a means of ascending this fine mountain it is a scrappy, rubble-strewn path with severely restricted and unappetizing views.

Tyrau Mawr
81. Sheet 124. Section 8 – Cader Idris. MR 677135. 661 metres.

Tyrau Mawr, like its companion Craig y Llyn, lies at the western end of the Cader Idris range. Its northern face, considered by Thomas Pennant to be the highest rock he ever rode under, is steep and very abrupt and emphasizes its affinity with the range

even though it is situated more than 3 kilometres (2 miles) from the main summit, Pen y Gadair.

The highest point of Tyrau Mawr is marked by a small cairn of slaty stones piled on the very edge of the precipice, here called Craig Las, and is an excellent vantage point for the Mawddach Estuary below. It is also an ideal place to be on a hot summer's day, giving a distant and undisturbed view of the throngs toiling up the final slopes of Pen y Gadair.

By contrast, the southern slopes of Tyrau Mawr are gentle and grassy and are crossed by the long-established Pony Path to Pen y Gadair from Llanfihangel y Pennant. With such a well-defined path passing so close to the summit of this mountain, it seems logical to use this approach, from Cwm Pennant, starting at 672089, in preference to the shorter but steeper alternative from Ty Nant (697152) to the north. Both paths, details of which are given in the entry for Pen y Gadair, meet at Rhiw Gwredydd, the col between Tyrau Mawr and the higher mountains to the east. From the col it is an easy walk, along a path on the south side of a fence which starts at the col and continues for 4 kilometres (2.5 miles) to the top of the second summit of Craig y Llyn; this fence is a valuable guide in mist, but on both Tyrau Mawr and Craig y Llyn it passes a short distance from the actual summit. In view of the suddenness with which the north face of Tyrau Mawr drops away, it is good counsel, in conditions of heavy snow or dense mist, to keep on the southern side of this fence.

Walkers ascending from Cwm Pennant need not continue all the way to Rhiw Gwredydd but may divert instead to the conspicuous pile of stones known as Carnedd Lwyd as soon as it comes into view. Carnedd Lwyd, a minor summit, is crossed by the path and fence leading west to the summit.

Tyrau Mawr may be combined easily with Craig y Llyn for a short, uncomplicated walk with magnificent views, and both can be used as an alternative return from Pen y Gadair to Cwm Pennant. The shorter walk, over Tyrau Mawr and Craig y Llyn, should take 3–3½ hours from Llanfihangel y Pennant, while the addition of Pen y Gadair will extend the time to about 5 hours.

Un-named Summit (Ysgafell Wen)

77. Sheet 115. Section 5 – Moelwyns. MR 663485. 669 metres.

As is the case on Creigiau Gleision further north, the un-named summit on Ysgafell Wen is really just another bump along a ridge. It is not so much a separate mountain as a subsidiary summit of one that simply falls within the criteria for inclusion in these lists. The summit lies a short distance north of the main summit of Ysgafell Wen and is shown on the 1.50,000 map as having a spot height of 668 metres. Nearby are the Llynnau'r Cwn, the *Dog Lakes*, the most easterly of which is immediately north of the summit.

The ascent from Nanmor, to the west, and the various comments made in the entry for Ysgafell Wen are equally applicable here. The summit has a small cairn on it.

Un-named Summit (Manod Mawr)

84. Sheet 115. Section 5 – Ffestiniog. MR 727458. 658 metres.

There are a number of un-named summits in Snowdonia over 600 metres in height, and there is nothing to say why they remain nameless. There is, however, some justification for using the name Craig Ddu for this summit since the slate quarries which have eaten away its south-western flanks are known as the Craig Ddu Slate Quarries. Tradition refers to this mountain only as the un-named hill north of Manod Mawr. In spite of this the Ordnance Survey sprawl the name of Manod Mawr across both mountains even though they are unmistakably separate entities with a fair descent and distance between them.

The easiest way to the summit is to include it in an ascent of Manod Mawr, from where the continuation north presents no difficulties. Alternatively there is a track leading from Llyn y Manod, referred to in the entry for Manod Mawr, that can be followed to the col between the two mountains, known, and not without good reason, as the Bwlch y Slates. There is a small lake at the Bwlch y Slates and from it a quarry road leads around the un-named summit, but this can be left after only a minute or so and a direct, easy line made to the summit. In the view north, Moel Penamnen, with its steep left edge, is prominent, and beyond lies the bulk of Moel Siabod. To the east that vast intractable area of bogland known as the Migneint rolls away endlessly towards the Arenigs.

165

Un-named Summit (Creigiau Gleision)
94. Sheet 115. Section 3 – Carneddau. MR 734622. 634 metres.

Creigiau Gleision is a long, undulating ridge to the south-east of Llyn Cowlyd which has three major bumps along its top. The most southerly of these is the main summit, the middle one has much less re-ascent than the others, while the most northerly, topped by a large cairn, has sufficient re-ascent to justify inclusion in these lists.

A walk along the entire ridge is rewarding and exhilarating, and the ascents to it described in the entry for Creigiau Gleision obviously apply to the un-named summit.

Un-named Summit (Cadair Bronwen)
106. Sheet 125. Section 10 – Berwyn Hills. MR 089369.
621 metres.

The un-named hill lying 3 kilometres (1.9 miles) north of Cadair Bronwen in the Berwyn Hills is a disappointing summit of burned heather and slaty outcrops and scarcely merits attention, being worth visiting only as an incidental top along the high-level traverse of these hills from Carrog in the north to Milltir Cerrig in the south. Its situation, however, close to the pass from the village of Cynwyd (north-west) in the Dee valley, to Llanarmon Dyffryn Ceiriog (south-east), makes it easily accessible. The top of the pass is marked by a memorial plaque (not a memorial stone as stated on the 1:50,000 map).

Use of this pass gives easy access to the main ridge of the Berwyn Hills. The path starts in the west at two points on the B4401 a short distance south of Cynwyd and descends eastwards into Nant Rhydwilym where it joins the minor road from Llanarmon DC.

Un-named Summit (Bwlch y Moch)
116. Sheet 115. Section 1 – Snowdon. MR 635552. 609 metres.

Only recent surveys and the 1:10,000 map reveal that the long ridge extending from Pen y Pass, at the top of the Llanberis Pass, to Bwlch y Moch, actually exceeds 600 metres. It is not a summit in the true sense, but an imposing ridge with steep descents on both sides, and is by far a better way to or from Bwlch y Moch

than the normal pilgrims' way along the lower part of the Pig Track.

The highest point lies only a few minutes above Bwlch y Moch and can be reached either from the *bwlch* or, preferably, by walking the length of the ridge from Pen y Pass.

Un-named Summit (Moel y Cerrig Duon)
120. Sheet 125. Section 10 – Cwm Cynllwyd. MR 918258. 606 metres.

Above the road which clings to the eastern wall of Cwm Cynllwyd, south of Bala Lake, lie two grassy summits which present the walker with little difficulty and even less of interest.

The un-named summit, which is the more northerly of the two, can easily be reached across a boggy depression from the southernmost, Moel y Cerrig Duon. Alternatively, by ascending into the depression from near the obvious scree and rock slope, Craig yr Ogof, it is possible to pick a way up the gentle slope to the summit.

A long continuing ridge north-east will lead to the higher summit, Foel y Geifr, above Cwm Hirnant.

Waun Oer
75. Sheet 124. Section 8 – Dovey. MR 786148. 670 metres.

To the east of Cader Idris, across the geological shift known as the Bala Fault, lies a small group of hills neatly arranged in a pleasant grassy ridge that reminds one of the Howgill Fells in England. Waun Oer, the second highest of these hills, lies at the centre of the main ridge, with the highest summit, Maesglasau, off the ridge to the east, overlooking Dinas Mawddwy.

The whole ridge is a delightful walk in an infrequently visited area, and a perfect panacea for those suffering from the over-population of the higher mountains to the north-east and west. An approach is best made over either Mynydd Ceiswyn to the south-west or Cribin Fawr to the north-east, details of which are given in the entries for those hills.

The summit of Waun Oer has an Ordnance Survey trig point and is a fine place to view the cliffs of Gau Craig and Mynydd Moel at the eastern end of the Cader Idris range. The southern

slopes of Waun Oer are newly planted and now have a wide forest road climbing from Cwm Ratgoed to the col between Waun Oer and Cribin Fawr. This road could be used as an ascent, but because of the extensive new planting it is better to avoid approaches from Cwm Ratgoed in general.

Y Garn
10. Sheet 115. Section 2 – Glyders. MR 631596. 947 metres.

Y Garn is a bulky peak with a fine shape and, perhaps more than Tryfan, dominates the Ogwen valley. It has a comfortable moulded appearance, reminiscent of an armchair, with bold, plunging ridges that curve together like arms around a raised hollow, Cwm Clyd, in which lies a sheltered lake, Llyn Clyd. But Y Garn has a dual personality, for the shapely rugged countenance looking down on Ogwen is let down by a posterior that is, like many posteriors, large and rounded. Yet it is an appealing mountain, inspiring the poetic pen of Mrs E. H. Daniell (one of the first ascendents of the rock climb named 'Hope' on the Idwal Slabs) to write:

> She sits in splendour, great against the sky,
> And broods upon the little ways of men.

Y Garn (Glyders) from Tryfan

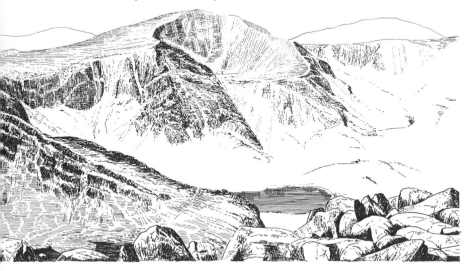

168

Perhaps the most attractive features of Y Garn are its two arms, the two ascending ridges curving to meet at the summit cairn. These could easily be used to form a short expedition in themselves, up the left ridge, down the right. Such a route would start at the Ogwen Outdoor Pursuits Centre (651603) and take the path leading into Cwm Idwal Nature Reserve. At the gate into the reserve a path over a bridge on the right leads around Llyn Idwal until a diversion can be made to the foot of the left ridge. This ridge, unlike the one on the right, has short sections of broken rock which give easy scrambling until easier ground is reached a short way below the summit. Neither of the ridges could be regarded as simple walking. They are both steep and airy, but an excellent introduction to the short range of mountains forming the escarpment above Nant Ffrancon.

An easier, though longer, ascent goes by the route through the Devil's Kitchen described in the entry for Glyder Fawr until Llyn y Cwn is reached. From the lake it is a simple uphill plod to the summit.

From the Pass of Llanberis the way up starts at Gwastadnant (614576) and follows the line of the Afon Las into Cwm Cneifio until easier ground is reached, when again it is a question of plodding uphill. This route is wholly uninteresting and is not recommended other than as a speedy descent to Llanberis.

The ridge north of Y Garn is by contrast a pleasure to walk, offering views east down steep cliff faces and grassy slopes to Nant Ffrancon. South-west lies the Snowdon range with the tip of Snowdon just appearing over the intervening bulk of Crib y Ddysgl. The whole of the Nant Ffrancon ridge, including an extension to Elidir Fawr, can be completed in four to five hours from Ogwen, ending with a steep descent from the last mountain, Carnedd y Filiast, to the old road through Nant Ffrancon near Ty'n y Maes where, at a public house, George Borrow, in his journey through Wales, found 'tolerably good ale'.

Y Garn
95. Sheet 115. Section 4 – Nantlle. MR 551526. 633 metres.

Like Y Garn above the Ogwen valley, the Nantlle Y Garn also marks the end of a ridge, but as an introduction to things to come it is far superior to the higher mountain in the Glyders. The Nantlle ridge, once out of bounds to the walker, and now

surviving solely by virtue of access arrangements made with local farmers by the National Park Committee, is a ridge walk second only to the Snowdon Horseshoe. Yet strangely it is a walk that is undeservedly neglected. The complete walk, starting from Y Garn and twisting to a finish on Mynydd Craig Goch overlooking the sea, is barely 8 kilometres (5 miles) long and can be traversed in both directions, from either end, in a long day. More usual is a single traverse followed by a tramp along the roads of Nantlle, unless transport can be organized to meet one at the end of the walk.

Y Garn is little more than an extension of Mynydd Drws y Coed, the next mountain along the ridge, but has a distinct shape

Snowdon from Rhyd Ddu

of its own and a far more handsome profile whether seen from Rhyd Ddu or the Nantlle valley.

The only ascent from Rhyd Ddu is by a gate (566526) barely half a kilometre (a quarter of a mile) south-west of the village on the Nantlle road. The way onto the ridge is marked by white arrows painted on rocks and, after the second stile where the path divides and sends a route across Bwlch y Ddwy Elor into Cwm Pennant, it climbs steeply up grassy slopes to the summit. Between one and one and a half hours will be needed to reach the summit by this route even though the distance from Rhyd Ddu is little more than 2 kilometres (1.25 miles). The dramatic prospect of the cliffs of Craig y Bera on Mynydd Mawr, however, and the

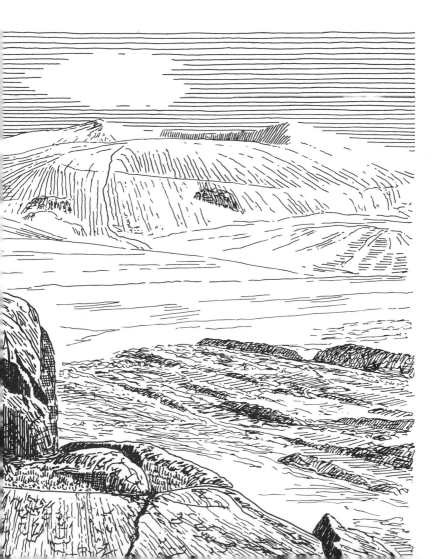

tranquil scene of beauty in the Nantlle valley below make the effort worthwhile.

The continuation to Mynydd Drws y Coed, almost due south, is narrow and steep in places, but if the edge of the *cwm* to the west is followed, the higher summit will not be missed.

Y Garn
98. Sheet 124. Section 6 – Rhinogs. MR 702230. 629 metres.

Connoisseurs of Rhinog country will enjoy Y Garn; most ordinary walkers, however, will not. After the unexpected transformation to grass and easy going on Y Llethr and Diffwys, it comes as a shock to the system to find Y Garn reverting to type. Yet for those who do not mind a bit of effort in virtually trackless country, it has its rewards.

The easiest ascent is through Cwm yr Wnin, along the minor road to Blaen y Cwm (712219). From here a steep ascent west leads to a wall, along the top of Y Garn's south ridge, through which there is a gate. An evasive path follows the wall, a short distance west of it, until at its highest point it must be crossed by a gap, and an ascent, north-west, made to the cairned summit. Walkers looking for the small lake, Nannau-is-afon, will find it on the east of the wall, but an ascent along the east side, while attractive in prevailing winds, does involve unnecessarily crossing a number of adjoining walls.

A longer alternative ascent, allowing a pleasant circuit and avoiding most of the worst going (which is mainly to the north of the mountain), can be made by starting into Cwm Mynach until a metalled track, signposted (Llwybr Cyhoeddus), leads towards Cesailgwm-bach (697213). After a while this track descends right to cross a stream and is signposted 'New Precipice Walk'. From the bridge across the stream it is easier to stay with the track (and the first part of the New Precipice Walk) until it is possible to gain, or pass in front of, the minor top, Foel Ispri, and so reach the long south ridge of Y Garn. From the top of the rise just after the bridge, however, a rough track can be followed to Cesailgwm-bach, and by keeping the farm below and on the left, an ascent can be made a short while later, diagonally upwards, right, to the south ridge. The wall along the top of the ridge needs to be crossed, at a gap, and then later re-crossed by the gate mentioned in the ascent from Blaen-y-cwm. A return may then be made

down the south-west ridge to rejoin Cwm Mynach at the southern edge of the forest.

Walkers seeking rough going and a lot of tranquillity should descend north-west from the summit to meet the northern edge of the forest along which there is a faint path leading to the forest track shown on the map, and a pleasant return through Cwm Mynach. An ascent by this route should not be countenanced.

Y Gribin

125. Sheets 124 and 125. Section 9 – Arans. MR 843177. 602 metres.

Y Gribin is a double-topped hill with the distinction of being not only the lowest summit in the Aran range but also the lowest in these lists. It can be reached, very steeply, from Cwm Cywarch by a path which ascends behind the farm, Gesail (852184) – the farm is not named on the 1:50,000 map but is obvious from the map reference. This approach, however, although shown as a right of way, is unclear on the ground, particularly in the lower section, and the upper part is exceedingly steep.

An alternative, marginally easier approach can be made from the end of the minor road network near Dolobran (844163). A path zigzags up the hillside and at a couple of points crosses a forestry road which generally proves to be easier going. Both path and road, the former indistinct, reach the ridge just a short distance north-east of the summit, the highest point of which is unmarked.

Y Llethr

44. Sheet 124. Section 6 – Rhinogs. MR 661258. 756 metres.

The summit of Y Llethr is the highest point of the whole Rhinog range and lies to the south of Rhinog Fach from which it is separated by a narrow neck of land and an ascent of 220 metres. The ground north of Y Llethr is rough, an area of deep heather concealing many boulders. It is no place to wander away from the few paths that exist. To the south, as if painted by a different hand, the terrain is almost Berwyn country.

It is not too difficult to reach Y Llethr, but it is time-consuming and involves either a long approach walk or some careful route-finding through heather. There are two main approaches, though

there are others, each worthy of the highest summit and taking in other mountains *en route*.

For a long, relatively gentle approach, a start should be made from Tal y Bont (590218) on the A496 road 6.5 kilometres (4 miles) north of Barmouth. There is a small car-park near some toilets and telephone kiosks. From the car-park a narrow lane alongside a stream leads into pleasant woodland. Through the woodland a path, staying with the stream and ignoring any diversions, will eventually lead to a small cottage, Lletty-lloegr, near Pont Fadog (606226) – the cottage is not named on the 1:50,000 map. The path, right, over Pont Fadog, goes to Llyn Irddyn and joins the old Harlech track mentioned in the entry for Diffwys. By going left at the cottage, however, and then round to the back of it, a wall can be followed uphill, away from the cottage, until at a stone stile it is possible to gain a graded track leading, right, into the valley between Y Llethr and Diffwys. The cottage, near which it is possible to park a few cars, can also be reached by road from Llanddwywe (586223). Once on the graded track the way is obvious, following first between walls and then onto the open hillside below the lower hill, Moelfre. Strong walkers will not find a direct ascent of Moelfre difficult, and it adds an interesting start to the day being topped by an ancient cairn built by the mysterious people who inhabited the Vale of Ardudwy at its feet. Legend also relates that from Moelfre the ubiquitous King Arthur cast a large quoit into the valley. Quoit-casting must have been a favoured regal pastime for there are many 'Arthur's Quoits' scattered about Wales.

Between Moelfre and Y Llethr the land dips, and the lowest point can be reached easily from the graded track. Across the dip a wall is met and followed gently upwards to a stile, followed by a short ascent to the summit. The continuation south (from the stile) leads across the minor top, Crib y Rhiw, to Diffwys, and then by the old Harlech track back to Lletty-lloegr. This whole circuit adequately fills a day, being in the region of 16 kilometres (10 miles).

Undoubtedly the best way, however, to reach Y Llethr is over Rhinog Fach, a route which crosses the narrow col between the two mountains. As a temporary halt a short walk downhill from the col leads to a pleasant resting place by the beautiful and sombre Llyn Hywel, reputedly the home of horrific one-eyed fish. The descent from Rhinog Fach and across the col in mist is

made easy by the presence of a wall, but it is essential to find the wall while near the summit since other paths leave the top, one of which drops very steeply down broken ground to the lake. Towards Y Llethr the wall will guide walkers up a series of small rock walls and ledges to the edge of the summit plateau, though an easier way can be found by a track ascending the wide hollow west of the wall. The top of the descent into this hollow is marked by a cairn and a post.

The summit of Y Llethr is surprisingly flat and grassy, and not at all what might be expected after the rough ground of the summits to the north. Walkers returning to Cwm Nantcol should follow the wall south-west from the stile at the start of the connecting ridge to Diffwys. By keeping on the north side of the wall, a new bulldozed track will be found, leading down to Cil Cychwyn (634259) in the valley. For the record, this also provides the shortest and easiest ascent of Y Llethr. It is also the most boring.

Y Lliwedd
17. Sheet 115. Section 1 – Snowdon. MR 622533. 898 metres.

Y Lliwedd is now the forgotten playground of heroes past, the Winthrop Youngs and Mallorys of the mountaineering world. It is, one suspects, too far for the modern cragsman to walk to reach the immense vertical columns of Y Lliwedd's northern face; if that is true, it is a sad reflection, for Y Lliwedd is:

A noble ground
a mecca of the past,
where long-departed heroes
learned their trade
amid the columns grey.

Y Lliwedd today is invariably ascended as part of the Snowdon Horseshoe, providing breathtaking views of the immense amphitheatre of Cwm Dyli and constantly arousing argument as to which of its two summits is the higher. It is a classic example of each peak appearing higher when viewed from the other. Modern survey techniques brook no argument; Y Lliwedd West is 898 metres, Y Lliwedd East 893 metres. Though doubtless no one will agree that there are 5 metres of difference.

The normal approaches to Y Lliwedd are, like those for Crib Goch across Llyn Llydaw to the north, from either end. From the

Y Lliwedd and Glaslyn (Snowdon)

east, starting at Pen y Pass, the Miners' Track is followed until on reaching Llyn Llydaw a path leaves the main track and ascends diagonally to a cairn just below the lesser top of Y Lliwedd Bach. From here a distinct and rocky path ascends to the higher summits. This same point may be reached from Gallt yr Wenallt or by leaving the route which starts in Nant Gwynant described in the entry for that summit and passing through the old mine workings of Cwm Merch. A direct ascent is then possible to the ridge below Y Lliwedd Bach.

From the west an approach is made through Cwm Llan by the Watkin Path until it is possible to gain the rocky path ascending from Bwlch Ciliau. Walkers with no fear of sudden drops will find a sketchy, scrambling route along the very edge of Y Lliwedd a much more rewarding experience.

Yr Aran
47. Sheet 115. Section 1 – Snowdon. MR 604515. 747 metres.

Yr Aran is an undeservedly neglected summit lying 3 kilometres (less than 2 miles) south of Snowdon; its remoteness from the centre of things makes it difficult to include with many of the other summits in the range. A start, however, from the car-park near the Bethania Bridge in Nant Gwynant (627506) facilitates an

excellent but unorthodox walk leading first over Gallt yr Wenallt, Y Lliwedd and Snowdon and then to Yr Aran, before returning into Cwm Llan and the Watkin Path. Details of this route are given in, or are obvious from, the entries for the respective summits.

The continuation from Snowdon to Yr Aran is a feast in itself. On the descent of Bwlch Main it is necessary to keep to the crest of the ridge at the point where a path, the *Beddgelert Path* as it is known (even though it leads to Rhyd Ddu), starts to descend, right, to Llechog. By staying with the crest, the turning around the head of Cwm Tregalan, down Clogwyn Du and over the minor top, Allt Maenderyn, will not be missed. This is a fine, steeply descending ridge with extensive views on both sides. To the east Cwm Tregalan is the upper part of Cwm Llan, and the legendary site of the final battle of King Arthur, a tale so evocatively told by Showell Styles in his book *The Mountains of North Wales*. From Allt Maenderyn the ridge drops very steeply to Bwlch Cwm Llan before the final pull to the summit of Yr Aran. A descent by the east ridge into Cwm Llan, or by returning to Bwlch Cwm Llan where there is a path, will enable a return to be made to Pont Bethania.

The path across Bwlch Cwm Llan also enables direct ascents to be made of Yr Aran, from Nant Gwynant through Cwm Llan by the Watkin Path, or from Rhyd Ddu by leaving the Beddgelert Path when the gate leading to Llechog and Snowdon (signposted) is reached, and taking instead a track to a disused quarry. There are toilets and ample car parking at Rhyd Ddu.

As an alternative, a more direct approach may be made by the south-west ridge, over the minor top of Craig Wen, from Beudy Ysgubor (583486), about one kilometre (a little over half a mile) north-west of Beddgelert on the Rhyd Ddu road.

Yr Elen
9. Sheet 115. Section 3 – Carneddau. MR 674651. 962 metres.

This top is conspicuous when seen from the Menai Straits on the North Wales coast, but from other directions it is obscured by its proximity to Carnedd Llywelyn, lying little more than one kilometre north-west of Wales' third highest top. It is a short, sharp ending to a delightful ridge walk from the higher summit and well worth the detour, though doubtless anyone attempting

the 'Welsh Three-Thousands' will consider it a nuisance.

To all those who visit it for its 'off-the-beaten-track' qualities, Yr Elen will provide a memorable day. It is a nice place to be. At its feet lies one of the smallest lakes in Snowdonia, Ffynnon Caseg, cradled in a quiet and lonely *cwm*, and its small summit defies the possibility of crowds.

A pleasant alternative ascent of Yr Elen can be made from Gerlan (633665), near Bethesda, through the Llafar valley. Details of this will be found under the entry for Carnedd Llywelyn.

Yr Wyddfa (Snowdon)
1. Sheet 115. Section 1 – Snowdon. MR 609544. 1,085 metres.

Yr Wyddfa is known to everyone as *Snowdon*. It is the highest, and probably the most popular, summit in England and Wales. The name 'Yr Wyddfa', like that of Cader Idris to the south, is a name with origins in legend. It is said, though there is no archaeological evidence to support it, that the summit of Yr Wyddfa is the tomb of Rhita Gawr, a fierce, king-killing giant who dressed himself in a cloak made of kings' beards. Rhita was eventually slain by King Arthur, who had a great cairn thrown over the giant on top of the highest mountain in Eryri. Arthur himself was slain not far away, at Bwlch y Saethau, the *Pass of the Arrows*, where a cairn, known as Carnedd Arthur, was built, though it now no longer exists.

No one knows when the first ascent of Snowdon took place. The first recorded ascent, however, was by a botanist, Thomas Johnson, in 1639, though Thomas Pennant, writing many years later in his *Tour in Wales* about the attitude of the Welsh people to an English king (Edward I: 1272–1307), relates that 'no sooner had Edward effected his conquest, than he held a triumphal fair upon this our chief of mountains; and adjourned to finish the joy of his victory, by solemn tournaments on the plains of Nevyn.' A triumphal fair may well have been a bit of a tight squeeze on Snowdon's summit, and more likely refers to some lower slope.

There is a history of refreshments being served on the summit dating back to 1838, a licence to sell intoxicating liquor being granted in 1845, not that for most of the 1970s it was of any assistance to walkers arriving at the summit on a Sunday; this part of Wales used to be 'dry' on the Sabbath. The railway, which plods mechanically to the summit from Llanberis, has done so

since 1896 and brings hundreds of tourists to the top of a mountain they might never otherwise reach. On some days it makes an interesting diversion to play a game of 'Spot the Mountaineer', the rules of which can be invented to suit the mood or the occasion; anyone counting more mountaineers than tourists misses a turn until the next train arrives.

Yet for all its trampled ways Snowdon remains an impressive mountain with a range of ascents to suit all abilities and dispositions, and though, as Pennant observed: 'It is very rare that the traveller gets a proper day to ascend the hill', when perfect days do come, the extent of view is remarkable, reaching as far as the hills of Scotland 250 kilometres (160 miles) distant.

The Llanberis Path affords the easiest, longest and dreariest way to the top, yet even this uncomplicated route conceals a winter danger for the unwary or the inexperienced who try to negotiate the slopes above Clogwyn Station in snow conditions without at the very least an ice-axe. That apart, the ascent, starting from the Royal Victoria Hotel, near the start of the Mountain Railway, in Llanberis, presents no problems other than those of an ascending walk of 8 kilometres (5 miles) with the same in return. The metalled roadway directly opposite the Royal Victoria Hotel leads steeply at first to Hafodty Newydd, but it is left after a little over one kilometre (three-quarters of a mile) at a signposted track, left, just before the road descends to pass beneath the railway line. There is room to park a few cars at this point, and most walkers prefer to drive the initial steepness from Llanberis. Thereafter the path is clear (and recently improved) all the way to the summit, calling for attention only after the Halfway House, when a fork in the path is encountered. The way straight ahead leads to the formidable cliff, Clogwyn du'r Arddu, which is worth visiting if only to marvel at the courage of the pioneers of the routes on this complex crag. A left turn at the fork leads up an incline and under the railway near Clogwyn Station. A steady plod over the shoulder of Crib y Ddysgl (the winter danger area mentioned above) leads to the summit. About 2½–3 hours will be required for the ascent, and another 1½–2 hours for the descent. Incredibly the record for the ascent *and* descent from the playing fields in Llanberis is held by Kenny Stuart (at the time of writing, 1993) and stands at 1 hour 2 minutes and 29 seconds, which he set in 1985.

The Miners' Track, constructed to bring down copper from the mines of Cwm Dyli, is the most popular way up Snowdon. It is full of interest, giving constantly changing scenery as it twists and turns round rocky outcrops and lakes. The track starts at Pen y Pass where, at an altitude of 350 metres, there is a car-park, youth hostel, café and toilets, all of which can be welcome in inclement weather. The car-parking charge, which varies according to the time of year, is now significantly more than the shilling that used to be charged until the early 1970s by a man sheltering in a wooden hut. When the car-park is full, or for those who dislike paying car-parking charges, there is a free car-park at Nant Peris half way to Llanberis, and a free Sherpa bus service operating between there and Pen y Pass.

From Pen y Pass the Miners' Track passes first round Llyn Teyrn, the *Lake of the Tyrant*, on the shores of which are ruins of barracks once used by the miners from the copper mines. Further on Llyn Llydaw, *Brittany Lake*, is reached, a lake divided by a causeway which has recently been reconstructed and raised in an effort to reduce the number of occasions on which it is completely flooded and impassable. The causeway was constructed during the last century to give access to the mines higher up the *cwm*. The

Snowdon from the Pig Track

180

track, once across the causeway, follows the shore of Llyn Llydaw and then starts to climb away from it towards a higher lake, Glaslyn. This upper lake, its waters tinted by copper ore, was once known as Llyn y Ffynnon Las, the *Lake of the Green Fountain*, and is the scene of one of the many legends which steep these hills with intrigue. The story concerns a legendary monster, an *afangc*, which lived in a pool near Betws y Coed from which it emerged from time to time in classic monster tradition to cause havoc. Not unreasonably the local inhabitants decided to put an end to this inconvenience and tempted the monster from its pool, using a lovely maiden as bait, planning in good neighbourly fashion to deposit it in the next valley. In the end the monster finished in Llyn y Ffynnon Las, where it remains to this day. Anyone doubting the tale should read Showell Styles' account in his book *The Mountains of North Wales*.

From Glaslyn the track ascends steeply through a confusing and badly eroded section of ground, eventually joining the higher Pig Track and continuing upwards by a short series of zigzags to the rim of the *cwm* where it joins the Llanberis Path and the railway. The top of the zigzags, for walkers descending into Cwm Dyli, is now marked by a large standing stone.

The Pig Track takes its name from Bwlch y Moch, the *Pass of the Pigs*, immediately below the steep ascent to Crib Goch. Like the Miners' Track, this route also starts at Pen y Pass, leaving by the corner of the higher part of the car-park and climbing a series of rocky steps all the way to Bwlch y Moch. Erosion along this section of the track has been a serious problem, and efforts are being made to contain it by improving the track and restricting access to certain areas.

From Bwlch y Moch the Pig Track actually *descends* towards Snowdon for a short distance before continuing an airy rising traverse of the lower slopes of Crib Goch. This is a rougher, more rugged way through Cwm Dyli, and in many ways more enjoyable than the lower Miners' Track which it eventually joins above Glaslyn. The way out of Cwm Dyli is clear enough, even in mist, providing the paths are not left, but in descent care is needed at the point where the two tracks meet not to descend unintentionally to the Miners' Track. The safest way of ensuring that the Pig Track is followed is to stay on the highest path at all times until it becomes obvious that the drop to Glaslyn has been passed.

181

The Watkin Path is named after Sir Edward Watkin, a rich and influential railway owner, who constructed it as a donkey path at the end of the nineteenth century and who should also be remembered as a pioneer of the Channel Tunnel. The path starts at the Bethania Bridge in Nant Gwynant (627506) but is a less interesting route than either of the two paths through Cwm Dyli, involving more ascent and with a final section below the summit of Snowdon which is badly eroded.

The path passes a large rock into which is set a slate tablet commemorating the visit in 1892 of W. E. Gladstone, when he addressed the People of Eryri upon Justice to Wales. The multitude sang Cymric hymns and 'The Land of my Fathers'. It rained, and afterwards Gladstone, who was then 83 years of age, drove through the downpour in an open carriage to Aberglaslyn.

The path continues beyond Gladstone Rock, climbing by a stony path to Bwlch Ciliau, at which point it turns left towards Snowdon. There is here another cairned path turning right; this leads up Y Lliwedd. From Bwlch Ciliau it is more rewarding to leave the path and follow a faint track, left, to Bwlch y Saethau along the rim of Cwm Dyli. The view, into the enormous amphitheatre, is breathtaking. This cliff edge path, equally impressive in both directions, passes over the top of a ridge, the Gribin, which ascends from the outlet of Glaslyn. It is not a difficult ridge and provides an alternative way to the summit of Snowdon from Cwm Dyli.

From Bwlch y Saethau it is prudent to rejoin the Watkin Path, even though the upper reaches of it do not ascend directly to the summit of the mountain. The whole of this section is treacherously loose and unstable, and it is better to follow the path to its junction, at the top of Bwlch Main, with the Beddgelert Path, from where it is only a few minutes to the top. The start of the descent by the Watkin Path at its junction with Bwlch Main is now marked by a large standing stone.

The Beddgelert Path despite its name starts at the car-park in the village of Rhyd Ddu. It is an easy walk, with the objective in view from the start. Later, as the path passes across the lower slopes of Llechog and the upward view is obliterated, the panorama across the Rhyd Ddu valley stretching from Moel Hebog in the south to Mynydd Mawr in the north is more than adequate compensation.

The path is never in doubt, and though it may seem to meander

as it gains the height of Llechog, it does so without too much effort, bringing first the summit of Snowdon and then the towering cliff rising from Cwm Clogwyn back into view. There is a short pull to the top of Bwlch Main, following which the path cavorts to the summit.

The Snowdon Ranger Path, starting near the Youth Hostel on the shores of Llyn Cwellyn (564551), is probably the oldest track up Snowdon, and though it does not compare in popularity with ascents from Pen y Pass or Nant Gwynant, there is nothing on all the other routes to match the view it provides from the top of Clogwyn du'r Arddu.

Like all the tracks up this mountain, it is easy to follow, and the top of it, where it meets the railway line, is now marked by a large standing stone. This should not be confused in mist with another stone perched above the zigzag descent into Cwm Dyli. The Snowdon Ranger Path *in descent* is on the *left* of the railway line.

The Snowdon Horseshoe and the Figure of Eight. No account of Snowdon would be complete without reference to possibly the most popular ridge walk south of the Scottish border. The *Snowdon Horseshoe* is a complete round of the summits enclosing Cwm Dyli, normally, but not necessarily, done in an anti-clockwise direction, starting with Crib Goch and finishing with Y Lliwedd. Purist walkers, however, will note that the first nail in the horseshoe is the un-named summit above Bwlch y Moch, and that the last is Gallt yr Wenallt. To do all six summits needs at least six hours, with eight or nine hours being a better overall time including rests.

Walkers with considerable staying power will find the *Figure of Eight* a good test, starting at Pen y Pass and following the anti-clockwise horseshoe route to Snowdon, including the first nail. The route then descends by the Beddgelert Path to Rhyd Ddu, then by the road for 2.5 kilometres (1.5 miles) to ascend the Snowdon Ranger Path from Bron y Fedw Isaf Farm (568546) back to Snowdon, from where the horseshoe is finished to Gallt yr Wenallt. With so much effort required, the total distance of 25 kilometres (16 miles) becomes quite meaningless – usually about half way round!

Ysgafell Wen

73. Sheet 115. Section 5 – Moelwyns. MR 667481. 672 metres.

Ysgafell Wen is the steep western edge of Cwm Fynhadog Uchaf (not named on the 1:50,000 maps), lying south-west of Moel Siabod. It is a curving ridge, starting on the lower summit, Yr Arddu, and continuing over Moel Druman to Allt Fawr. The main summit of Ysgafell Wen, marked by a small cairn, lies due east of Llyn yr Adar and is not, as is sometimes supposed, the second top near the Llynnau'r Cwn a little way to the north. Despite the appearance of level ground on maps, the area is a confusion of minor bumps and lakes, and the highest point has a very small lake close by, though this is only shown on 1:25,000 and larger maps. Care is needed in misty conditions, mainly because there are so many lakes, and though the old iron fence-line rising from Moel Meirch to the north is a guide, it neither passes over the highest points nor continues to the next mountain, Moel Druman.

There is an ascent from the wild valley of Nanmor to the west, starting at the converted chapel, Blaen Nant (635491), though this is not named on maps. After winding around farmhouses, the path climbs first to the almost circular Llyn Llagi, set against a backdrop of cliffs, before ascending by a conspicuous gully to the higher Llyn yr Adar. The path then continues to Llyn Terfyn on the col between Ysgafell Wen and Moel Druman, but walkers who can walk on a compass bearing will have no difficulty ascending directly from Llyn yr Adar to the summit of Ysgafell Wen – a practice which, if needed in reverse, has a lot to commend it.

From the top of the gully on the left of Llyn Llagi a line straight ahead will lead to Llynnau'r Cwn and the un-named summit which lies just north of the main top.

Bibliography

An Introduction to the History of Wales, A. H. Williams (University of Wales Press, 1948/1949)

A Tour in Wales, Thomas Pennant (Henry Hughes, 1783)

A Tour through England and Wales, 1724–6, Daniel Defoe (Dent, 1928)

Britain's National Parks, Ed. Mervyn Bell (David & Charles, 1975)

Britannia, William Camden (John Stockdale, 1806, 2nd Ed. Vol. III)

Eryri, The Mountains of Longing, A. Lovins (Friends of the Earth, 1972)

Great Walks of North Wales, Frank Duerden (Ward Lock, 1982)

Hill Walking in Snowdonia, E. G. Rowland (Cidron Press, 1951)

I Bought a Mountain, Thomas Firbank (Harrap, 1940)

Landscapes of North Wales, Roy Millward and Adrian Robinson (David & Charles, 1978)

Mysterious Wales, Chris Barber (David & Charles, 1982)

North Wales, Rev. W. Bingley (Longman & Rees, 1804)

On Foot in North Wales, Patrick Monkhouse (Maclehose & Co., 1934)

Portraits of Mountains, Ed. Eileen Molony (Dennis Dobson, 1950)

Princes and People, John Miles (Gomerian Press, 1969)

Rambles in North Wales, Roger Redfern (Robert Hale, 1968)

Snowdon Biography, Young, Sutton and Noyce (J. M. Dent & Sons, 1957)

Snowdonia District Guide Books: (Gaston/West Col Productions)
 Snowdon Range, Showell Styles
 Glyder Range, Showell Styles
 Carneddau Range, Tony Moulam

Snowdonia National Park Guide, No. 2, Ed. Edmund Vale (HMSO, 1958)

The Big Walks, Ken Wilson and Richard Gilbert (Diadem Books, 1980)

The Journey through Wales, Gerald of Wales (Giraldus Cambrensis) (Penguin Classics, 1978)

The Mountains of North Wales, Showell Styles (Gollancz, 1973)

The Mountains of Snowdonia, H. R. C. Carr and G. A. Lister (Crosby Lockwood, 1948, Second Edition)

The Snowdonia National Park, W. M. Condry (New Naturalist Library, Collins, 1966)

The Welsh Peaks, W. A. Poucher (Constable, 1962)

Wales, Owen Morgan Edwards (T. Fisher Unwin, 1901)

Welsh Walks and Legends, Showell Styles (John Jones, 1979)

Wild Wales, George Borrow (John Murray, ed. 1901)

185

INDEX

Page numbers in italic indicate where substantial coverage begins.